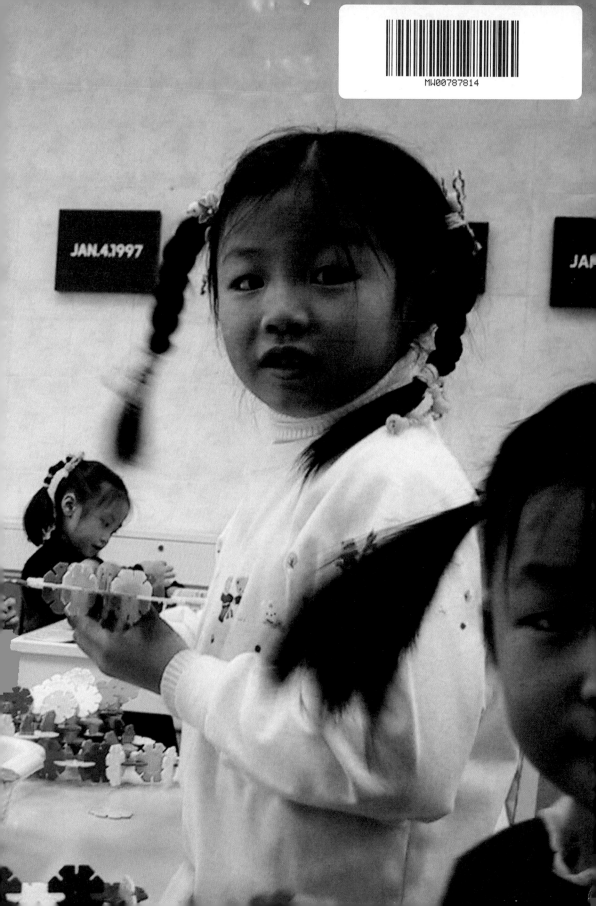

Uncooperative Contemporaries
Art Exhibitions in Shanghai in 2000

With essays by Jane DeBevoise, Lee Weng Choy, Liu Ding and Carol Yinghua Lu and Mia Yu; archival texts by Xu Hong and Zhou Zixi; reflections by Ai Weiwei, Chen Lingyang, Chen Yanyin, Feng Boyi, Hou Hanru, Li Liang, Li Xiangyang, Li Xu, Liang Shaoji, Xu Zhen, Yang Zhenzhong, Yang Zhichao, Zhang Qing, Zheng Shengtian and Zhu Yu (assembled by Anthony Yung); and an introduction by John Tain

Exhibition Histories

Exhibition Histories

Afterall's *Exhibition Histories* book series, published since 2010, addresses what happens when art becomes public. Research led, it is committed to presenting a plurality of voices and critical perspectives, while bringing archival and other primary materials to bear on current and future practice. The series to date has focussed on curatorial experimentation; exhibitionary activity led by artists; and contested articulations of the 'global' and the 'located'. Complementing the books are online publications at afterall.org, discussion events and a research-based masters course in Exhibition Studies at Central Saint Martins, University of the Arts London. As researchers, publishers and teachers at Afterall, we will continue to explore situations that productively challenge and refine our understandings of 'art', 'exhibition' and 'history', mindful of what those terms might mean for the present. This would not be possible without the collaboration of our project partners: Asia Art Archive, based in Hong Kong, and the Center for Curatorial Studies at Bard College, New York.

Inside cover image, front:
Photograph from the 2000 Shanghai Biennale showing On Kawara's series *Pure Consciousness* (1997), at Xinlei Music Kindergarten, Shanghai. Photography: Hou Hanru. Courtesy the Estate of On Kawara

Inside cover image, back:
Installation view, 'Useful Life', Shanghai, 2000, showing work from Xu Zhen's series *Problem of Colourfulness* (2000). Photography: Chinese-art.com Archive at Asia Art Archive

First published 2020 by Afterall Books in association with Asia Art Archive and the Center for Curatorial Studies, Bard College

***Exhibition Histories* Series Editors**
Lauren Cornell, Tom Eccles, Charles Esche, Pablo Lafuente, Lucy Steeds and John Tain

Managing Editor
David Morris

Assistant Editors
Bo Choy and Louis Hartnoll

AWP Research Intern
Kathleen Gorman

Copy Editor
Deirdre O'Dwyer

Design
Andrew Brash

Print
die Keure

Afterall
Central Saint Martins
University of the Arts London
Granary Building
1 Granary Square
London N1C 4AA, UK
www.afterall.org

Afterall is a Research Centre of University of the Arts London, located at Central Saint Martins, directed by Charles Esche and Mark Lewis

Distribution
Buchhandlung Walther König (Germany, Austria, Switzerland / Europe: verlag@buchhandlung-walther-koenig.de); Thames & Hudson Ltd., London (outside the United States and Canada, Germany, Austria and Switzerland: www.thamesandhudson.com); D.A.P. / Distributed Art Publishers, Inc. (outside Europe: orders@dapinc.com)

British Library Cataloguing-in-Publication Data
A catalogue record for this book is available from the British Library

ISBN 978-3-96098-753-6 (Koenig Books)
ISBN 978-1-84638-248-2 (Afterall Books)

Uncooperative Contemporaries
Art Exhibitions in Shanghai in 2000

Exhibition Histories

Contents

Introduction: Uncooperative Contemporaries
— John Tain

In the history of contemporary art in China, there are a number of exhibitions that have made their mark. In 1979, for instance, a loose affiliation of students and self-taught artists known as the Stars 星星 Group hung their work on the rails outside the National Art Gallery, without authorisation, and argu- ably produced the earliest exhibition of contemporary art in the country.[1] A decade later, the 'China/Avant-Garde Exhibition' 中国现代艺术展 opened, in February 1989, as the first display by unofficial artists inside the hallowed halls of the National Art Gallery (today known as the National Art Museum of China).[2] Though the performative firing by artist Xiao Lu 肖鲁 of a pistol on the opening day led to the show's immediate closure, it could be said to have been a shot heard around the world, loudly proclaiming the '85 New Wave generation of artists – just before the events in Tiananmen that year. Or the improvised series of performances from late 1993 into 1994 staged and documented by a loose grouping of artists in the so-called Beijing East Village 北京东村, a set of buildings on the city outskirts that they happened to occupy, and which became a defining milestone in the history of performance art in the country.[3]

Then there is the 2000 Shanghai Biennale. Unlike the above examples, it did not take place in the capital Beijing, at that point still the seat of political, economic and cultural power, but in Shanghai, which had been the country's cosmopol- itan 'city on the sea' in the twenties and thirties, but which in the nineties was still re-establishing itself as an Asian hub of finance and modern urban culture. Nor was the Biennale initiated by artists, or the result of any artistic trends or movements. Instead, it emerged as the brainchild of organisers at the Shanghai Art Museum, who were state employees and, as such, a strategic product of the government. Yet while it may have enjoyed the official stamp of approval, it did not prove entirely satisfactory. Whereas the earlier art events mentioned above were undeniably *succès de scandale* in a classic avant-garde vein, the Biennale was denounced by detractors on both ends of the cultural spectrum as a failure.[4]

If it is the 2000 Shanghai Biennale – together with the satellite exhibitions 'Fuck Off' 不合作方式 and 'Useful Life' 有效期 – rather than earlier ex- hibitions that form the focus of *Uncooperative Contemporaries*, the eleventh

volume in Afterall's *Exhibition Histories* series, it is because this cluster of shows perhaps most definitively diagrammed the onset of contemporary art in China in the wake of globalisation. Taking place at the turn of the century, the biennial exhibition served its intended purpose of focussing the art world's attention on China, and also pivoted official attitudes to both contemporary art and curatorial authorship. The pairing with 'Fuck Off' and 'Useful Life', which together with a whole slew of unofficial satellite exhibitions took place at the same time as the Biennale, provide a means of assessing the larger forces at play – economic and cultural, curatorial and artistic.

It is not insignificant that the city hosting these exhibitions also happened to be one of the nation's key laboratories for liberalisation, and where its first stock exchange opened, in 1990. But while the arrival of marketisation in China did not immediately change the attitude of either the state or artists themselves towards art, it did pave the way for the establishment of commercial galleries. In 'Shanghai 2000: Let's Talk About Money', Jane DeBevoise plots out the development of the art market over the course of the decade leading up to the Biennale, during a period when the city regained its preeminent status as a financial and cultural powerhouse. Detailing the galleries, art fairs and auction houses that sprung up like mushrooms across the country, DeBevoise singles out the galleries in Shanghai in particular for their cultivation of local audiences and international collectors. Notably, one of the city's early veterans, ShanghART, became the first gallery from China to take part at the 2000 Art Basel fair in Switzerland, which, as DeBevoise notes, was equated by some local press to the 'Olympics of the art world'. By the end of the decade, the commercial aspects of the art field were prominent enough a feature of the scene for artists such as Zhou Tiehai 周铁海, Xu Zhen 徐震 and Yang Zhenzhong 杨振中 to produce art and exhibitions that commented on it.

However, the 2000 Biennale made clear that China did not wish simply to be seen on the world stage, but also intended to establish itself as an arbiter of contemporary art, what cultural theorist C.J.W.-L. Wee, as quoted by Lee Weng Choy in his essay for this publication, calls 'the curatorial capacity to represent'. Hence, the show did not only promote Chinese contributors, but included an equal number of artists from Asia, Western Europe, North America, Africa and Oceania. Mia Yu, in 'Manifolds of the Local: Tracing the Neglected Legacies of the 2000 Shanghai Biennale', offers a fresh look at the official exhibition, reassessing the particular configuration of local and global discourses. Drawing on archival documents and conversations with interlocutors from the time, Yu maps out the significant divergences in the four curators' approaches. The two in-house members of the team, Zhang Qing 张晴 and Li Xu 李旭, saw the exhibition as an occasion to redress perceived imbalances in China's relationship to the West by giving exposure to more mainstream Chinese artists. By contrast, Toshio Shimizu, one of the two non-Chinese curators, championed a broadly non-Western perspective, bringing in artists from other parts of the non-West. For his part, Hou Hanru's transnational approach took inspiration from Shanghai's cosmopolitan history to argue for the continued relevance of hybridity and mobility, rather than fixating on national localities.[5] In addition to reviewing the approaches taken by the exhi-

bition's four curators to the local-global problematic, Yu also examines how those outlooks translated into the actual spatial arrangements of artworks in the Museum. In doing so, she looks beyond the view of the exhibition as a 'failed' or compromised venture to underscore the ways that the Biennale's imaginings of the local, especially the juxtaposition of non-Western artists that it enabled, have since informed current curatorial approaches.

Taking advantage of the increased attention – and foreign visitors – drawn to Shanghai by the Biennale, artists and galleries in the city not surprisingly organised unofficial satellite events, over a dozen by one count, to run concurrently with the larger exhibition.[6] More surprisingly, one of these (nearly) upstaged the main event. But 'Fuck Off', co-curated by Ai Weiwei 艾未未 with Feng Boyi 冯博一, never aimed to be understated or subtle. Its ambition can be gauged from the roster of 47 artists drawn from across the country, mixing more established artists such as Ding Yi 丁乙 and up-and-comers such as Cao Fei 曹斐 and Song Tao 宋涛 (who with Ji Weiyu 季炜煜 would become the group known as Birdhead 鸟头). Liu Ding and Carol Yinghua Lu's essay on the exhibition charts the exhibition's antagonistic stance, making clear that its 'uncooperativeness with any system of power' was addressed to both Chinese governmental and Western market interests, both of which threatened assimilation.[7] But that stance was as much a pose as it was a position: the contrast between the provocation of the English-language title and the comparative blandness of the Chinese (translatable simply as 'uncooperative way'), or the inclusion of photographs of Zhu Yu 朱昱's shocking performance *Eating People* 食人 in the catalogue but not in the actual exhibition, suggests the elaborate choreography needed to stoke controversy while actually not being completely shut down by censors. The exhibition's continuing impact on the international understanding of Chinese art as avant-garde can be measured by both Ai Weiwei's continued popularity as a household name, and the high visibility enjoyed by several of the participating artists.[8]

But not all of the work in 'Fuck Off' was cut from the same scandalous cloth. Whereas the artists old enough to remember the Cultural Revolution firsthand tended to employ more confrontational, at times visceral aesthetics, their younger peers – those who had grown up in the wake of China's consumerist turn – produced work of a more ambiguous nature, that engaged the body in less brutal and more mediated ways. This difference becomes even clearer when one turns to 'Useful Life', an exhibition of three Shanghai-based artists who also took part in 'Fuck Off'. Within the relatively intimate three-person exhibition, which was supported by the commercial ShanghART gallery, the media-based work by Xu Zhen, Yang Fudong 杨福东 and Yang Zhenzhong took on a very different affect, offering at time ephebic bodies engaged in uncertain pleasures.[9] In terms of exhibition-making, the triangulation of these three initiatives in the present volume is intended to open out to the wider field of exhibition activity in Shanghai around this moment.

Further afield, the three exhibitions offer an interesting point from which to assess the broader phenomenon of biennials and triennials then being established all across the Pacific, from Gwangju (begun in 1995) to Taipei

(1996), Yokohama (2001), Guangzhou (2002), not to mention the Asia Pacific Triennial (founded in 1993),[10] but also with other events in Asia that offer a counterpoint to these mega-events; independent initiatives, often founded in networks of exchange between artists and advancing their own regionally defined alternatives to globalisation's universalism as well as the overbearing presence of nationalism (as touched upon in the *Exhibition Histories* volume *Artist-to-Artist,* dedicated to Chiang Mai Social Installation in the 1990s).[11] On the question of scale, Lee Weng Choy, in 'Coincidence and Re-collection; Lateness and Insight', offers his appraisal of the 2000 exhibitions from the perspective of Southeast Asia, tying it in to the larger sequence of events that led to globalisation.

The present volume on Shanghai may also be understood as a successor to the two earlier *Making Art Global* volumes of the *Exhibition Histories* series, which address the 'global' reorientation of art worlds that was taking shape through the 1990s via two 1989 exhibitions in Havana and Paris.[12] Shanghai in 2000 allows us to consider the legacies of that moment in a new light, as part of another phase of the global changes inaugurated in 1989, and perhaps indicating an understanding of globalisation as a process no longer grounded in the West. While the specific constellation in Shanghai partakes of the broader trend of the global diffusion of contemporary art and its attendant rituals, the dynamics between the different exhibitions in Shanghai offer a stark reminder that the specific conditions under which the contemporary could be articulated varied widely, resulting in situations that could be described as the contemporary with a difference.

Complementing the commissioned critical essays, *Uncooperative Contemporaries* also presents the 'voices' of a dozen artists and curators involved with the three exhibitions, some excerpted from texts of the period, others drawn from more interviews done for the project, which have been assembled for this publication by Anthony Yung, whose research informs the various aspects of this book including its conceptualisation. In addition, the book translates two texts from the early 2000s in their entirety. 'To Select, to Be Selected and Who Selects: The Shanghai Biennale in the Context of Globalisation' (2000)presents an assessment of the Biennale by Xu Hong, who at the time was working at the Shanghai Art Museum, and who was familiar with her colleagues' thinking without entirely agreeing with it. According to Xu, if China was entering the globalised field of contemporary art with the biennial, it was in part to better make the case for what such a globe would look like from the vantage point of China, and to better make its own case for what art and which Chinese artists should matter in that mapping. Xu no doubt understood clearly the capacity of exhibitions as catalysing events, having herself experienced this as one of the artists of the 1989 'China/Avant-Garde Exhibition'. In addition, she would have been particularly attuned to the dynamics of representation through her own participation in various exhibitions of Chinese and women artists both in China and abroad.

By contrast, Zhou Zixi's 'From Niuzhuang Village to BizArt' (2004) offers a useful reminder that the local was not exclusively the territory of the national.

It could also be far more granular in scale. Written by Zhou as a first-hand account very much based on personal memories, it conveys an intimate involvement with a particular cultural community in Shanghai, through the fact of living and working together in close proximity. Among the figures that share this space can be counted the three artists of 'Useful Life', but also other, less well-known artists, who do not participate in the same rituals of shuttling between domestic and international exhibitions. Zhou's impressionistic recollections reveal an altogether different set of concerns from the nationalistic frame of analysis to be found in Xu Hong's account of the Biennale, situating the three exhibitions within a very different exhibition history.

In the conclusion to his essay, Lee Weng Choy touches on the ever-evolving present from which the past is understood, evoking the 2019 protests here in Hong Kong. In light of his cautionary note concerning the over-determination of the past by the present, it would be remiss to not acknowledge that at the moment of writing, China and the world are in an altogether different relationship than in 2000. The country has now unmistakably found its footing as a global superpower, and since 2013, the country has promoted its own version of globalisation and its own politico-economic campaign via an updated Silk Road policy known as One Belt One Road (now officially the Belt and Road Initiative). In the field of art, the nation's economic ascendance can be seen in the growth of the Chinese art market into one of the world's largest in terms of sheer value. But that has run simultaneously to the decline of art's function for cultural diplomacy. Meanwhile, globalisation, formerly the golden child of neoliberalism, has come to be viewed elsewhere in the world as less a desired inevitability than as something of a Trojan Horse. This suspicion has only become more urgent with the onset of the coronavirus pandemic, as the world has quickly become aware of the public health perils posed by large-scale mass transportation, and discovered the hazards of supply-chains stretched thin as thread spanning across the planet. Given the vicissitudes of history, exhibitionary or otherwise, and at a moment when even seemingly basic realities such as the plodding march of calendar time and the availability of viewing publics can no longer be taken for granted – when even the seemingly inevitable and orderly procession of biennials is facing previously unimaginable disruption – we should take heed of the positions that were on display already in Shanghai in 2000, both cooperative and uncooperative, and understand their continued relevance for today.

Notes

1 On the Stars Group exhibitions, see Hui Ching-shuen, Janny (ed.), *The Stars: 10 Years* (exh. cat.), Hong Kong: Hanart 2, 1989; Huang Rui (ed.), *Huang Rui: The Stars' Times, 1977–1984*, Beijing: Thinking Hands + Guanyi Contemporary Art Archive, 2008; and Sylvia Fok, *The Stars Artists: Pioneers of Contemporary Chinese Art 1979–2000*, Taipei: Artist Publishing, 2007 (text in Chinese). For an overview of exhibitions in China, including Stars Group and 'China/Avant-Garde Exhibition', see Wu Hung, 'Exhibiting Experimental Art in China', in *Exhibiting Experimental Art in China* (exh. cat.), Chicago: David and Alfred Smart Art Museum, 2000, pp.10–46, which expanded into a later exhibition in Beijing, see, *An Exhibition about Exhibitions* 关于展览的展览：90年代的实验艺术展示 (exh. cat.), Beijing: OCAT Institute, 2016. For a history of exhibitions focussing on Shanghai, see Biljana Ciric (ed.), *A History of Exhibitions: Shanghai 1979–2006*, Manchester: Centre for Chinese Contemporary Art, 2014.

2 On 'China/Avant-Garde Exhibition', see Gao Minglu, 'Post-Utopian Avant-Garde Art in China', in Aleš Erjavec (ed.), *Postmodernism and the Postsocialist Condition: Politicised Art under Late Socialism*, Berkeley: University of California Press, 2003, pp.247–83; originally published as 'Fengkuang de yijiubajiu – Zhongguo xiandai yishuzhan shimo', *Tendency Quarterly*, no.12, 1999, pp.43–76. 'China/Avant-Garde Exhibition' is also featured in Phaidon and Bruce Altshuler (ed.), *Biennials and Beyond: Exhibitions that Made Art History, 1962–2002*, London: Phaidon, 2013, pp.265–80.

3 Wu Hung, *Rong Rong's East Village*, New York: Chambers Fine Art, 2003. See also the discussion of the East Village in Thomas Berghuis, *Performance Art in China*, Hong Kong: Timezone 8 Limited, 2006, pp.102–11.

4 A selections of texts and interviews from the period in English can be found in Wu Hung (ed.), *Chinese Art at the Crossroads: Between Past and Future, Between East and West*, Hong Kong and London: New Art Media Limited and Institute of International Visual Arts, pp.219–85. In Chinese, a larger anthology of documents can be found in Ma Qingzhong (ed.), *Zhongguo shanghai 2000 nian shuang nian zhan ji waiwei zhan wenxian* (Documents of the 2000 Shanghai Biennale and its satellite exhibitions), Hubei: Hubei Fine Arts Publishing House, 2002. For accounts of the Biennale itself, see Mia Yu's essay in this volume; Wu Hung, 'The 2000 Shanghai Biennale: The Making of a Historical Event', *Art Asia Pacific* no.31, 2001, pp.42–49; and Joe Martin Lin-Hill, 'Becoming Global: Contemporary Art Worlds in the Age of the Biennials Boom', unpublished doctoral thesis, New York University, 2013, pp.430–599.

5 For Chinese audiences, Hou Hanru would have been the embodiment of hybridised identity and mobility: by the time of the 2000 Biennale, he had already been involved with a number of exhibitions, the second (and last) Johannesburg Biennial (1997), the French Pavilion at the 48th Venice Biennale (1999), the third Asia Pacific Triennial of Contemporary Art (1999) and 'Cities on the Move' (1997–99) among them.

6 See Ma Qingzhong (ed.), *Zhongguo shanghai 2000, op. cit.*, pp. 282–83.

7 Ai Weiwei and Feng Boyi, 'About "Fuck Off"', *Fuck Off* (exh. cat.) Shanghai: Eastlink Gallery, 2000, n.p.

8 The controversy surrounding the 2017 exhibition 'Art and China after 1989: Theater of the World', in which video documentation of a 2003 performance by Peng Yu and Sun Yuan, two artists from 'Fuck Off', played no small part, confirms the view of Chinese art of the period as 'brutal'. See Alexandra Munroe, Philip Tinari and Hou Hanru (ed.), *Art and China after 1989: Theater of the World*, New York: Guggenheim Museum, 2017.

9 Philippe Pirotte provides a closer account in '"Useful Life": Reflection Among Exhibition Frenzy (Shanghai, 2000)', *Afterall*, issue 29, Spring 2012, pp.95–104. See also B. Ciric (ed.), *A History of Exhibitions: Shanghai 1979–2006, op. cit.*

10 On the rise of biennials in Asia, see John Clark, 'Biennials and the Circulation of Contemporary Asian Art', *Yishu*, vol.8, no.1, January/February 2009, pp.32–40 (part of a special section on 'Contemporary Asian Art and the Phenomenon of the Biennial'); Charles Green and Anthony Gardner, '1989: Asian Biennialization', *Biennials, Triennials, and Documenta: The Exhibitions that Created Art History*, Oxford: John Wiley & Sons, 2016, pp.111–43.

11 See David Teh and David Morris (ed.), *Artist-to-Artist: Independent Art Festivals in Chiang Mai 1992–98*, London: Afterall Books, 2018.

12 See Rachel Weiss et al., *Making Art Global (Part 1): The Third Havana Biennial 1989*, London: Afterall Books, 2011; and Lucy Steeds et al., *Making Art Global (Part 2): 'Magiciens de la Terre' 1989*, London: Afterall Books, 2013.

很快，世界真正的改变仍然是让人措手不及自上而下地发生的，九十年代全面经济改革的威力转变了所有人的注意力。而当代艺术的发展相对滞后地转入地下状态却也势头迅猛，除了自由表达的诉求也有艺术形式探索。97年我从杭州搬到上海，工作烟口之余还能摸索着折腾自己的作品。那时候国内确实没有多少艺术市场介入，连当代艺术的画廊也屈指可数。但是我也幸运地认识了很多同样好折腾的新朋友，我们一起连续地自我组织起很多展览：《晋元路310号》、《超市》、《物是人非》等等，我们尝试了很多非常规的展览形式，时不时有些展览还会被查封，但是那种地下状态"革命"的幻觉也带给我们很多乐趣和刺激。2000年之后，地下状态开始好转了，我们这种不间断地自我组织展览和活动的方式仍然延续了很多年。

杨振中
艺术家，参加《有效期》及《不合作方式》
引自沙越访谈，2017年

Before long, real changes in the world would still happen in a top-down manner, taking people by surprise. The comprehensive economic reforms of the 1990s showed their force and shifted everyone's attention. The somewhat delayed development of contemporary art went underground, but did so at full throttle, seeking free expression and exploration of art forms. I moved from Hangzhou to Shanghai in 1997, and found myself looking for ways to make my own art besides working to make ends meet. At that time, there wasn't much intervention on the part of the art market in China; even contemporary art galleries were few and far between. However, I was lucky to have met many new friends who, like me, loved to make things happen. Together we organised a run of exhibitions: '310 Jinyuan Road', 'Art for Sale', 'The Same Yet Changed' and so forth. We tried many unconventional forms of exhibitions, and on occasion shows were banned. But the underground revolutionary 'illusion' also brought us a lot of fun and excitement. After 2000, underground activities took a turn for the better, but our continual self-organised exhibitions and events lasted many more years.

~Yang Zhenzhong, artist, participant in 'Useful Life' and 'Fuck Off'. From an interview with Sha Yue, 2017

Voices

美术馆一直是事业单位。所谓事业单位就
是公立的、由财政拨款的公益性机构。但是
改革之初，在我1993年去任职的时候，上
海美术馆却变成了自负盈亏的就像公司和
企业那样运作的单位。

当时我什麽都不懂，只是与文化局领导签
了聘任合同，就满腔热血地去搞改革了。应
该说改革还算成功吧，因为人少，加上离退
休的总共才七十多人，有这么大一幢楼，多
办点展览，改善服务，靠收租金日子还是蛮
好过的，工资奖金马上翻翻了。那是强调经
济效益的年代，谈美术馆的品质和定位，好
像是奢侈的。

后来，出过国了，才知道"美术馆"原来跟
"展览馆"不一样，就有了更高的想法和追
求。也因为大家的生活水准提高了，积极性
调动起来了，"温饱思淫欲" 嘛，就琢磨着
能否做一个有意义的、可以持续发展的项
目，但是并不知道做什么，怎么做。

96年，有海外朋友特别是几个上海籍的旅
外艺术家给了很好的建议，说是现在国际
上流行双年展，要做就做上海双年展。至于
什么是"双年展"，怎么做"双年展"，从馆
长方增先到每一位员工，都是没有经验的，
上海艺术圈裡的人，也大都没有听说过。所
以，当时就有"双年展"是"商业展"的笑
话，因为这两个词上海话发音很像。大家去
看看第一届双年展的题目，就特别加上了上
海（美术）双年展的括号。

李向阳
原上海美术馆执行馆长（1993–2005年）
翁子健访谈，2019年9月

The art museum [in China] has always been a government-funded organisation for the benefit of the public. But at the beginning of the reform programme, the Shanghai Art Museum, where I went to work in 1993, was turned into a financially independent entity operating just like a company or an enterprise.

I had no idea what I was dealing with at the time. I had hardly signed my employment contract with the leaders of the Bureau of Culture before I passionately entered into the reforms. I should say the reforms were fairly successful. We didn't have too many people on the payroll – some seventy, including the retirees. With such a big building, we could certainly focus on doing more exhibitions and improving services. The rent alone guaranteed a doubling of salaries and bonuses. It was a time of economic benefits; any talk of the quality and identity of an art museum seemed to be a luxury.

It was only after we had some experience abroad that we realised the difference between an art museum and an exhibition hall, and began to incubate higher thoughts and pursuits. General living stan- dards had improved and so had people's incentives. As the saying goes, 'the well-fed and well-clad tend towards lust'; the thought of a meaningful and sustainable project was floated, but no one knew what to do or how to do it.

In 1996, some friends abroad, especially several overseas artists originally from Shanghai, gave us some very good advice, saying that biennales were popular on the international art scene, and that if we were to do anything it should be a biennale. As to what a 'biennale' was, or how to do it, neither our director Fang Zengxian nor any staffer had any idea; people from the Shanghai art circles had scarcely heard of it. As a result, there was a joke that a biennale was nothing more than a commercial show, for the two terms sound very close in Shanghainese. When the title of the first Shanghai Biennale was made public, it had a special parenthetical emphasis: the Shanghai (Fine Arts) Biennale.

~Li Xiangyang, executive director of Shanghai Art Museum (1993–2005). Interviewed by Anthony Yung, September 2019

Shanghai 2000: Let's Talk About Money
— Jane DeBevoise

pp.134–83

By the year 2000 the pressures of an emerging art market loomed large in the imagination of Chinese critics, curators and some artists. In his introductory essay to the catalogue of that year's Shanghai Biennale 上海双年展, Zhang Qing 张晴, a member of the organising team and a senior curator at the Shanghai Art Museum, which hosted the event, wrote: 'The 1990s was a decade of extraordinary change. […] The burgeoning art market played an important role in the change. In Beijing and Shanghai, patrons from embassy districts and galleries hosted by foreigners exerted a strong aesthetic influence on local artists, who were kept busy producing lucrative "new paintings for export" with amazing speed and quality.'[1] Zhang elaborated his point by citing

p.70

the 45th and 48th Venice Biennales of 1993 and 1999, respectively. Without naming names – though everyone in the art world would have known whom he was talking about – Zhang implicated approximately thirty members of what was then a fairly small community of artists who, according to his analysis, were 'following the West blindly and pursuing fame and profit at the cost of national dignity'.[2] The critic-curator Wang Nanming 王南溟 voiced similar concerns at a symposium organised in conjunction with the Shanghai Biennale. In an address titled 'The Shanghai Art Museum Should Not Become a Market Stall in China for Western Hegemony', Wang attacked artists who seemingly pandered to Western tastes in pursuit of international acclaim. He singled out Wenda Gu 谷文达, Cai Guo-Qiang 蔡国强 and Huang Yong Ping 黄永砅, three artists living overseas at the time; according to his harsh indictment, they used essentialist 'markers of Chinese-ness' to create 'Chinatown' art for foreigners, 'almost as if taking orders at a trade fair'.[3]

Concerns about the deleterious effects of a foreign-dominated art market on the character of Chinese art were not new. As early as 1979, when China's economy was just emerging from the devastating impact of the Cultural Revolution, the chair of the Chinese Artists Association, Jiang Feng 江丰, warned artists against pursuing financial gain at the expense of quality; and, in 1983, the critic Hai Yuan 海源 wrote disapprovingly of painters who were 'acting like walking photocopy machines', churning out slight variations on popular themes 'to maximise profit'.[4] But in the late 1980s, amid government initiatives to promote economic reform through such capitalistic incentives as private ownership and monetary reward, the discourse began to shift. While the art market was still in its infancy – if it existed at all –

the Shanghai-based artist Yu Youhan 余友涵 in 1988 created a series of four colourful, Pop-inspired canvases featuring Chinese banknotes. The following year, Wu Shanzhuan 吴山专 compared the museum to a marketplace at the now-infamous 'China/Avant-Garde Exhibition' 中国现代艺术展 by selling frozen shrimps to an excited group of visitors, including the director of the National Gallery of Art in Beijing (now the National Art Museum of China), the site of the performance. Whether Yu's paintings or Wu's performance were critiques of capitalism remains unclear. But when critics of the 1992 Guangzhou Biennial Art Fair 广州双年展, organised by the critic-curator Lü Peng 吕澎 in an attempt to develop a domestic art market, sprayed Lysol disinfectant in the exhibition hall 'to extinguish the stench of commerce', their message was unambiguous.[5]

The complexity of reconciling the paradigmatic shift in state ideology that only a few years before had vilified capitalists and assailed Western hegemony should not be underestimated. This shift was undoubtedly unsettling – or, more likely, galling – for critics and curators as they watched a previously debased class of business entrepreneurs eclipse their own power and prestige. Still, Zhang Qing's severe critique of his fellow artists stands out, especially in the context of a major museum publication in which introductory remarks are usually reserved for anodyne statements about cultural exchange and mutual understanding. Furthermore, in a city that took great pride in its history of internationalism, such expressions of unabashed nationalism seem somewhat out of place.

What was it about the market for Chinese art at the time and the role of foreign galleries and collectors that might have prompted Zhang's outburst? Did the art market entangle and entrap, contaminating artists and their output, as his criticism suggests? Was the promise of profit causing artists to sacrifice their integrity and compromise national dignity, or did the market offer a new imaginary that opened opportunities to experiment, interrogate and reflect on a rapidly evolving social reality? Did commerce introduce a new language that became both the material and the method for art?

Shanghai Rising

The year 1992 was an inflection point in the development of China's economy. Market-related reforms initiated in the early and mid-1980s had begun to revive economic activity that had stalled during the Cultural Revolution. The establishment of diplomatic relations with the United States in 1979 and ensuing reform measures under the banner of the 'Four Modernisations' increased tourism and foreign investment; introduced free markets in the agricultural sector, which improved farm production almost overnight; and facilitated experiments in private enterprise that created new jobs, especially in the light-manufacturing sector. As a result, between 1976 – the year that Mao Zedong 毛泽东 died and the Gang of Four were arrested – and 1989, China's gross domestic product grew fourfold.[6]

The bloody Tiananmen Square crackdown of 1989 ended this boom. Tourists fled, foreign manufacturers put their investments on hold and the overall

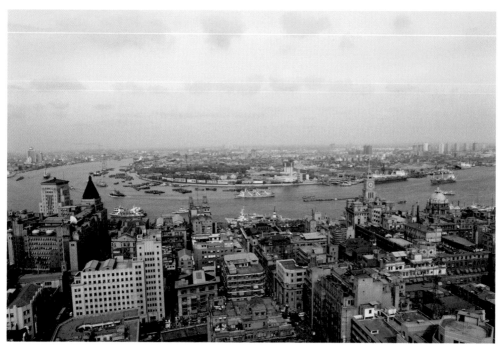

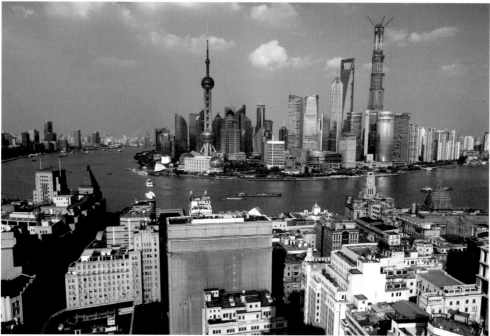

The Pudong district in Shanghai,
documented in late 1987 and
in 2013, post-development.
© Reuters/Stringer (above) and
Reuters/Carlos Barria (below)

economy stumbled for the first time in ten years.[7] Unsettled by this down-turn, Deng Xiaoping 邓小平, the most influential leader in China at the time, took a widely recorded trip in 1992 to China's southern provinces, where he witnessed the success of certain economic experiments that had been initiated in the mid-1980s. This since-mythologised 'Southern Tour' confirmed his conviction in a novel strategy for economic growth that combined political control with capitalistic incentives, popularly known as 'socialism with Chinese characteristics'. When then-President Jiang Zemin 江泽民 called on all citizens in a speech that same year to 'accelerate reform, open to the outside world and drive for modernisation', China was on its way to becoming the largest state-controlled market economy in the world.[8]

Deng Xiaoping's Southern Tour stopped in Shanghai, which in the early 1980s had been given the green light to experiment with capitalistic economic structures. One such experiment was the ambitious Shanghai Centre – still among p.25 the largest hotel, residential and office complexes in the city. Inspiration for the project came in 1979 during Deng's inaugural trip to the US, shortly after the establishment of official diplomatic relations between the two countries. Deng stayed at a high-rise hotel in Atlanta, designed by John Portman and Associates.[9] Impressed by what he experienced, he invited the American architect to China to plan a similar hotel and office complex that would embody Deng's vision for a centrally planned, yet Western-leaning, quasi-open, economically opportunistic and urbanised China. Breaking ground in 1985, the Shanghai Centre – to this day often referred to as the Portman – opened in 1990. Located (perhaps symbolically) across the street from the Soviet-style Shanghai Exhibition Centre, built in 1955 to commemorate Sino-Soviet friendship, the project departed radically from Communist-period owner-ship systems that required absolute government control. Instead, this joint venture sought to bring together the wholly state-owned exhibition centre, the Portman architectural group, the US insurance company AIA and the Japanese construction company Kajima to test a hybrid approach to invest-ment that Deng was imagining for China more broadly.[10]

Deng's ambition for the country was reflected not only in the project's invest-ment structure but also in its size and design. At 48 storeys, the hotel tower was the tallest building in Shanghai at the time, 22 storeys higher than the next tallest, the Park Hotel, which had opened in 1934 and was also designed by a foreign team.[11] Quite literally combining elements of an American shop-ping mall with those of a Chinese palace, the design of the Shanghai Centre attempted to embody what was then probably deemed the best of both these worlds. In this awkward pairing, a horseshoe-shaped driveway leads vehicular traffic through a large arched entrance into a vaulted courtyard, past tall red columns topped with orange cornices styled after the stepped timbers that support the ceramic-tiled roof of the Forbidden City. The few tourist buses and private cars in Shanghai in the early 1990s then stopped in front of the expansive glass exterior of the hotel's main entrance, on either side of which extends a double-level commercial space featuring every amenity a foreign visitor could want: restaurants, hair salons, airline offices, shops and, in the middle of it all, a long escalator leading to a thousand-seat theatre, usually re-

served for performances by traditional Chinese acrobats. Ersatz Chinese-style gardens with decorative rockery and waterfalls dot the grounds. Foreign businesspeople, diplomats and tourists staying in either the hotel or the residences located in two flanking towers never had to leave the premises unchaperoned by local guides appointed by the Shanghai tourist bureau. And that was probably part of the plan, at least on the part of the Chinese leadership, still uncertain about the effect of unrestricted exchange between foreigners and local Chinese. Likewise, despite the 'open gesture' implied by the wide entrance and open courtyard, few Shanghai residents would have been courageous enough to venture up the long, sloping driveway.[12] Though likely unintentionally, the grand gateway and deeply recessed hotel entrance would have intimidated all but the most intrepid pedestrian, who in any case would hardly have been able to afford a meal at the relatively expensive restaurants, let alone an apartment or hotel room.

But Shanghai was in a hurry. In addition to high-profile hotel projects intended to attract and accommodate tourists and foreign investors – other luxury hotels in the city included the Hilton, which opened in 1988; the Garden, in 1989; and the Mandarin, in 1990 – the reopening of the Shanghai Stock Exchange (SSE) in 1990 was another bold step towards reviving the economy. The re-establishment of the SSE, originally founded in 1929, when Shanghai was China's commercial capital, was critical to Deng's reform programme, because it allowed state-owned enterprises to privatise a portion (always a minority) of their ownership, thereby raising capital to fund new investments while attracting foreign expertise. In another bold move, the city's Pudong district was designated a special development zone, and starting in 1993 the few buildings and homes located there were razed to make way for what would shortly become a gleaming landscape of spiky, postmodern skyscrapers. Emblematic of Shanghai's soaring aspirations was the 468-metre-tall Oriental Pearl Tower, finished in 1994, which is punctuated by enormous spherical spaces fitted with karaoke rooms, a revolving restaurant, viewing galleries and the Space Hotel. Another example is the 88-storey, 420-metre Jin Mao Tower, designed by the American architectural firm Skidmore, Owings and Merrill. It opened for business in 1999 with a 33-storey atrium and a five-star Grand Hyatt Hotel that was advertised at the time as the tallest in the world.[13]

Massive infrastructure projects also epitomised Shanghai's roaring 1990s. Work on a sprawling new metro system started in 1993; a futuristic eight-lane bridge over the Huangpu River, linking booming Pudong to the older section of the city, opened in 1997; and the state-of-the-art Shanghai Pudong International Airport began booking flights in 1999. In the ten years between 1990 and 2000, the cityscape changed unrecognisably as the population grew by 23 per cent, mostly via migration from the countryside, and median incomes rose by 400 per cent. The highest earners saw their annual incomes rise even faster, though by Western standards they were still comparatively low, estimated at about USD 3,000 in 2000.[14]

Shanghai's meteoric growth reflects its recent past. Once known as the 'Paris of the East', Shanghai in the 1920s and 1930s was the most pros-

p.22

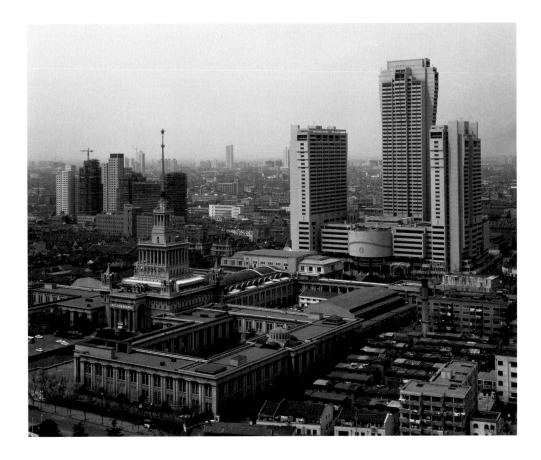

perous city in China, where international communities mixed with local Chinese to create a distinctly modern and cosmopolitan culture, albeit under semi-colonial rule. This historical moment, though short-lived, is indelibly imprinted onto the city's imagination, and recuperating it, without colonial oppression and wartime turmoil, was the goal. Shanghai was to become the New York City of China, as was often repeated in the press, and the city's leadership, including Xu Kuangdi 徐匡迪, mayor from 1995 to 2001, seemed to have the substantial political support it needed to make it happen. After all, the president of China from 1993 to 2003, Jiang Zemin, had been mayor of Shanghai from 1985 to 1987, and he had been succeeded in that role, from 1988 to 1991, by Zhu Rongji 朱镕基, who served as China's premier from 1998 to 2003.

Economic achievement alone was not sufficient to put Shanghai on top. The city's building boom extended to cultural projects. In 1996 the Shanghai Museum of antiquities moved to a brand-new building in People's Park that had been designed to suggest an ancient three-legged bronze ritual vessel. The ambitious Shanghai Grand Theatre opened in 1998, and in 2000 the Shanghai Museum of Modern Art (now more commonly referred to as the Shanghai Art Museum) relocated to a renovated colonial-style building that

Chen Yifei, *Lingering Melodies from Yunyang River*, 1991, oil on canvas, 130 × 149cm. Courtesy Marlborough Fine Art

once housed the Race Club. These were large-scale, brick-and-mortar initiatives, all of them government owned and operated, which meant that their programming was politically approved. As will be discussed ahead in this essay, the Shanghai Biennale presented at the Shanghai Art Museum encountered the pressures of political approval, but so did the performing arts. Referring to the opening programme of the Grand Theatre, the *Los Angeles Times* reported in 1998 that 'the $150-million glass culture palace, designed by French architect Jean-Marie Charpentier to host international performers such as tenor José Carreras and operas such as *Aida* and *Faust*, is meant to be a declaration about the state of the arts in Shanghai. But the performances that do not happen here say more about the art of the state in its efforts to open the door to cultural exchange while trying to control what goes through.'[15] For example, the cellist Yo-Yo Ma was prohibited from playing at the theatre 'because he contributed to the soundtrack for *Seven Years in Tibet*, a 1997 film about the Dalai Lama that Beijing claimed portrayed China "incorrectly"'.[16]

The private sector was equally keen to participate in building the cultural ecology, but on an entirely different scale. Though the prominent Shanghai artist Chen Danqing 陈丹青 declared in 2001 that the city lacked a commercial gallery culture, some evidence indicates that the situation was not

as bleak as he suggested.[17] According to a 2002 article in the magazine *Yishu shenghuo* 艺术生活 (Art Life), there were fifty galleries in Shanghai in 1994, over two hundred in 1997 and at least four hundred in 2000.[18] The editor Ye Juelin 叶觉林, in the preface to his delightful 250-page gallery guide *Shanghai siren hualang* 上海私人画廊 (Shanghai Private Galleries), claimed that there were over a thousand establishments selling paintings in 2001, if *hualang* (galleries) and *huadian* (shops) were included.[19] However, the most reliable accounts agree that only a few were professionally run; Ye chose to list only 45 galleries in his guide.[20] Even more stringent in his requirements was the local critic-curator Li Xu 李旭, who counted only ten.[21]

The Growth of Commercial Galleries in China

More or less banned after the establishment of the People's Republic of China in 1949, along with other forms of capitalist enterprise, commercial art galleries did not re-emerge in China until the 1970s, when government policies loosened enough to allow a trickle of foreign visitors back into the country. Most establishments selling art at that time were government-run 'friendship stores', as they literally were called (*youyi shangdian*), which carried relatively inexpensive (by Western standards) souvenirs for foreign visitors. Among these were paintings that often featured mountainous landscapes or pine trees and bamboo, rendered in ink on paper. Colourfully dressed women from China's ethnic minorities were another favourite subject, as were cheerful peasants. Friendship stores were sometimes large and stand-alone, and almost always located in the central city, not far from, and sometimes adjacent to, regularly visited tourist locations. And while they were run ostensibly to earn foreign currency, the service attitude was remarkably indifferent. In fact, it was rare that salespeople did anything but lounge in a corner, often looking bored and even vaguely annoyed if asked a question. These were exactly the habits that Deng Xiaoping wanted to eradicate. Monetary incentives and semiprivate ownership, he wagered, would change this indifference, and indeed, by the late 1980s and early 1990s, the service culture, along with the overall economy, improved appreciably.

Deng's reforms did more than inject new energy into government-owned stores; by the 1990s, privately established galleries began to emerge as well. Shops offering ink paintings rendered in the millennium-old Chinese tradition continued to exist, but new momentum developed behind galleries promoting oils and acrylics. The paintings' range of styles included colourful abstraction and expressionism, but more often they displayed a naturalism that highlighted the exceptional technical skills of China's academically trained artists, who seductively merged Soviet-inspired realism with a beaux arts aesthetic. While few artists would achieve the name recognition of the Shanghai superstar Chen Yifei 陈逸飞, whose soft-focus portraits of pretty ladies cloaked in Qing dynasty robes and picturesque scenes of Jiangnan canal towns were selling for record auction prices and showing at the prestigious Marlborough Gallery in London and New York, his success would certainly have been an inspiration to many locals.[22] According to one outspoken gallerist, it was these technically proficient paintings, with their meticulous attention to realistically rendered detail, that attracted both local

and foreign audiences. Attractive, too, would have been the nostalgic subject matter that conjured the idyllic days of an imagined old Shanghai, though this same gallerist expected interest in such paintings eventually to decline in favour of more 'artistic' work.[23]

pp.35 & 37

The exact number of commercial art galleries in Shanghai in 2000 awaits further investigation, but a list of stand-outs found general acceptance among those involved in the nascent contemporary art scene. At or near the top of that list was ShanghART, established by the Swiss national Lorenz Helbling and opened in 1996 at the Portman Hotel. But, as will be discussed ahead, ShanghART was exceptional in many ways. More typical were galleries like the Grand Theatre 大剧院, Hwa 华氏, J. 杰 and Yibo 艺博,[24] which were founded in the late 1990s; the first three mentioned were directed by Chinese who had returned from studying or working overseas and sought to address a gap in the cultural ecosystem – and to make a profit. Yu Jinglu 俞憬璐, director of the Grand Theatre Gallery, had earned an MA and a PhD in the US, and afterwards worked in cultural exchange. On returning to China, she focussed on introducing to local audiences Chinese artists who had made a name overseas, like the Yunnan School painter Ding Shaoguang 丁绍光, who created a five-metre-long mural of the 'goddess of art' for the theatre's main lobby. Ding specialised in decorative renditions of willowy dancers from China's Miao ethnic minority, often depicted wearing skimpy, form-fitting sarongs. Only a few of his original paintings were displayed in the gallery; more accessible would have been his limited edition prints, priced around RMB 2,000.[25] Yu Jinglu also carried oil paintings by young or middle-aged academicians from China's tertiary art system, an approach taken by other gallery directors. For instance, the director of Hwa Gallery, Hua Yuzhou 华雨舟, who had studied and worked in Japan, showed paintings by the distinguished professors Luo Zhongli 羅中立 and Xu Jiang 许江, who were then or would soon be the respective deans of the Sichuan Fine Arts Institute (commonly called the Sichuan Art Academy) and the Zhejiang Art Academy (now the China Academy of Art).[26] The director of J. Gallery, Song Yunqiang 宋云强, had likewise spent years in Japan and focussed on academically trained oil painters. Backed by a Japanese investor and located in the Japanese-operated Okura Hotel, J. Gallery got high marks in the press. In fact, one reporter from Taiwan was so impressed with 'its serious atmosphere, bright lighting, soft music and colourful Western-style paintings' that they claimed it could have been mistaken for a gallery there.[27]

Yibo Gallery was not founded by a returnee but a local, Zhao Jianping 赵建平, who, after nearly twenty years in a managerial position at the Pudong Agricultural Bank, left his job in finance to open one of the first galleries in that newly developed district. Located in a large rented space at the foot of Jin Mao Tower, Yibo showcased oil painters, several of whom had already developed strong domestic reputations. The gallery's inaugural exhibition presented 33 paintings by Xia Junna 夏俊娜, a graduate of the Central Academy of Fine Arts in Beijing; according to Zhao, her paintings sold out on the first night.[28] Other notable artists handled by Yibo include He Duoling 何多苓, Zhou Chunya 周春芽 and Mao Yan 毛焰. Another commercial establishment

showing artists who would go on to distinguished careers was the short-lived Yidian 艺典 Gallery. Like Hwa, by 2001 Yidian was showing, if not representing, artists who would later achieve international acclaim, such as the painter of colourful oils Liu Ye 刘野, the sculptors Zhan Wang 展望 and Sui Jianguo 隋建国, and the prominent women artists Jiang Jie 姜杰 and Xiang Jing 向京.[29]

Dong Hai Tang 东海堂 Gallery should also be acknowledged. As one of the earliest commercial galleries in Shanghai, it opened in 1989, and was situated at a distance from the centre of the city in a Spanish-style villa on Hongqiao Road. Founded by a Shanghai ink painter, Xu Longsen 徐龙森, the gallery specialised in oil paintings by recognised early twentieth-century Chinese masters such as Xu Beihong 徐悲鸿, Pan Yuliang 潘玉良, Guan Zilan 关紫兰, Guan Liang 关良 and Sha Qi 沙耆. Xu Longsen marketed their work to a group of what he called 'knowledgeable collectors' and 'art-business people from Hong Kong and Taiwan'.[30] Later in the 1990s, he opened a second gallery, closer to the city centre, showing younger-generation oil painters.

What was the audience for these galleries? Tourists, businesspeople and diplomats from the West were a focus, but more so were visitors from neighbouring Asian territories – Japan, Korea, Hong Kong and Taiwan – whose arrivals far outnumbered those from Euro-America.[31] Developing a foreign audience was, however, only a short-term strategy. Most gallerists had their sights on the newly emerging beneficiaries of Deng's economic reform policies: local entrepreneurs and the rising Chinese middle class, which, according to optimistic articles and interviews at the time, would take around three to five years to emerge.[32] This new middle class was growing rapidly as income levels began to multiply, but in 2000 their purchasing power was still limited, and buying art was not yet a priority. As Ye Juelin observed in 2002, 'People are happy to spend RMB 8,000 on an electronic device that will be thrown out in a few years, but not RMB 3,000 on a painting.'[33] Zhao Jianping of Yibo Gallery put it differently: 'As people get wealthy, first they buy real estate, then stocks, and then art. The first two stages have happened in Shanghai, the third is yet to come.'[34] As proof of the market's immaturity, Zhou estimated that in 2001 no more than four hundred 'quality' paintings had sold in all of Shanghai.[35]

But even for those few local Chinese who might have been so inclined, pricing was often cited as an obstacle. The cost of artwork by established painters, as reported in contemporary publications, was quite consistent, ranging from several thousand RMB for an ink painting to tens of thousands for oil paintings.[36] An example at the high end of the market were the oil paintings by Xia Junna presented at Yibo Gallery's inaugural show, which ranged in price from RMB 10,000 to 50,000 (USD 1,200 to 6,050). Though the artist's works sold out, the director was unsure that such success could be repeated. And despite claims that sixty per cent of Yibo's clients were Chinese, the average annual per capita income in Shanghai, or at least that officially listed (there was and still is a lot of opportunity to earn 'grey

Ding Ceng (Top Floor) Gallery in 2003
(above) and 2005 (below). Courtesy
Zhao Danhong

money' in China), hovered around RMB 12,000, with the highest income listed at RMB 24,000; it was therefore unlikely that the buyers were local.[37] Indeed, Lorenz Helbling readily admitted that 'Chinese buyers at his gallery were almost zero'.[38] Might Yibo's clients instead have been tourists or visiting businesspeople from Hong Kong or Taiwan?

Sales were the primary motivation of these tightly focussed commercial gallerists, though there were exceptions to that rule. Conceived in 1999 and opened in 2000, Ding Ceng 顶层 (Top Floor) Gallery, also called Room with a View, was directed by art writer and critic Wu Liang 吴亮 and supported financially by local entrepreneur Zhao Danhong 赵丹虹. Wu expressed little interest in the commercial side of the business, instead fostering a relaxed, pub-like experience.[39] The gallery's first exhibition, 'Waiting' 等待, featured nothing on the bare white walls of the sizable exhibition space. The second, 'Red' 红色, presented 23 works from the Ding Ceng collection. And while Wu also organised solo shows of works by notable Shanghai experimentalists, such as Sun Liang 孙良 and Li Shan 李山, his expectations for sales were consistently low. As he said in an interview, 'the works [in my gallery] aren't really collectible in a traditional sense. [...] I'd rather compare my gallery to a catwalk for future generations of models.'[40]

The work shown and created at DDM Warehouse, founded in 1999 by the Shanghai-born artist Wang Ziwei 王子卫, was also ostensibly for sale. This large multipurpose space functioned as both a studio and an incubator: emerging artists could work and display their art in the same place. Known for his Pop-style paintings, many included in the several watershed overseas exhibitions of Chinese art in the early 1990s, Wang had just returned to Shanghai from Canada when he set about converting a raw, 1,300-square-metre warehouse into DDM. It was located in what was then still an operational industrial complex, and neither the initial refurbishing cost nor the annual rent on the five-year contract was insubstantial.[41] Yet he did not expect sales to cover his expenses, at least not initially. He organised two exhibitions in the first year of operation, which did not make a profit. The design studio is where he made money.[42]

pp.32–33

BizArt also rarely, if ever, made a profit. Founded in 1998 by the Italian Davide Quadrio with artist Huang Yuanqing 黄渊青 and the Belgian Katelijn Verstraete, who were joined in 2000 by artist Xu Zhen 徐震,[43] this hybrid organisation – part gallery, part experimental art space – initially tried to support its eclectic series of exhibitions, artist talks, lectures and events by selling art. But business was tough. In 2001, Quadrio was quoted as saying: 'I have no buyers.'[44] So instead the organisers sold art services to foreign companies and consulates; such services included interior design and an ingenious programme of renting art to decorate office walls. As Quadrio explained, purchasing art was expensive compared to entering into an agreement to rent art that would be rotated every four months.[45] The scheme offered benefits for both sides: it gave company employees fresh opportunities to learn about a wide range of local art practices, and artists took up the opportunity to broaden their audience.

Whether many of the galleries listed in the 2002 *Shanghai Private Galleries* guidebook are still operating is unclear. However, Grand Theatre, Yibo (under its new name, YiboM), Hwa and J. are still in existence; Top Floor, DDM and BizArt are closed. Eastlink Gallery, another important early venue for Chinese experimental art – it provided space for the controversial 'Fuck Off' 不合作方式 exhibition in 2000 – is now dormant. Unique among this pioneering group of galleries is ShanghART, which by all appearances has not just survived but continues to thrive as one of the most internationally recognised art galleries in China. To what does ShanghART owe its position? Its original location at a five-star hotel was not unusual among its peers; with, arguably, a few exceptions, its initial roster of six artists was not more distinguished; and the local market for contemporary art in which it first operated was unpromising. Moreover, its director, Lorenz Helbling, was a foreigner whose lack of fluency in the local language and culture, at least at the beginning, could have been an impediment. Yet again and again the local press described ShanghART as the most professional gallery operation. What set Helbling apart for many was his familiarity with contemporary art – his brother and father were artists – while most other gallerists had primarily business backgrounds. He also understood the importance of developing an audience by balancing the pursuit of profit with an intellectual admiration for the unprofitable. From the outset he mounted museum-scale

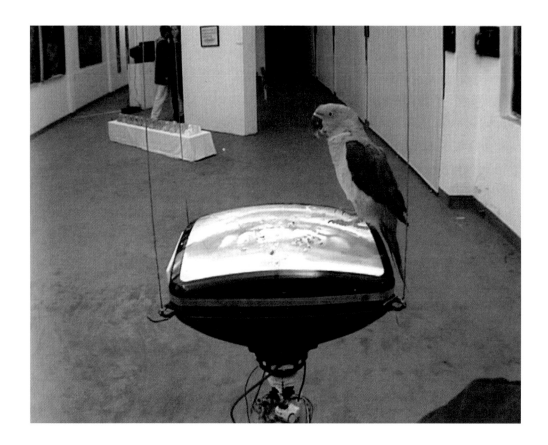

solo shows (when he could); published serious catalogues; assembled tidy notebooks of background material, available on open shelves in his gallery; circulated announcements for upcoming events; and regularly showed his artists at fairs. He even supported alternative practices by emerging artists that could have been nothing but a drain on his pocketbook. At the same time, whether by luck or design, Helbling was uniquely positioned as the only English- and German-speaking gallerist in Shanghai to focus on experimental art. As such, he was singularly equipped to cultivate connections with opinion-makers in the international, at that time primarily Europe-based, art world who wanted on-the-ground advice.

In its first year of operation, with almost no staff, ShanghART managed to produce five solo shows, among them substantial presentations at the Shanghai Art Museum (which was rentable at the time) for the Shanghai-based artists Xue Song 薛松 and Pu Jie 浦捷. The exhibition of Pu's work was accompanied by a slim but stylish catalogue with a preface by Uli Sigg, the newly arrived Swiss ambassador to China, who would go on to build one of the largest collections of Chinese art in the world. The catalogue also included short essays by renowned members of the Shanghai academic and intellectual communities.[46] ShanghART had just moved that year to the Portman Hotel, where Helbling was occupying, rent-free,

Installation view, 'Mantic Exstasy', BizArt, Shanghai, 2001, an exhibition focussed on photography, film and video art, curated by Chen Xiaoyun and Tong Biao. In the foreground, Yang Zhenzhong, *If you have a parrot, what words would you teach him (her)?*, 2001. Courtesy Yang Zhenzhong

an open mezzanine space that came with a sofa, a phone line and bare walls.[47] ShanghART's first show, '15 × Red: New Works on Paper by Ding Yi' 十五·红色，丁乙纸上新作, drew from the artist's ongoing series *Appearance of Crosses* 十示, begun in the late 1980s. Ding Yi 丁乙 would become one of ShanghART's most enduring artists. In the following year, the gallery arranged five more solo shows, including a large presentation for Ding Yi at the Shanghai Art Museum, and published another substantial catalogue with essays by the Italian art expert Monica Dematté and the poet Xiao Kaiyu 潇开愚.[48] The catalogue was co-published with New Amsterdam Art Consultancy (NAAC), founded by the Dutch expatriate Hans van Dijk. Since 1994, NAAC had been actively promoting contemporary art in Beijing alongside two other foreign-run galleries, Red Gate (founded in 1991) and Courtyard (founded in 1996).

Bidders, Buyers and Critics

In the ecology of art and commerce, galleries traditionally play the primary role in introducing artists to the public and, in particular, to potential buyers, but by infusing a certain transparency into this process, art fairs and auctions increasingly have become critical venues for socialising art and legitimising prices. Accordingly, with the explicit goal of promoting the business of art, the Shanghai municipal government began, in 1997, to support an annual art fair. Their investment was substantial. Hefty catalogues were published, with introductions by top-level government officials, including senior Communist Party members and Mayor Xu Kuangdi.[49] On the first page of the 1999 catalogue, the Chinese minister of culture contributed a poem in his own calligraphy: 'Displaying the charm of art, enriching cultural life'. Promotional materials were circulated widely, and advertisements reminiscent of political slogans appeared in local art magazines, for example, 'Shanghai the international city, where the economy and culture are taking off together', and 'At the Shanghai International Art Fair, where art and the market form a blissful union'.[50]

The local press covered these fairs in detail. A report on the 1997 fair enthused over its internationalism, listing participants from France, Switzerland, the US, Japan, Korea, Taiwan and Hong Kong (ShanghART was then identified as a Swiss gallery).[51] Another report applauded the 1998 fair for beating the odds and thriving, despite the financial crisis that was dampening economic activity in the Asia region.[52] That these initial fairs were met with strong interest, both locally and internationally, was undeniable. The inaugural fair purported to attract 380 exhibitors, including one hundred galleries from both inside and outside mainland China. An article about the 1998 fair claims that it was oversubscribed to the point that sixty applicants were turned away for lack of space.[53] Equally sought after was space at the 1999 fair, whose list of exhibitors included a wide variety of arts-related entities. Participants at this fair ranged from art galleries to art schools and departments at educational institutions from Shanghai and other parts of China; cultural centres to artists' associations and studios; craft and art supply companies to stationary stores, bookstores and magazines.[54] The international participants numbered 25 from 13 countries, with an additional ten galleries from Taiwan and Hong Kong.

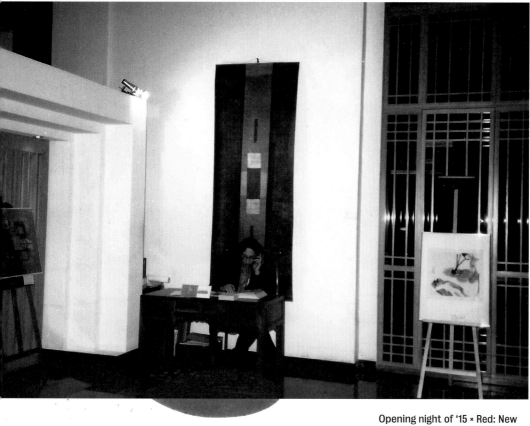

Opening night of '15 × Red: New Works on Paper by Ding Yi', ShanghART at the Portman Hotel, Shanghai, 1996 (above); Lorenz Helbling at ShanghART, c.1996 (below). Courtesy ShanghART

From Shanghai were ShanghART, J., Hwa, Yibo and the auction house and art company Duo Yun Xuan 朵云轩.[55] Unusual, at least to this writer, was the number of individual artists who participated in the fairs, exhibiting their own work. The practice caused at least one local critic to compare these artists to street hawkers who would boast about the value of their wares until the last moment, then sell them for any price they could get.[56]

That the Shanghai fairs positioned the city to compete with Beijing for China's cultural top spot was clear from the press reports, but the ultimate goal was international recognition. Not only was Shanghai single-mindedly and at all levels competing to become the country's cultural and commercial capital, but China was at that moment vying to join the World Trade Organization and host the 2008 Summer Olympics. So when, in 2000, ShanghART – by that time identified as Chinese – was invited to be the first Chinese gallery to participate in the world's premier art fair, in Basel, Switzerland, the event was heralded in the local press. Art Basel was the 'Olympics of the art world', as many local critics wrote, and ShanghART had brought to Shanghai the honour of participating in such a globally recognised event. For its first participation at Art Basel, ShanghART hosted a solo exhibition of Zhou Tiehai 周铁海, presenting three of the artist's five-metre-long scrolls.[57]

Focussed and persistent, ShanghART had worked hard to bring attention to its artists. By 2000, the gallery had organised 24 solo shows, including four museum shows; published numerous catalogues; and participated in multiple art fairs in Beijing, Shanghai and abroad, in addition to organising a show of over seventeen artists for the prestigious international symposium the Fortune Global Forum in 1999. Keeping up with the latest technology, the gallery launched a website in 1998 and hosted the online project *Social Investigation Shanghai No.2* 社会调查 - 上海 No. 2, by Paris-based artist Chen Zhen 陈箴. ShanghART moved the following year from the Portman mezzanine to a charming hundred-square-metre stand-alone space deep in the picturesque former concession district next to Fuxing Park. Its physical growth continued with Helbling's rental, beginning in 2000, of a spacious warehouse on West Suzhou Road to house his mounting inventory of artworks – themselves increasing in size and ambition – by a roster of artists that had expanded from six to nearly thirty.[58]

pp.46–47

pp.222–35

In addition to its commercial practice, ShanghART supported experiments by emerging firebrands. Among such experiments were the ambitious 'Art for Sale' 超市 exhibition in 1999, which, despite its title, ended unprofitably; and 'Useful Life' 有效期 in 2000, which presented photographs and videos of transgressive performances by Xu Zhen, Yang Fudong 杨福东 and Yang Zhenzhong 杨振中. More publicly appealing, yet perhaps equally unprofitable, were two strikingly visible interventions by Zhao Bandi 赵半狄, who borrowed the language of commerce in large-scale artworks that recalled formats more typically used for advertising. His series of billboards *Come and Meet the Panda* 与熊猫咪约会 was erected in Parkson Plaza, a popular shopping section of Shanghai, in 1999–2000, and images from the artist's *Zhao Bandi and the Panda* 赵半狄和熊猫, a series begun in 1996, was shown in lightboxes in the arrival and departure terminals of the new airport in 2000. ShanghART facilitated both projects.

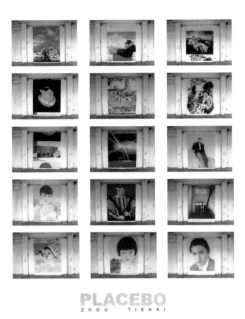

PLACEBO
Z H O U T I E H A I

ShanghART Art 31 Basel Art Statements H3 Hall 2.1
2A Gaolan Rd. Shanghai 200020 P. R. CHINA Tel: 86 21 6359 3923 Fax: 86 21 6359 4570 www.shanghart.com shangart@uninet.com.cn

Installation view and leaflet of 'Placebo',
solo project by Zhou Tiehai, organised by
ShanghART at Art 31 Basel, 2000 (above);
ShanghART at Fuxing Park, Shanghai, 2001
(below). Photograph (below): Zhou Tiehai.
Courtesy ShanghART

How could ShanghART support all this activity? The 2002 gallery guide repeated in print the undoubtedly common rumour that Helbling was a wealthy man, enriched by the success of his artists.[59] But what was the actual market for his artists? At what prices did their artwork (mostly paintings) sell? Who were the buyers, and how frequently did they collect? Above all, how deep was the actual interest?

Gallerists are typically tight-lipped about the identity of their clients, and if collectors are reluctant to reveal themselves publicly, it is rarely clear who, exactly, they are. Auction houses never circulate their buyers lists. At most, vague references to the geographic residence of the winning bidder are released, but in today's interconnected world, a 'buyer from Europe' could be a Chinese national living in the US with a secondary residence in Paris. From what can be gleaned from the available public information, contemporary artists in the 1990s, and that would include ShanghART's, were not selling well or often. Inside China in the 1990s, there were only two sizable public auctions dedicated to contemporary experimental art. The first took place in December 1996 at the Beijing International Art Palace, and the other the following year at the Yan Huang Gallery, also in Beijing. Both were sponsored by the Sungari International Auction Company and organised by the art critic and art market activist Leng Lin 冷林, who wrote in the preface to the catalogue for the first auction: 'Today's Chinese art has broken the restraints of ideology and has begun to blend into a new space' that was 'expanding rapidly with the establishment of the market economy in China', providing 'experimental art with infinite possibilities to connect itself with reality'.[60] To Leng, developing a domestic market for experimental art accomplished several goals. For one, he imagined that a market would also become a 'vernacular space', as University of Chicago professor Wu Hung 巫鸿 has called it, free from the stultifying ideological restrictions imposed by the government. This vernacular space would also help close the gap between art and its Chinese public by providing a legitimate opportunity for engagement and exchange that might even result in sales. Lessening the uncomfortable reliance on foreign buyers was an essential part of the plan.[61]

Unlike Lü Peng's 1992 Guangzhou Biennial Art Fair that ended in controversy and lawsuits, the first Sungari auction was not a failure.[62] Of the 73 artists listed in the auction catalogue, it appears that most of their lots sold and prices were respectable. The bestsellers seem to have achieved tens of thousands of RMB, with the top lot (a 170-by-140-centimetre oil on canvas from Zeng Fanzhi 曾梵志's 1996 *Mask* 面具 series) going for RMB 65,000 (approximately USD 7,800).[63] But again, it is not clear who the buyers were or whether the auctions achieved their stated goals. Judging by the fact that this effort was discontinued after two attempts, it is probable that they did not.

Outside China, the market for Chinese artists was thin as well. Even though an oil painting by the 27-year-old Beijing artist Liu Xiaodong 刘晓东 achieved a respectable price at a 1991 auction at Christie's Hong Kong, interest in Asian (including Chinese) contemporary art was not enough to justify a

dedicated auction until October 1998.[64] Unfortunately this auction, 'Asian Avant-Garde', organised by Christie's London, was by most accounts a flop. Of 170 lots, only 25 sold; of the fifty lots by forty mainland Chinese artists, only three sold.[65] One of the latter was a 1997 mixed-media composition by Xue Song. The fact that this work featured a colourful silhouette of a waving Mao Zedong may confirm widely held suspicions that Pop-inspired artwork with immediately recognisable symbols of China was the only art from the country that Westerners wanted. However, it may also have been bought to support an equivalent price level for a work by Xue Song that had recently been exhibited, and was probably concurrently being sold, at a commercial gallery in Germany.[66] The sale price was a hefty GBP 6,325 (approximately USD 10,700). Nonetheless international auction houses were unnerved. The next dedicated auction would have to wait eight years, when Sotheby's New York organised its watershed 'Asian Contemporary Art' auction in 2006.[67]

Just as robust auction results do not guarantee an artist's continued commercial success, poor auction results do not mean that an artist is not selling. A good example is Zhou Tiehai, whose career path presents an interesting contrast to Ding Yi's. Ding's career has been nothing if not consistent, as he continues to this day to develop his series *Appearance of Crosses*. Zhou, on the other hand, no longer works as an artist. In fact, just as the art market was peaking, he cut back on his practice to focus on upgrading the infrastructure for art in Shanghai, co-organising the SH Contemporary 上海艺术博览会国际当代艺术展 art fair in 2007 and directing the Minsheng Art Museum from 2009 to 2012.[68]

Lorenz Helbling has referred to Zhou Tiehai as an activist, and indeed, Zhou's career offers a sharp contrast to Ding Yi's insistence on a solitary studio practice and the hermetic language of abstract art. One might say that Zhou has always been on a mission: his self-appointed task is to explore and exploit unequal power relations in the art world. Exposing this disequilibrium became the subject of his work, and neither side was exempt from his critique. In 1995 he exposed the prejudices of many Western critics in frequently stereotyping Chinese artists. 'Too Materialistic Too Spiritualized' was his accusation, announced in bold, white text beneath a photo of himself on a fake *Newsweek* magazine cover.[69] In a 1996 video, he lampooned the Chinese art world and its willy-nilly, sometimes cringe-inducing pursuit of Western acceptance. In one scene of this grainy black-and-white work, titled *Will* 必须 (alternatively called *Will/We Must*), a determined group of revolutionary comrades dressed in padded army jackets huddle around a table inspecting a city map. They proclaim, 'We must take action immediately to build our own airport', for they intend to 'welcome museum presidents, critics and gallery owners'. In another scene, a long line of patients jostle on a crowded bench, test results in hand, waiting to see a foreign doctor who is hidden behind a white curtain, though they only ever see a nurse. In yet another vignette, titled 'The Godfather' 教父, a foreigner bemoans 'the lack of outstanding artists', at which point the film concludes with a scene of struggling youths sprawled on a recreation of

 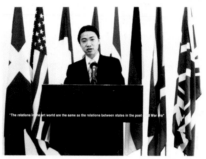

Théodore Géricault's *Raft of the Medusa* (1818–19), who desperately shout 'Farewell, art!' as it heads out to sea.[70]

In 1998, Zhou turned the critique on himself to lay bare his own dependence on the foreign market. In his work *Press Conference* 新闻发布会, a text-based component called 'New Listing, Zhou Tiehai, Rises on Debut Before Reaching Fair Value' 新上市证券周铁海，在到达合理价格前继续上涨 reveals the precariousness of Zhou's career by imagining the artist as a Class B Share on the SSE (a share class denominated in US dollars and available only to foreign investors). In language borrowed from an equity analyst's report, Zhou describes his shares as 'undervalued' when first issued, but then steadily appreciating after rumours that a European buyer was accumulating 'large blocks'. Illustrated by a price chart that traces his slow rise, peak and precipitous fall, Zhou as artist-analyst-art object writes, 'If Zhou climbs much higher, it will find itself very vulnerable to market fluctuations and exposed to the whims of profit-takers', which it does before his share price finally levels off, to find 'fair value'.[71] Zhou's exploration of the vicissitudes of stock market investing coincided with feverish activity on the actual Shanghai exchange, which was then exhibiting casino-like swings.[72] Shanghai was a boom town, and Zhou Tiehai understood that, like the soaring stock markets, he and his artwork were caught up in the gold rush.[73]

Zhou's interrogation of the art system continued in 2000, in the solo exhibition 'Placebo Suisse' at the Hara Museum of Contemporary Art in Tokyo, for which the artist boldly pulled the curtain aside to reveal art-scene power brokers. In the catalogue, a large airbrushed headshot of the international curator Harald Szeemann accompanies a long introductory text in which Szeemann describes Zhou's work as comprising 'visualised strategies' that use 'art as an expanded medium' to expose 'the triangle artist-gallery-museum, and the associated expectations – more glory, more money'.[74]

Another catalogue illustration catches Lorenz Helbling napping on a couch surrounded by Zhou's unfinished paintings. The image is overwritten with a quotation: 'A dealer shouldn't have opinions.' Also included is a portrait of Uli Sigg and his wife, Rita, likewise accompanied by a revelatory quotation: 'When I was a child I used to dream of my face being printed on bank notes.' The catalogue not only illustrates the members of this co-dependent community like photographs in a family album, but it also functions as a travelogue documenting noteworthy stops on the artist's journey to success, from the modest front door at ShanghART's gallery in Fuxing Park to the imposing façade of the Italian Pavilion at the Venice Biennale; up the pedestrian escalator to Art Basel; and into the Sigg residence in Switzerland. And at the centre of this map of influential people and places, the artist appears as the cartoon cigarette spokesperson Joe Camel, branded to ensure that his identity will never be lost, even as he assumes, in chameleon-like fashion, the roles of a black-robed priest, a short-sleeved tourist, a ruffle-collared aristocrat and a tuxedo-wearing celebrity. Analysing with frustrating ambivalence the determinants of fame and fortune, Zhou is perfectly willing to expose his complicity in Szeemann's mutually reinforcing triad. As we have seen, much criticism at the time was focussed on artists who, to gain the attention of foreign buyers, ostensibly were exploiting the 'made in China' brand via such recognisable 'Chinese symbols' as Cultural Revolution propaganda, Mao Zedong, Tiananmen Square and red flags. Rather than eschewing these supposed tactics, Zhou claimed them as his own by inventing a personal logo and unpacking its efficacy and impact in plain sight.

That Zhou's unapologetic strategy bore fruit is clear. In 1998, the artist was awarded USD 3,000 and first prize at the inaugural Chinese Contemporary Art Awards (CCAA), founded by Uli Sigg; on the jury sat Harald Szeemann. In 1999, Szeemann selected Zhou, along with eighteen other artists from China, to participate in the Venice Biennale. During this time and beyond, Sigg became a generous supporter of the artist. An analysis of the Sigg Collection at M+ in Hong Kong shows that Zhou's work constitutes one of the largest concentrations by a single artist, with 28 works, including examples of the 1996 series of fake magazine covers, a print of 'New Listing' and paintings from the 'Placebo Suisse' exhibition.[75]

Shanghai Fax: Let's Talk About Money pp.42–44

Zhou Tiehai was not the only artist in Shanghai to interrogate the mechanics of the art world and its economic entanglements. In 1996, Hank Bull, a Vancouver-based artist and arts organiser, and a group of Shanghai-based artists including Zhou, Ding Yi, Shen Fan 申凡 and Shi Yong 施勇, began exploring ways to mount an international exhibition. According to Bull, after discussing and dismissing many themes as too sensitive, they settled on the theme of money, which not only was topical but also legitimised their endeavor. Inspired by Deng Xiaoping's purported slogan 'It doesn't matter what colour the cat, as long as it catches mice', the organisers settled on a 'fat cat' as their logo and 'Let's Talk About Money' as their title. Participants were asked to consider 'alternative forms of currency, ways of circulation and

!!! 富裕之路的秘方 !!! 陈妍音 CHEN. YANYIN

《我告诉你们 如何造金币》
《I'll Tell You How to make money》

- 第一步
 在纸上画草图
 Frist step
 making the disign on paper.

- 第二步
 制成浮雕. 用石膏
 翻铜成模型.
 Second step
 making the model with plaster

- 第三步
 用缩小机把模型
 缩小到和国币一样
 Putting the model on
 reduce machine, It
 be samll model.

- 第四步
 把缩小了的模型放到冲床上,
 然后一下是压成钱币.
 Putting samll model on Collide machine
 and make metal be money.

- 第五步:
 收起你的钱, 要成大富翁
 Picking your money and
 be a very wealthy man.

52

缩小的模型在中
被压成币的
金块.

▲ 这是古老的发财之道.

ASIAN
BUSINESS
survey after page

The Economis

MATCH 9TH - 15TH 1996

OZAWA
ON JAPAN
pages 19 - 21

AFTER
KEATING
pages 15 and 25

Let's don't talk about money

59

Australia	A$6.90	Hong Kong		New Zealand	NZ$7.50	Sri Lanka		
Bangladesh	TK95		US$4		R$60	Taiwan		
Brunei	B$7.50	Indonesia		Macau	HK$35	Pakistan	Thailand	
Cambodia	US$4.00	Japan		Malaysia	RM7.50	Papua New Guinea	K6.20	Tonga
China	RMB 40	Korea		Myanmar	US$4	Philippines	Peso75	Vietnam
				Nepal	NR90.00	Singapore	S$7.75 inc. GST	

0 09281 02674 7

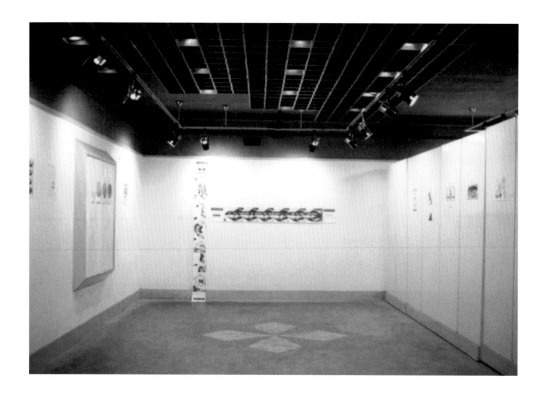

monetary integration and union, as a means of reflecting on such subjects as society, identity and the environment'.[76]

Over one hundred people responded to the call by sending faxes to Ding and Zhou, two of the few artists in Shanghai who had the means and reason to own such modern machines. What arrived were black-and-white A4-size images that included eccentric and sometimes prescient meditations on the future of the global financial system, such as logos for a world currency, credit cards that functioned as official IDs and sketches for the manufacture of both money and happiness. Challenging the preeminence of money by showing what could be done without it, this inexpensive form of circulation and display dismantled institutional barriers by circumventing the necessity for bureaucratic procedures and government approval. The exhibition, popularly known as 'Shanghai Fax', is rarely recorded in histories of the period, but it made an impression on the young Xu Zhen, who, according to Bull, was so inspired by 'the artistic agency on display' that he brought a piece of his own work to the exhibition and, when no one was looking, pasted it to the wall.[77]

By the end of the 1990s, Xu Zhen and his generation of artists faced a dilemma. The visibility of Chinese contemporary art had grown overseas, but the venues for its display inside China were still limited. While rentable by private individuals, the mostly government-run museums remained hesitant to display anything but anodyne ink and academic oil paintings. Installations and

video art were verboten. And even though the number of commercial galleries had increased, their clientele remained primarily foreign. The discrepancy in purchasing power between overseas salaries and Chinese incomes meant that even a modestly priced artwork was still far out of reach of the average citizen. So, how did contemporary artists engage their Chinese public? Where could they test their experiments? How could they sustain their practices without being awkwardly reliant on a limited number of (overseas) collectors with an almost singular preference for oil painting? As Xu Zhen wrote, younger-generation artists needed to find a way to 'release their inexhaustible passions' free 'from reliance on existing systems'.[78] 'Shanghai Fax' offered one possibility, and the exhibition 'Art for Sale' another. And in both cases, commerce was both inspiration and alibi.

pp.46–47

Art for Sale

In the sponsorship brochure for this eccentric exhibition, the curators of 'Art for Sale' – Xu Zhen, Yang Zhenzhong and Alexander Brandt – explained:

> *Commerce has become the predominant religion in Shanghai since the economic reforms of the 1980s. Shopping centres are now erected everywhere and in fact have become the city's new temples. Everything is for sale. [...] How are art and artists going to function within this system? How is the making of art going to interact with this business-minded ear? [...] There is only one way to find out: To operate the way commerce operates.*[79]

To the show's few, mostly foreign sponsors – among them Evian, WestLB bank and the German Consulate General – which the organisers managed with great effort to enlist, this goal may have sounded benign, if not a little naïve. But the artworks on display were anything but. Divided into two parts, the exhibition began with an introductory section designed to resemble a moderately sized supermarket. Loosely arranged shelves along narrow aisles displayed a wide variety of packaged goods. At first glance, the merchandise looked innocent enough. One reporter wrote that, upon entering the space, shoppers might feel at ease because 'everything on display was closely related to their daily lives', but they would soon realise, maybe with shock, that nothing was what it seemed. On the shelves, in pretty packaging, were chocolates in the shape of coffins for RMB 28; pigs' feet adorned with jewelry for RMB 30; bars of soap in the form of male genitalia that promised, for a mere RMB 50, to 'strengthen your confidence to surmount all earthly concerns and achieve joyfully what you really desire in life'; and, most disturbingly, jam jars filled with a taupe-coloured substance that purported to be the pureed 'brains of at least six homo sapiens with academic degrees'. The title of this product was 'Basics of Total Knowledge', and a label on the cap warned 'Please do not eat'.[80]

The 'supermarket' section of the exhibition occupied a relatively small area through which visitors had to pass in order to enter the main space; an orange-clad tour guide, played by the artist Song Dong 宋冬, urged 'shoppers' to explore. This main space was conventionally structured and subdivided into small rooms or alcoves, but its content would have been no less surpris-

45

Opening of 'Art for Sale', Shanghai Square shopping mall, 1999; a page from the exhibition catalogue (below right); and review of the exhibition 'Art in the Supermarket: Stimulating? Nauseating?', written by Shen Jialu and published in *Xinmin Weekly* (above right). Courtesy Yang Zhenzhong and Francesca Dal Lago Archive at Asia Art Archive

人的灵魂在哪里？ 一个疯人的脑袋值多少钱？ 一个美女的乳房是否可以拆零买卖呢？ 或者当猪蹄子涂了指甲油并戴上金首饰时，将是怎样一种增情景呢？

这一连串问题在上海的一个现代化商厦里可以找到答案。

4月10日上午，一个名叫"超市艺术"的现代艺术展在淮海路上一个叫做上海广场的大厦百货商厦四楼开幕了，30多名青年艺术家展出了自己的作品，这群艺术家来自全国各地，还有几个是在中国留学的外国青年。他们大多有一读谱的中国姓名。展览没有时下流行的一本正经的开幕式，没有掌声与鲜花，也没有新闻传媒的镜头，一切静悄悄地进行着。但是前来观展的观众发现眼前的一切既与日常生活情景密切相关，又难以与过去的思维轨道吻合

"超市艺术"刺激？ 恶心？

本刊记者 沈嘉禄

面对瓶装的脑浆，你有什么感觉

据说这个展览的策划者们故意将现代艺术设在四楼一个没有窗棂过的大厅里，为的是造成一种�工业化的粗糙效果，在拥挤所有一个小型超市，一条搁棚挂着柜架，消费就是理想，销费更狠的样的标价单…

∨那个女艺术家围着一根围地边带，以备得心成

他育定地回答：是人别，记者听了不禁毛骨悚然。

来是是来自北京的青年艺术家，从中央美院期中华自就就成了自由艺术家，从记者把青"创作"的给代，是为了加深对人本身的认识。他说，"大脑袋我们全部知识的载体，据死亡后的大脑就成了零，脑果以直流的形态是人日常生活，可以回膜取代，存在应是等，当记者问到这件"作品"从制作到卖是否得到死者的允许时，他说也是在某医学院解剖室内制作的。

记者到货架边寻看瓶子内人头奖假的小姐惊怀地，她一股般吃地厌恶迷，不怕。她还迷等天还在布展时，就有一个黄牛女买了一罐。今天雨看，在展框一小时里已经卖出五瓶，也有人计价还价，但最低也不多于60元。

在另一个货架上，一个傅寿的事本瓶罢放的是曲血渍渍，看来精液加个量形器照明摄或的像体，拆组与精美的装铺摆地的收罐证书，开标明线红一件。也这件"艺术品"的下面，又一个小特别的胶袋装一罐展开，但标的字体这是"psyche灵魂"，记者拿起一件摊打开，里面似有

改装过的小闹钟13元一个，印有女人头像的男式内裤11元一条，叫"玉环爱情三张爱"之行怪的电脑软盘10元一碟，电子的的"大脑"集发标价要瓶和，1000元。还有像成药性生理器形状的解色春色，印有语音·丹玛斯预言的开封。日学单人赛机。题为一个最感的传奇故事30专门门迷个人性情的布碟，做成人嘴字有舌头纹出来的螺蝶一醒医生今迷，嘴那与直么是难人的性能感器官一…前让人遗毫形的商品是一种装在果酱瓶里的脑袋，每瓶98元。

记者拿起一瓶子细绳，里面某么的就体青有不少暗光色的玫珠粒。瓶子上均标着明白白花瓶写着"脑浆"，还标明了产能品。北京，制造商"贤江集团"和键健及能，条型码等商品要素。在盖子上则标明"梦食"二字。记者在发现这是件"艺术品"的作者来是怎么发同人脑构成。

ing to the ordinary visitor. Dimly lit and unrenovated, each sub-space hosted an installation or performance, art forms already unfamiliar to the average audience at the time, made that much more challenging by their content. In one section, a piano player tapped out a tune that corresponded to the heartbeat of a masturbating man, whose rhythmic actions were displayed on a small, blurry video screen. In another area, a three-channel video showed a young man and woman seated side by side in their underwear, incessantly sniffing each other and themselves. Across the room, three squealing piglets were tied to a couch, and a young women nearby circled a small, withered, white-bandage-wrapped tree to which she was tethered. The show was shut down by the authorities within three days.[81]

Artists in Shanghai were not alone in their search for new spaces of expression and display where they might test aesthetic conventions, question social norms and experiment with alternative forms of exhibition and exchange. But a comparison between 'Art for Sale' and another experimental exhibition held the same year in Beijing highlights differences that Davide Quadrio has characterised as typically Shanghai.[82] Quadrio points out that 'Post-Sense Sensibility: Alien Bodies and Delusion' 后感性, 异型与妄想, curated by Qiu Zhijie 邱志杰 and Wu Meichun 吴美纯, was, like 'Art for Sale', shut down by the authorities, presumably for its similarly transgressive content, but only 'Post-Sense Sensibility' was truly 'underground' per both meanings of the term: it took place in an actual basement, and in an obscure location on the outskirts of the city. Moreover, the address of the venue and the opening date were kept secret until the last moment, and then only released to a small group of invitees and their associates. By contrast, 'Art for Sale' took place on the fourth floor of a busy shopping mall in central Shanghai – nothing about it was secret. There was a press conference and a fundraising event; sponsorship documents were distributed to potential funders; and advertisements were circulated in the local media. The goal of this self-described 'wacky' event was to 'allow people to interact with art as consumers and make art more accessible'; as a result of the publicity, ordinary shoppers swarmed the opening.[83] According to newspaper reports, the aisles were crowded and business was brisk; even a few jars of pureed brains sold.[84]

The two shows differed as well in their degree of censorship. As Quadrio points out, the Beijing closure would not have been known to anyone outside a small art-world circle, whereas the termination of the Shanghai show was widely reported in the local press. Coverage was not only lengthy; it also provided detailed descriptions and images of the products for sale, including the noxious jars of brain. The Shanghai press clearly understood that its job was to express displeasure, even horror, at the depravity of some of the show's most sensationalist exhibits. Headlines described 'Art for Sale' as 'nonsense' and 'nauseating', and visitors deemed it 'boring', 'scary' and 'unnecessary'.[85] But reporters also understood the social commentary advanced by the exhibition, as well as its humour, and they were not unsympathetic to many of the issues raised. Positive visitor responses were accompanied by thoughtful interpretations. Indeed, among the most critical observations one reporter could make was that some work risked being misunderstood. Responding to

a display of individually wrapped candies that purportedly improved boys' chances of picking up girls, this reporter worried about its corrupting influence on teenagers, warning that 'while the artist's intention may have been a sarcastic critique of a current social phenomenon, he should also take into consideration the effect on society'.[86]

Conclusion

When ShanghART brought Zhou Tiehai to Art Basel, one of the most prestigious and enduring venues for the purchase and sale of contemporary art, the market for experimental art in China was still in its infancy.[87] There were few galleries showing it; few auctions houses willing to trade it; few buyers willing to purchase it; and almost no museums willing to display it, much less invest in its long-term future by adding it to their collections. The 'artist-gallery-museum' triangle that Harald Szeemann described so baldly in the catalogue of the 'Placebo Suisse' exhibition might have existed in Europe, but it had not resulted in 'more money, more glory' for most Chinese artists. In this light, Zhang Qing's vilification of artists who had shown at the Venice Biennale seems as overwrought as Zhu Qi 朱其's denouncement of Zhou Tiehai as a second-rate artist who socialised only with foreigners.[88] Nonetheless, at least for Zhang Qing, the 2000 Shanghai Biennale intended to address this troubling trend by putting the decision-making authority back into the hands of Asian curators. Only then would the unequal distribution of the cultural power be rectified; the canon of Asian art should and would be determined by Asians.[89]

p.37

pp.134–83

But the Shanghai Biennale and its all-Asian curatorial team also came under fire. On the one hand, there was reason for celebration. As the first presentation since the 1989 'China/Avant-Garde Exhibition' of experimental forms of art, including installation and video, at a major government-controlled museum, the biennial was an important step in legitimising contemporary experimental practice in China. However, the choice of works, especially by mainland Chinese artists, raised questions of compromise. Certainly, artists who had shown at the offending Venice Biennales, with some exceptions, were excluded, but so too were most younger-generation renegades. Only two of the artists who had shown work in 'Art for Sale' were invited: Zhang Peili 张培力 and Zhao Bandi. And participants in cutting-edge shows elsewhere, such as 'Post-Sense Sensibility', were likewise almost entirely overlooked.[90]

pp.46–47

In response, these outsiders began to organise their own shows. One was 'Useful Life', touched upon briefly above. In a text accompanying this brutally frank exhibition, supported in part by ShanghART and including work by Xu Zhen, Yang Zhenzhong and Yang Fudong, the author Chen Xiaoyun 陈晓云 offers a scorched-earth assessment of the art scene. Chen concludes his stream-of-consciousness diatribe by combining money and sex into a tangled metaphor:

pp.222–35

> *If you still have ideals to pursue, it proves that the new proletariat artist's daydreams are not yet thorough enough. […] Ensure that of artworks, nothing but the consumer itself is sold. Ensure that of money, nothing is sold but the*

benefits themselves. [...] Until the detumescence of the struggle ... there will always be something forcing you to realise that trusting art is just as pathetic as trusting a whore.[91]

pp.184–221

Overshadowing 'Useful Life', and even the Shanghai Biennale itself, at least in the minds of the Western press and later historians, was the provocatively titled 'Fuck Off'. According to the catalogue, the exhibition, presented at Eastlink Gallery, aimed to provide an alternative space where artists could express their resistance to all forms of conventional thinking, including the 'threat of assimilation and vulgarisation'.[92] For the two curators, Ai Weiwei 艾未未 and Feng Boyi 冯博一, 'uncooperativeness with any system of power discourse' was the goal, and the hastily assembled array of mostly photographs and installations was meant to express this rebellious attitude.[93] Certainly, one 'system of power discourse' that irked the 'Fuck Off' curators was the conservative definition of public acceptability promulgated by the Chinese government. Probably more infuriating, however, was the willingness of the Shanghai Biennale curators to comply with the restrictions. Where many saw progress, Ai and other members of the art community saw complicity.

But did this threat of 'assimilation and vulgarisation' include the foreign-dominated art market, as well? Did the definition of 'any system of power discourse' include Szeemann's triangle of artist-gallery-museum? Presumably it did, even though Ai Weiwei would soon sit on a jury with Szeemann to adjudicate the CCAA.[94] Ai was also among those maligned artists who joined the Venice Biennale that Szeemann organised in 1999. Moreover, several of his works that featured unmistakable signs of Chinese-ness – Han dynasty pots, Ming-style furniture, temple fragments and blue-and-white porcelain – would form a major part of Uli Sigg's collection.[95]

Returning to the questions posed at the beginning of this essay, what did the market mean for Chinese artists and their advocates in 2000? I would argue that the market was a catalyst that fired the imagination. To entrepreneurs, the market offered the promise of profit; to curators like Lü Peng and Leng Lin, a space of self-determination, free from the rigid restrictions of government control.

pp.42–44

For the organisers of the 'Shanghai Fax' exhibition, the market – and, more specifically, money – was a cover that not only legitimised this innovative project but also provoked wide-ranging discussion of economic inequity, commodification and globalisation.[96] For Xu Zhen, the market was at once an alibi and a lure to entice (one might say, quite cynically) ordinary shoppers

pp.46–47

to the 'Art for Sale' exhibition, only to turn the mirror of commercial activity back on them, thus questioning convention and testing the limits of social acceptability. And finally, for certain artists, the market became both the material and the method of art. Zhou Tiehai appropriated its language with

p.40

humour in *Press Conference* and packaged himself as a product, Joe Camel. Similarly, Xu Zhen copyrighted his own name as he continued to explore the conflation of art, artist and market; his art-creation company, Madein, established in 2009, is a natural result of this investigation.

50

Sententious critiques of commercialisation have a long history in China, as they do elsewhere, and critics in the 2000s were no less fearful of the corrupting influence of the art market than their predecessors had been decades before. Were their virulent critiques of commercialisation an overreaction? Were they xenophobic throwbacks to the Anti-Bourgeois Liberalism campaigns of a previous era? Were Chinese artists really at risk of 'selling out'? The art market is a force field through which most artists, then and now, must travel to produce and circulate their work. However, in the absence of an alternative not-for-profit space, experimental artists and their advocates in China have relatively limited avenues of support and display other than conservative government platforms. Thus, staying alert to the risks that Zhang Qing and others so vividly decried may be particularly pertinent, so as to resist the systems of power that threaten, by prohibition or reward, to restrict the freedom to innovate, express and act.

Notes

All in-depth research takes a village; it is rarely a solitary endeavor. Likewise, the research that underpinned this article has benefited from the support of many people and years of study, travel, conversations and interviews in the field. In particular, I would like to acknowledge the valuable support of Asia Art Archive researcher Congyang Xie, who helped identify some key primary source material in Shanghai, and who shared my delight in its discovery; and my New York-based colleague Furen Dai for her good humour and superb translation skills. Marcie Muscat must also be singled out for her expert editorial advice that improved my text in both big and small ways.

1 Zhang Qing, 'Chaoyue zuoyou: Zhuanzhe zhong de Shanghai shuangnian zhan' (Beyond Left and Right: Transformation of the Shanghai Biennale), preface to *2000 Shanghai shuangnian zhan* (Shanghai Biennale 2000) (exh. cat.), Shanghai: Calligraphy and Painting Publishing House, 2000, unpaginated. In the text, Zhang explains that the goal of the biennial was to 'redefine Asian culture and draw on its essence in the attempt to elevate Asian nations and cultures to the forefront of mainstream discourse'. (A note on translation: this catalogue, like many cited in this essay, is a bilingual publication in which the individual translator is not credited. Translations not provided by the author derive from various sources; all individuals who assisted with translations are named in the acknowledgments above.)

2 *Ibid*. Regarding the 45th Venice Biennale in 1993, fourteen mainland artists were exhibited in the 'Passage to the Orient' exhibition organised by Achille Bonito Oliva: Ding Yi 丁乙, Fang Lijun 方力钧, Feng Mengbo 冯梦波, Geng Jianyi 耿建翌, Li Shan, Liu Wei 刘炜, Song Haidong 宋海东, Sun Liang, Wang Guangyi 王广义, Wang Ziwei, Xu Bing 徐冰, Yu Hong 喻红, Yu Youhan and Zhang Peili. Curator Kong Chang'an 孔長安 selected eight artists for another show in the same biennial, of whom two, Wu Shanzhuan and Wang Youshen 王友身, were from mainland China. It is regularly reported that Harald Szeemann, curator of the 48th Venice Biennale in 1999, selected nineteen artists from mainland China, including Ai Weiwei, Fang Lijun, Liang Shaoji 梁绍基, Lu Hao 卢昊, Ma Liuming 马六明, Qiu Shihua 邱世华, Wang Jin 王晋, Wang Xingwei 王兴伟, Xie Nanxing 谢南星, Yang Shaobin 杨少斌, Yue Minjun 岳敏君, Zhang Huan 张洹, Zhang Peili, Zhao Bandi, Zhou Tiehai and Zhuang Hui 庄辉. Also selected were Chinese artists living overseas: Cai Guo-Qiang (US), and Chen Zhen and Wang Du 王度 (both France). However, one of the names on oft-circulated lists of participating artists, Ying-bo, turned out to be a pseudonym for a non-Chinese person: Szeemann's wife. Not selected by Szeemann but representing France that year was another Chinese artist living overseas, Huang Yong Ping.

3 Wang Nanming, 'The Shanghai Art Museum Should Not Become a Market Stall in China for Western Hegemony: A Paper Delivered at the 2000 Shanghai Biennale', in Wu Hung (ed.), *Chinese Art at the Crossroads: Between Past and Future, Between East and West*, Hong Kong and London: New Art Media Limited and Institute of International Visual Arts, 2001, pp.265–68. Cai Guo-Qiang and Huang Yong Ping participated in the 1999 Venice Biennale (see note 2). Wenda Gu, originally from Shanghai, participated in the 1998 Shanghai Biennale.

4 Jiang Feng, 'Guanyu Zhongguohua wenti de yifengxin' (A Letter About the Problem of Chinese Painting), *Meishu* (Art), no.12, 1979, p.10; and Hai Yuan, 'Jingti yishu shangpinhua de buzheng zhifeng' (Watch Out for an Incorrect Tendency Towards Commercialisation in the Arts), *Meishu*, no.1, 1983, p.42. That foreigners dominated the market for art at the time exacerbated concerns for both Jiang Feng and Hai Yuan.

5 Moralistic injunctions against commercialism in the arts seem to be particularly prevalent among critics. Artists, on the other hand, often express a more ambivalent attitude, as reflected in Yu Youhan's and Wu Shanzhuan's playful works. For more information about the 1992 Guangzhou Biennial Art Fair and reactions against its commercial agenda, see Jane DeBevoise, 'Making a Market for Contemporary Chinese Art', *Between State and Market: Chinese Contemporary Art in the Post-Mao Era*, Leiden and Boston: Brill, 2014, pp.219–33.

6 China's economy in the last forty years has grown at an unprecedented rate. GDP went from RMB 298.86 billion in 1976 to 1.718 trillion in 1989, 10.028 trillion in 2000 and 90.031 trillion in 2018.

7 GDP in China increased by 11 per cent between 1987 and 1988 but dropped to a little over 4 per cent between 1989 and 1990. From 1992 to 1995, year-on-year growth was back to the double digits.

8 For the full English-language text of Jiang Zemin's 12 October 1992 speech, see *Beijing Review* [online journal], http://www.bjreview.com.cn/document/txt/2011-03/29/content_363504.htm (last accessed on 5 September 2019).

9 See Charlie Qiuli Xue and Yingchun Li, 'Importing American Architecture to China: The Practice of John Portman and Associates in Shanghai', *The Journal of Architecture*, vol.13, no.3, July 2008, pp.317–33. The hotel complex in Atlanta, Georgia that inspired Deng Xiaoping's idea for the Shanghai Centre was the Westin Peachtree Plaza.

10 *Ibid*. See also *20 Years of the Portman Ritz-Carlton Shanghai*, a limited edition volume published by the hotel to commemorate its twentieth anniversary, in 2018.

11 See C. Qiuli Xue and Yingchun Li, 'Importing American Architecture to China', *op. cit*. The Park Hotel, on Nanjing Road, was designed by the Hungarian architect László Hudec.

12 The reference to the courtyard entrance as an 'open gesture' appears in *ibid*., p.322.

13 See Kristin Baird Rattini, 'Grand Hyatt Shanghai: The 2009 World's Best Hotels', *Institutional Investor* [online journal], 21 December 2009, https://www.institutionalinvestor. com/article/b150qb24s958rk/grand-hyatt-shanghai-the-2009-worlds-best-hotels (last accessed on 5 September 2019).

14 As reported by the China National Bureau of Statistics and the Shanghai Bureau of Municipal Statistics, and per historical CNY foreign exchange rates. During this period, the Chinese GDP doubled, but Shanghai incomes rose at an even faster rate. It is important to reiterate that median incomes were still extremely low by Western standards, ranging from RMB 2,119.80 (USD 443) in 1990 to RMB 10,586.57 (USD 1,280) in 2000. The highest incomes in 2000 were reported at RMB 24,111 (USD 2,921). A more informal source on income levels is a 1999 review of Shanghai art fairs in which the author, Li Yan 李延, claims that Shanghai residents earned USD 3,000 a year, heading to USD 5,000 by the year 2000. Li was undoubtedly referring to the highest income earners. See Li Yan, 'Yishu zhumu shichang: 1998 yishu bolanhui huimou' (Art Eyes the Market: A Look Back at the 1998 Art Fair), *Meishu xiangdao* (Art Guide), no.2, 1999, p.42.

15 Maggie Farley, 'China: Clash of Culture, Control in Shanghai: Arts, Politics Still Mix in Shanghai', *Los Angeles Times*, 9 November 1998. The same article describes another censorship debacle: a few weeks before it was set to open at Lincoln Center in New York, the traditional Chinese opera *The Peony Pavilion*, written by Tang Xianzu 汤显祖 in 1598, was banned. Shanghai's top cultural official objected to revisions made by the Chinese-American director Chen Shi-Zheng, which included 'unconventional staging, a love scene considered "pornographic" though it was discreetly silhouetted behind a screen, "superstitious" elements such as actors burning "hell money" at a funeral, and showing "dirty" things such as chamber pots on stage'.

16 *Ibid.*

17 Chen Danqing 陈丹青, 'Hualang zhi souyi shi hualang' (Why Galleries Are Galleries), in Ye Juelin (ed.), *Shanghai siren hualang* (Shanghai Private Galleries), Shanghai, 2002.

18 Xia Jingcen 夏菁岑, 'Shanghai hualang ye xin jiegou' (Shanghai's New Gallery System), *Yishu shenghuo* (Art Life), vol.3, 2002, p.20.

19 Preface to Ye Juelin (ed.), *Shanghai siren hualang* (Shanghai Private Galleries), *op. cit*.

20 *Ibid.*

21 Li Xu 李旭, 'Shanghai hualang xiaoshi' (A Short History of Galleries in China), in *ibid*., p.154.

22 Chen Yifei moved to the US in the early 1980s and started showing almost immediately at the Hammer Galleries in New York. In the mid-1990s he was picked up by Marlborough Gallery, first in London and then in New York. His work regularly sold at auction for record prices in the

1990s. For example, in the first stand-alone auction of Chinese oil painting, which took place at Christie's Hong Kong on 30 September 1991, Chen's piece *Lingering Melodies from Yunyang River* (see image on p.26) sold for HKD 1,375,000 (USD 178,750). An oil painting by the younger-generation artist Liu Xiaodong, *Touching Intimacy* (1991), sold at the same auction for HKD 71,500 (approximately USD 10,000).

23 Shi Kefei 史克非, 'Zhongguo weilai de Niuyue' (China's Future New York), *Diancang yishu* (Art and Collection), vol.90, March 2000, p.161.

24 Grand Theatre, Hwa, J. and Yibo are discussed in Ye Juelin (ed.), *Shanghai siren hualang* (Shanghai Private Galleries), *op. cit.*, pp.2–7, 8–13, 18–23 and 138–43, respectively. Shanghai was not the only city to host contemporary art galleries. While the commercial art scene in Beijing in the 1990s and early 2000s awaits in-depth study, several galleries played a pioneering role, including Red Gate Gallery, established in 1991; New Amsterdam Art Consultancy, in 1994; and Courtyard Gallery, in 1996. Only Red Gate continues to operate today.

25 See Yu Juelin (ed.), *Shanghai siren hualang* (Shanghai Private Galleries), *op. cit.*, pp.2–7 and 18. See also 'Shanghai Grand Theatre Gallery', *Art Now* [blog], http://www.artnow.com.cn/CommonPage/ArtOrgDetail.aspx?ChannelID=330&OrganizationId=196 (last accessed on 13 July 2019). Though further research is needed to confirm the opening dates of all the mentioned galleries, a preliminary investigation indicates that Grand Theatre Gallery opened in 1999 and is still in operation.

26 Ye Juelin (ed.), *Shanghai siren hualang* (Shanghai Private Galleries), *op. cit.*, pp.8–13. Preliminary investigation indicates that Hwa Gallery opened in 1997 and is still in operation.

27 The flagship of the art company Jiao Wang, which was established by a Japanese investor, J. Gallery opened in 1996, changed its name to J. Art in 2009 and is still in operation. See Shi Kefei, 'Zhongguo weilai de Niuyue' (China's Future New York), *op. cit.*, p.161. See also Diancang bianji bu (Collection Editorial Department), 'Qipai feifan, bu shu Taiwan: Shanghai hualang mai kai bufa' (Very Extraordinary, As Good As Taiwan: Shanghai Galleries Stepping Out), *Diancang yishu* (Art and Collection), no.59, 1997, p.132; and Ye Juelin (ed.), *Shanghai siren hualang* (Shanghai Private Galleries), *op. cit.*, pp.8–13.

28 *Ibid.*, p.72. Yibo Gallery opened in 1998 and is still in operation.

29 *Ibid.*, pp.64–66. Yidian seems to have existed for only one year.

30 *Ibid.*, pp.102–9. See also Shi Kefei, 'Zhongguo weilai de Niuyue' (China's Future New York), *op. cit.*, p.161. Dong Hai Tang is now closed; its former director, Xu Longsen, is working as an artist.

31 Calculations indicate that in 2006, 83 per cent of all visitors to mainland China came from Hong Kong, Macao and Taiwan, with 11 per cent from elsewhere in Asia (the largest numbers from Japan and Korea) and 4 per cent from Euro-America. See Travel China Guide [website], https://www.travelchinaguide.com/tourism/2006statistics/inbound/ (last accessed on 17 September 2019).

32 See Shi Kefei, 'Zhongguo weilai de Niuyue' (China's Future New York), *op. cit.*, pp.161–62.

33 Ye Juelin (ed.), *Shanghai siren hualang* (Shanghai Private Galleries), *op. cit.*, p.42.

34 Xia Jingcen, 'Shanghai hualang ye xin jiegou' (Shanghai's New Gallery System), *op. cit.*, p.23.

35 *Ibid.* Shanghai at the time was a city of twelve to thirteen million people.

36 See preface to Ye Juelin (ed.), *Shanghai siren hualang* (Shanghai Private Galleries), *op. cit.*; Shi Kefei, 'Zhongguo weilai de Niuyue' (China's Future New York), *op. cit.*, pp.160–63; 'Shanghai xun meng: Hualang yezhe youzhi yitong' (Shanghai Gallerists Have the Same Dreams), *Diancang yishu* (Art and Collection), vol.99, December 2000, pp.38–41; and Xia Jingcen, 'Shanghai hualang ye xin jiegou' (Shanghai's New Gallery System), *op. cit.*, pp.20–23.

37 See *ibid.*, p.23, in which the director of Yibo claims that 60 per cent of his customers were from China, using the term *guonei* 国内, which literally means 'inside the country'. However, it is quite possible that this term, which I have translated as 'China', also included Chinese from Hong Kong, Taiwan and Macao.

38 *Ibid.*, p.22.

39 See Ye Juelin (ed.), *Shanghai siren hualang* (Shanghai Private Galleries), *op. cit.*, pp.9–12 and 28–31. The gallery was located in a 360-square-metre space on the twelfth floor of an office building on Nanjing East Road. Ye Juelin likens the atmosphere to a living room where Wu Liang 'entertained friends non-stop from 3 p.m. to midnight'.

40 *Ibid.*, p.10.

41 The space was located on Da Dong Ming Road, hence the initials in the gallery's name. The annual rent on the five-year contract was reported as RMB 300,000, and the refurbishing cost as RMB 1,000,000, but these figures seem too high for the time. See *ibid.*, pp.32–35. Wang Ziwei's paintings were shown in the exhibitions 'New Art from China: Post-1989', which first took place in two locations in Hong Kong – Hong Kong City Hall and the Hong Kong Arts Centre – before

travelling in modified form to Taipei, Sydney, Melbourne, Vancouver and five cities in the United States; 'China Avant-Garde' at Haus der Kulturen der Welt in Berlin; and 'Road to the East' at the 45th Venice Biennale.

42 *Ibid.*, p.35.

43 Another early member of the BizArt team was Vigy Jin 金利萍, who joined in 1999. Her responsibilities at BizArt included finance, logistics and communications. Jin continues to work with Xu Zhen today.

44 Ye Juelin (ed.), *Shanghai siren hualang* (Shanghai Private Galleries), *op. cit.*, pp.46–49; this source claims that Shanghai-based Huang Yuanqing was another founder. First-hand descriptions of BizArt as well as an annotated timeline of events and exhibitions are gathered in Vigy Jin, Davide Quadrio and Xu Zhen (ed.), *Shanghai Contemporary Art Archival Project: 1998–2012*, Milan: Mousse Publishing, 2017. Concurrent with the 2000 Shanghai Biennale, from 8 November to 3 December 2000 BizArt hosted the exhibition 'Portraits, Figures, Couples and Groups', curated by Hans van Dijk and Eduardo Welsh and featuring works from the collections of the Modern Chinese Art Foundation (MCAF) and also Robert Bernell, founder of the (now defunct) online journal *Chineseart* and the publishing house and bookstore Timezone 8. The exhibition was shown again in 2001 in Ghent, Belgium; see *Portraits, Figures, Couples and Groups From the Collection of the Modern Chinese Art Foundation* (exh. cat.), Ghent: MCAF, 2002. Prior to that, the MCAF collection was introduced in *Modern Chinese Art Foundation*, Ghent: MCAF, 1999. MCAF was established in September 2000 by the Belgian businessman Frank Uytterhaegen, who in the late 1990s, together with Hans van Dijk and Ai Weiwei, had founded China Art Archive and Warehouse (CAAW) in Beijing, a space for both the exhibition and sale of art. CAAW relocated in 2001 to a complex located in the Caochangdi district of the city that included Uytterhaegen's office and home. Since van Dijk's passing in 2002, CAAW has been more or less dormant.

45 See Xia Jingcen, 'Shanghai hualang ye xin jiegou' (Shanghai's New Gallery System), *op. cit.*, p.23. See also V. Jin, D. Quadrio and Xu Zhen (ed.), *Shanghai Contemporary Art Archival Project*, *op. cit.*

46 *Pu Jie* (exh. cat.), Shanghai: ShanghART Gallery, 1996. The catalogue includes essays by Zhang Zishen 张自申, former dean of the School of Fine Arts at Shanghai University, and Yu Tianbai 俞天白, editor of the literary magazine *Meng ya* 萌芽.

47 The manager at the hotel, who arranged for Lorenz Helbling to have the space for free with no strings attached, was himself Swiss. L. Helbling, conversation with the author, 2 June 2019.

48 *Ding Yi* (exh. cat.), Shanghai: ShanghART Gallery; Beijing: New Amsterdam Art Consultancy, 1997.

49 See the 1998, 1999 and 2000 Shanghai art fair catalogues: Shanghai Cultural Development Foundation and Shanghai Municipal Bureau of Culture (ed.), *'98 Shanghai yishu bolanhui* ('98 Shanghai Art Fair), Shanghai: Calligraphy and Painting Publishing House, 1998; Editorial Committee of Shanghai Art Fair (ed.), *'99 Shanghai yishu bolanhui* ('99 Shanghai Art Fair), Shanghai: Calligraphy and Painting Publishing House, 1999; and Organization Committee of Shanghai Art Fair and Shanghai Municipal Bureau of Culture (ed.), *2000 Shanghai yishu bolanhui* (2000 Shanghai Art Fair), Shanghai: Calligraphy and Painting Publishing House, 2000. For a report on the 1997 fair, see Sheng Mi 生米, 'Guanyu '97 Shanghai yishu bolanhui de baodao' (A Report on the 1997 Shanghai Art Fair), *Jiangsu huakan* (Jiangsu Pictorial), no.1, 1998, pp.13–16. While it is unclear who the organisers were in 1997, in 1998 and 1999 they included the Shanghai Cultural Development Foundation and the Shanghai Municipal Bureau of Culture. In 2000 they were the Shanghai Cultural Development Foundation and Shanghai Municipal Administration of Culture, Radio, Film and Television. The venue in 1997, 1998 and 2000 was Shanghai Mart; in 1999, it was the Shanghai International Exhibition Centre.

50 The advertisement appeared in *Jiangsu huakan* (Jiangsu Pictorial), no.5, 1998, p.50.

51 Sheng Mi, 'Guanyu '97 Shanghai yishu bolanhui de baodao' (A Report on the 1997 Shanghai Art Fair), *op. cit.*, p.14.

52 Li Yan, 'Yishu zhumu shichang: 1998 yishu bolanhui huimou' (Art Eyes the Market: A Look Back at the 1998 Art Fair), *op. cit.*, p.42.

53 *Ibid.* The report lists 380 exhibitors, the same number that had appeared the previous year. However, the catalogues for the subsequent fairs (see note 49) list far fewer participants. There were 220 exhibitors in 1999, of which 127 were domestic galleries, 25 international galleries and ten galleries from Taiwan and Hong Kong. In the 2000 catalogue, the officially listed galleries and 'art companies' numbered approximately 120, of which 85 were domestic, 35 were international and one was from Hong Kong.

54 See Sheng Mi, 'Guanyu 97 Shanghai yishu bolanhui de baodao' (A Report on the 1997 Shanghai Art Fair), *op. cit.*, pp.13–16. Of the 380 participants mentioned in this report, one hundred were galleries and two hundred other types of art companies.

55 Whether more Shanghai-based galleries beyond ShanghART, J., Hwa and Yibo participated in the fair is likely but awaits further research. It is important to note that a number of galleries participating in the fair also handled early to mid-twentieth-century artists. Duo Yun Xuan is just one of these galleries. Founded in 1900 as a shop for scholarly accoutrement such as brushes, paper, ink and ink stones, and revived in the late 1970s and early 1980s, after a lull in activity during the Cultural Revolution, Duo Yun Xuan has since become a multifunctional art company specialising in publishing, the provision of art supplies and the sale of pre-modern Chinese painting and antiquities. It also sells works by select living artists working in the millennium-old ink tradition, as well as those working in idioms of the early to mid-twentieth century and before. Duo Yun Xuan established one of the first art auction houses in China in 1992.

56 See Li Yan, 'Yishu zhumu shichang: 1998 yishu bolanhui huimou' (Art Eyes the Market: A Look Back at the 1998 Art Fair), *op. cit.*, pp.42–43. According to this article, artists selling their own work at art fairs was more common in Beijing; it mentions the participation of about ten such individual artists in the 1998 Shanghai fair.

57 See Uta Grosenick and Bepler Sine (ed.), *ShanghART Gallery 10 Years*, Cologne: Verlag der Buchhandlung Walter König, 2007; and *ShanghART 20 Years: 1996–2016*, Shanghai: Shanghai Peoples Fine Arts Publishing, 2017.

58 U. Grosenick and B. Sine (ed.), *ShanghART Gallery 10 Years*, *op. cit.*; *ShanghART 20 Years: 1996–2016*, *op. cit.*; and Xia Jingcen, 'Shanghai hualang ye xin jiegou' (Shanghai's New Gallery System), *op. cit.*, p.21.

59 See Ye Juelin (ed.), *Shanghai siren hualang* (Shanghai Private Galleries), *op. cit.*, p.20.

60 Leng Lin 冷林, 'Jiushi niandai zhongguo dangdai yishu de jingshen henji' (The Trace of the Spirit of 1990s Contemporary Chinese Art), in *Reality: Present and Future – '96 Chinese Contemporary Art* (auc. cat.), Sungari International Auction Co., Ltd., Beijing, 6–8 December 1996, unpaginated. A partial translation of Leng's preface appears in Wu Hung, *Exhibiting Experimental Art in China* (exh. cat.), Chicago: David and Alfred Smart Museum of Art, 2000, p.92. Leng's goal was not dissimilar to Lü Peng's in organising the 1992 Guangzhou Biennial Art Fair. Lü also wanted to create a domestic market for contemporary art, so as to offer an alternative to both the conservative, mostly government-controlled system of adjudication inside China and the then-foreign-dominated overseas market, as well as to close the gap between the art world and the local public.

61 According to Leng, 'Art is leaving its self-confinement and going out towards the public', and the intended public was composed of mainland Chinese. The goal was to overcome an over-reliance on 'others', meaning Westerners, because 'the other in the eye of the Westerners will never form a true subject consciousness'. Leng Lin, 'Jiushi niandai zhongguo dangdai yishu de jingshen henji' (The Trace of the Spirit of 1990s Contemporary Chinese Art), *op. cit.*

62 For more on the 1992 Guangzhou Biennial Art Fair and reactions against its commercial agenda, see J. DeBevoise, 'Making a Market for Contemporary Chinese Art', *op. cit.*

63 In the copy of the 1996 Sungari auction catalogue (see note 60) in the collection of the Asia Art Archive library, Hong Kong, the list of artists contains handwritten notes detailing amounts that were presumably the prices at which the works sold. The then-prevailing RMB to USD exchange rate was 8.33 to 1.

64 See note 22.

65 The auction, dedicated solely to Asian contemporary art, took place on 12 October 1998 at Christie's London and included works by ten ShanghART artists. Its failure has been blamed on a number of factors: a lack of advance marketing, the London location and the general immaturity of the organisers. Overly aggressive estimates were probably also part of the problem, with prices expected to achieve USD 6,600 on the low side to USD 25,000 on the high side. That was, in fact, the range suggested for two large acrylic paintings by Ding Yi: lot 4, measuring 197.5 by 197.5 centimetres, was estimated between USD 6,600 and 8,200; lot 82, a triptych measuring 200 by 420 centimetres and boasting a strong exhibition history, was estimated between USD 17,000 and 25,000. Neither sold. A Mao painting by Xue Song (lot 65), one of the three paintings by mainland Chinese artists to find buyers, was estimated between GBP 5,000 and 7,000, and fetched GBP 6,325, equivalent to USD 10,711 (on 12 October 1998, the USD to GBP exchange rate was 1.6935 to 1). The other two works to sell were Pop-style works by Wang Ziwei and Wang Guangyi.

66 See *Asian Avant-Garde* (auction cat.), Christie's, London, 12 October 1998, lot 166, for evidence that an almost identical work by Xue Song was submitted to the sale, even though it had been included in a 1997–98 exhibition at Galerie Ilse Lommel, a commercial gallery in Leverkusen, Germany.

67 The *Asian Contemporary Art* auction held in March 2006 at Sotheby's New York provided the first convincing evidence that the secondary market was ready for contemporary art from China. That being said, the few ShanghART artists chosen for the sale achieved decent but not extravagant results. Again, a mixed-media collage of Mao's head in silhouette by Xue Song and

dated 2000 found favour, selling for USD 26,400, the same price achieved for a Ding Yi diptych dated 1997. See *Asian Contemporary Art* (auction cat.), Sotheby's, New York, 31 March 2006, lots 7 (Xue Song) and 236 (Ding Yi).

68 See Aimee Lin, 'Interview: Zhou Tiehai', *ArtReview Asia* [online journal], Autumn 2016, https://artreview.com/features/ara_autumn_16_feature_zhou_tiehai/ (last accessed on 5 September 2019).

69 Zhou Tiehai's *Too Materialistic Too Spiritualized* is a small-scale print (27 × 21cm) created in 1995. It is part of a multiyear series that took as its basis the covers of well-known Western magazines, for example, *Newsweek, Art in America, Flash Art*, and *The New York Times Magazine*, which Zhou altered to ironic effect by overlaying them with pithy text and sometimes images of himself or his artwork.

70 The work was commissioned by the Japanese cosmetics company Shiseido, working with the Japanese curator Toshio Shimizu. The script of the film and a clip are available on the ShanghART website, https://www.shanghartgallery.com/galleryarchive/generic/web/viewer.jsp?id=43161 (last accessed on 5 September 2019). The script is also transcribed and illustrated with fine black-and-white pencil drawings in the large catalogue *Zhou Tiehai: An Other History*, published by ShanghART in 2006 to accompany Zhou's solo retrospective at the Shanghai Art Museum. Interestingly, Zhou's name does not appear in the credits (at least as reported in the catalogue). Rather, he is named as scriptwriter and Hong Bin as director.

71 Zhou Tiehai's *New Listing* is reproduced in *Jiangnan: Modern and Contemporary Art from South of the Yangzi River* (exh. cat.), Vancouver: Annie Wong Art Foundation and Western Front Society, 1998.

72 See Adam Marszk, 'The Transformation of the Chinese Stock Market Between 1990 and 2012', *International Business and Global Economy,* no.33, 2014, pp.340–51; and Chao Deng, 'China's Stock Markets: Nearly 25 Years of Wild Swings', *Wall Street Journal*, 31 June 2015. See also Biljana Ciric (ed.), *A History in Exhibitions: Shanghai 1979–2006,* Manchester: Centre for Chinese Contemporary Art, 2014, pp.304–21; and B. Ciric, 'Hank Bull, Shen Fan, Zhou Tiehai, Shi Yong, and Ding Yi, "Let's Talk About Money: Shanghai First International Fax Art Exhibition"', in Elena Filipovic (ed.), *The Artist as Curator: An Anthology*, Milan and Cologne: Mousse Publishing and Verlag der Buchhandlung Walther König, 2017, pp.283–95.

73 'Shanghai in the 1990s is a city consumed with its own growth. […] Bathed in its boomtown glow, one has the feeling that anything is possible'. Hank Bull, 'Fish and Rice', *Jiangnan: Modern and Contemporary Art from South of the Yangzi River, op. cit.*, p.13.

74 Harald Szeemann, introduction to *Placebo Suisse* (exh. cat.), Tokyo: Hara Museum of Contemporary Art, 2000, unpaginated.

75 After the 89 works by the ink artist Chen Guangyu, the 28 works by Zhou Tiehai represent the second-largest concentration of works by a single artist in the Sigg Collection at M+, followed by Ai Weiwei (26 works), Duan Jianyu (25), Qiu Shihua (24) and Zheng Guogu (23). The total number of works Sigg donated to M+ was 1,510. Other ShanghART artists in the Sigg Collection at M+ are Pu Jie (7 works), Ding Yi (6) and Xue Song (3). Younger-generation artists who would be shown at and represented by ShanghART in or around 2000, such as Xu Zhen, Yang Zhenzhong and Shi Yong, are also present in the collection. For a full listing of Sigg's gift to M+, see https://www.westkowloon.hk/en/mplus/m-sigg-collection-2791 (last accessed on 5 September 2019).

76 A full-scale facsimile of the original materials produced in conjunction with the 'Shanghai Fax' exhibition was published in 2015; see Fayen d'Evie and Matt Hinkley (ed.), *Re-print #2: Shanghai Fax (1996) 'Let's Talk About Money'*, Muckleford, Australia: 3-Ply, 2015. See also Biljana Ciric (ed.), *A History in Exhibitions: Shanghai 1979–2006,* Manchester: Centre for Chinese Contemporary Art, 2014, pp.304–21; and B. Ciric, 'Hank Bull, Shen Fan, Zhou Tiehai, Shi Yong, and Ding Yi, "Let's Talk About Money: Shanghai First International Fax Art Exhibition"', in Elena Filipovic (ed.), *The Artist as Curator: An Anthology*, Milan and Cologne: Mousse Publishing and Verlag der Buchhandlung Walther König, 2017, pp.283–95.

77 See F. d'Evie and M. Hinkley (ed.), *Re-print #2: Shanghai Fax, op. cit.*, unpaginated.

78 See Xu Zhen, 'Once Things Get Rolling, They Go Out of Control', and Yang Zhenzhong, 'Just a Simple Sorting Through', in V. Jin, D. Quadrio and Xu Chen (ed.), *Shanghai Contemporary Art Archival Project, op. cit.*, pp.6–11 and 12–17. Yang says that artists were looking for ways for art to 'directly engage in a dialogue with reality'.

79 The 'Art for Sale' sponsorship brochure is translated in Wu Hung (ed.), *Contemporary Chinese Art: Primary Documents*, New York: Museum of Modern Art, 2010, pp.337–38.

80 See Shen Jialu 沈嘉禄, 'Chaoshi yishu ciji? Exin?' (Art in the Supermarket: Stimulating? Nauseating?), *Xinmin zhoukan* (Xinmin Weekly), 13 April 1999, pp.34–37; and Yang Zhanye 杨展业, 'Chaoshi yishu zhan, bulun bulei' (Supermarket Exhibition: Neither This nor That), *Xinmin wanbao* (Xinmin Evening News), 13 April 1999, p.13.

81 The exhibition opened on 10 April 1999 and was forced to close a few days later, on 13 April.

82 D. Quadrio, 'No Cleaning and No Money Required: Personal Traces of the Making of Bizart', in V. Jin, D. Quadrio and Xu Chen (ed.), *Shanghai Contemporary Art Archival Project, op. cit.*, p.40.

83 Advertisement for 'Art for Sale' (publication unknown), Francesca Dal Lago Archive at Asia Art Archive, https://aaa.org.hk/en/collection/search/archive/francesca-dal-lago-archive-1999-art-for-sale-shanghai/object/art-for-sale-847 (last accessed on 18 September 2019).

84 See Shen Jialu, 'Chaoshi yishu ciji? Exin?' (Art in the Supermarket: Stimulating? Nauseating?), *op. cit.*; and Yang Zhanye, 'Chaoshi yishu zhan, bulun bulei' (Supermarket Exhibition: Neither This nor That), *op. cit.*

85 Shanghai Art Museum curator Li Xu called some of the displays 'poorly made', 'out of date' and merely attention-grabbing gambits; see Shen Jialu, 'Chaoshi yishu ciji? Exin?' (Art in the Supermarket: Stimulating? Nauseating?), *op. cit.*, p.34. The dim lighting, bare walls and unfinished flooring are described as 'depressing' in Yang Zhanye, 'Chaoshi yishu zhan, bulun bulei' (Supermarket Exhibition: Neither This nor That), *op. cit.*, p.13.

86 Shen Jialu, 'Chaoshi yishu ciji? Exin?' (Art in the Supermarket: Stimulating? Nauseating?), *op. cit.*, p.37.

87 According to Zhou Tiehai, only one of the three paintings brought to Art Basel sold. See A. Lin, 'Interview: Zhou Tiehai', *op. cit.*

88 Zhang Qing, 'Chaoyue zuoyou' (Beyond Left and Right), *op. cit.*; and Zhu Qi, 'Do Westerners Really Understand Chinese Avant Garde Art?', in John Clark (ed.), *Chinese Art at the End of the Millennium: Chinese-art.com 1998–1999*, Hong Kong: New Art Media Limited, 2000, p.59.

89 Zhang Qing, 'Chaoyue zuoyou' (Beyond Left and Right), *op. cit.*

90 Of the artists included in the 2000 Shanghai Biennale, Fang Lijun and Zhang Peili showed at the 1993 Venice Biennale, and Zhang, Fang, Cai Guo-Qiang, Huang Yong Ping, Liang Shaoji, Xie Nanxing and Zhao Bandi were included in the 1999 Venice Biennale.

91 Chen Xiaoyun, 'Reasons for the Daydreaming Proletariat', ShanghART website, 16 October 2000, https://www.shanghartgallery.com/galleryarchive/texts/id/174 (last accessed on 5 September 2019).

92 In contrast to the government-sponsored biennial, held in the municipally run Shanghai Art Museum, 'Fuck Off' was independently funded and organised by Ai Weiwei and Feng Boyi and presented in a privately rented warehouse space run by Li Liang of Eastlink Gallery. See Ai Weiwei and Feng Boyi, 'About "Fuck Off"', *Fuck Off* (exh. cat.), Shanghai: Eastlink Gallery, 2000.

93 *Ibid.*

94 See Ai Weiwei (ed.), *Chinese Artists, Texts and Interviews: Chinese Contemporary Art Awards (CCAA), 1998–2002*, Hong Kong: Timezone 8, 2002.

95 It is not clear when Sigg started collecting work by Ai Weiwei, but after Zhou Tiehai, Ai's 26 works in the collection account for the third-largest concentration by a single artist. For more on artists in Sigg's collection and his donation to M+, see note 75.

96 Biljana Ciric calls money 'a provocation' in Julia Gwendolyn Schneider, 'Bridging the Past, Present, and Future', *Yishu Journal*, vol.14, no.4, July/August 2015, p.12.

1992年，我受文化部邀请，参与筹办了在广州举行的第一届中国艺术博览会，促进中国艺术市场与国外接轨。自此，我一直希望国内能出现一个学术性的双年展，能与全球当代艺术同步。1994年以来，我曾多次与上海美术馆的朋友议论过这种可能性，并提出一些建议。第一届上海双年展于1996年开幕，我去参加了开幕式。虽然这个展览除个别海外华人外，只有国内艺术家参加，而且仅限油画一种媒介，但毕竟跨出了第一步。

1998年5月中国美院举行七十周年校庆时，上海美术馆方增先和陈龙馆长在杭州找我谈话，希望梁洁华基金会能赞助与合作举办今后的双年展。我当时是基金会的秘书长。我立即安排主席梁洁华与馆长见面，她也欣然同意每届赞助五十万元人民币。所以从同年的第二届起，上海双年展就正式由美术馆与基金会合办。梁洁华担任双年展组委会副主任，我担任双年展组委会委员和艺委会副主任。

第二届双年展举行后，大家对于2000年第三届要向国外策展人和艺术家开放，并不对创作媒介做限制，达成了共识。也就是说，要使上海双年展成为中国第一个国际性的展览。基金会推荐了旅法策展人侯瀚如，美术馆推荐了日本的清水敏男共同担任第三届双年展策展人。侯瀚如有相当的经验，也是我们基金或的顾问之一。他使出浑身解数，要将这次展览办得有声有色。

由于这是在中国的公营美术馆第一次举行的当代艺术展，筹办过程中的困难可以想见。尤其是不时出现各种反对意见，甚至对策展人贴上政治标签。我曾几次与方增先、李向阳和张晴等人开会商议。最重要的一次会议是在1999年威尼斯双年展期间。当时，两个合作单位的首脑都在场。还有许江、侯瀚如、蔡国强、陈定中、翁菱好几位参与或关心双年展的热心人。

起步不久的第三届双年展正面临决定性时刻：虽然早已定下展示当代艺术、邀请中外艺术家的大方向，但文化部始终未给当代艺术开绿灯，市领导也明确表示不会来参加开幕活动。在当时的政治背景下，人心惶惶并不意外，关键是主事人不能动摇。

1999年威尼斯双年展参展的华人艺术家人数最多，蔡国强又获得大奖，大家都很兴奋，证明第三届双年展的开放方向是对的，不能倒退。这次战署性会议双方取得共识，保证了第三届双年展按计划如期举行。

郑胜天
学者，原上海双年展组委会委员和艺委会副主任
翁子健访谈，2020年3月

In 1992, I was invited by the Ministry of Culture to participate in organising the first China Art Exposition in Guangzhou to connect China's art market to the international art community. Since then I had hoped we would have an academically oriented biennial in China to keep domestic contemporary art abreast with the global scene. From 1994 onwards, I discussed the possibility many times with my friends at the Shanghai Art Museum (SAM), and I offered some advice. The first Shanghai Biennale opened in 1996, and I attended the opening ceremony. Although it featured mostly domestic artists with the exception of a few overseas Chinese artists, and despite exhibiting exclusively oil paintings, it was a first step after all.

During the celebrations in May 1998 for the seventieth anniversary of the founding of the China Academy of Art, SAM directors Fang Zengxian and Chen Long had a conversation with

me about their hope that the Annie Wong Art Foundation would sponsor and collaborate with them on future Shanghai Biennales. In my capacity as the secretary general of the foundation at the time, I immediately arranged a meeting between the two directors and our chair, Annie Wong, who gladly agreed to contribute CNY 500,000 to every edition of the Shanghai Biennale. The second edition, that same year, was officially co-organised by SAM and our foundation; Annie Wong served as the deputy director of the organising committee, and I as a member on the organising committee and the deputy director of the advisory committee.

After the second edition, we reached a consensus that the next would be open to international curators and artists and that the limit on medium would be lifted. In other words, the Shanghai Biennale was to become China's first international art exhibition. The third edition was co-curated by the French-based curator Hou Hanru, at the recommendation of the foundation, and by the Japanese curator Toshio Shimizu, at the recommendation of SAM. Hou Hanru was an advisor to our foundation and had extraordinary experience. He went all out to make the exhibition the best it could possibly be.

The fact that this edition was going to be the first contemporary art show in an official Chinese museum meant that tremendous difficulty was to be expected in the organising process. Objections arose from time to time, and the curators were even labelled politically. I had several meetings with Fang Zengxian,

Li Xiangyang and Zhang Qing, the most important of which took place during the Venice Biennale. The top leaders at SAM and Annie Wong Art Foundation were present, as well as such warm-hearted friends as Xu Jiang, Hou Hanru, Cai Guo-Qiang, Chen Dingzhong and Weng Ling, who either participated in the Shanghai Biennale or cared deeply about it.

Not long after preparatory work kicked off, the third Shanghai Biennale faced a moment of truth: despite the agreed-upon general direction of exhibiting contemporary art and inviting both domestic and international artists, the Ministry of Culture had not given the go-ahead for contemporary art, and the municipal leaders in Shanghai made it clear that they would not be attending the opening ceremony. Against the political backdrop of the time, it was not surprising that a disquiet descended on many people, but it was imperative that the decision-makers not dither.

The 1999 Venice Biennale saw the most Chinese artists to date, and Cai Guo-Qiang won the Golden Lion, exciting everyone and proving that the direction of openness for the Shanghai Biennale that year was right. There was no going back. The strategic meeting resulted in a consensus which guaranteed that the third Shanghai Biennale would be held according to schedule.

~Zheng Shengtian, scholar, former member of the organizing committee and vice-president of the art committee of the Shanghai Biennale. Interviewed by Anthony Yung, March 2020

参展的作品，是需要经过双年展评委的讨论的。当时我提交的是个新方案，据说评委没有异议期待我的新作品，可是上海美术馆的馆长看不懂，结果是选用了〈一念之间的差异〉这件1995年的作品。95年上半年我在英国，看了所有我认为重要的美术馆同时也看了很多超常规的展示活动。很难说哪作品或者哪位艺术家影响了我，但至少让我对自己的认识与英国的当代艺术进行了比较和反省。在英国时，我住了半天的医院，朋友送鲜花让我开心的动作让我有很多的联想。花如此之美，怎么运用到作品中，把花的美与人性中的美结合起来？所以这件作品是在被花的美感动下产生的。

〔在2000年上海双年展的展出〕准备了一个月的时间，原因是为了制一批六百只带气的输液袋。一般输液袋装的是药水或葡萄糖水，由于当时的美术馆的天花板不可载重，所以这件作品输液袋内装的是气。对作品的表现力来说更为丰富，对于生命，氧气和葡萄糖都一样重要。

陈妍音
艺术家，参加第三届上海双年展
翁子健访谈，2020年2月

The official selections were all assessed by the Biennale's review panel. I had proposed a new plan. It was said that the panel approved the plan and looked forward to my new piece, but the director of the Shanghai Art Museum didn't understand it, and so my work *Discrepancy Between One Idea*, from 1995, was selected. I had spent the first half of 1995 in the United Kingdom visiting all the art museums I considered important, as well as some unconventional shows and events. It's difficult to say which work or which artists influenced me, but at least I was able to measure my knowledge base against British contemporary art and ruminate on it. While in the UK, I was hospitalised for half a day, and my friends' act of giving me flowers to cheer me up made me think a lot. How could I incorporate the beauty of flowers into my work and combine it with the beauty in human nature? So this work was born out of my affective relationship to the beauty of flowers.

Preparations took a month because six hundred air-filled intravenous drip bags had to be made. Regular drip bags contain medical or dextrose solutions, but because the ceiling of the art museum at the time couldn't bear any load, I had to fill the bags with air. It ended up enriching the work, for oxygen and glucose are equally important for life.

~Chen Yanyin, artist, participant in the 2000 Shanghai Biennale. Interviewed by Anthony Yung, February 2020

"1999年，我参加了威尼斯双年展及伊斯坦布尔双年展后。回国后，接到第三届上海双年展组委的通知，让我递交方案和作品资料。我提交了蚕为媒介的〈自然系列 —— 墙〉及以记录山上植竹，其生命变化过程为题的〈自然之度〉，这两个作品的创作分别历时三年及五年。后来，又加入了〈自然系列No.15 —— 宝宝〉，那是用红色丝绸的褓裸包裹白白的蚕茧，撒在砖地上，以激发人们对小生命的怜爱珍视之心。在中国桑乡，乡民都亲咧地称蚕为"宝宝"。

2000年的上海双年展是具划时代意义的展览，它是我亲历过在中国举办最开放的一次展览，装置和影像作品首次登上了中国官方美术馆舞台。这是诸如肯特利奇、杜玛斯、基弗、宫岛达男和李禹焕等国际艺术家第一次一起在中国展出。"

梁绍基
艺术家，参加第三届上海双年展
翁子健访谈，2020年1月

In 1999, I participated in the Venice Biennale and the Istanbul Biennial. Upon returning home, I received a request from the organising committee of the Shanghai Biennale for exhibition plans and relevant materials for my works. I submitted *Wall/Nature Series*, which used silkworms as the medium, and *Natural Degrees*, which documented the planting of bamboos on the mountain and the changes in their life cycle. These works had taken three and five years to complete respectively. Later I added another work, *Babies/Nature Series No. 15*, which featured silkworm cocoons swaddled in sewn blankets made of red silk, strewn about on a brick floor to activate people to care about these little life forms. In China's silkworm heartlands, villagers lovingly call silkworms 'babies'.

The 2000 Shanghai Biennale was a watershed exhibition. It is the most open exhibition I've personally experienced. Installation and video art debuted on China's official art museum scene. It was also the first time that such international artists as William Kentridge, Marlene Dumas, Anselm Kiefer, Tatsuo Miyajima and Lee Ufan were collectively exhibited in China.

~Liang Shaoji, artist, participant in the 2000 Shanghai Biennale. Interviewed by Anthony Yung, January 2020

Manifolds of the Local: Tracing the Neglected Legacies of the Shanghai Biennale 2000
— Mia Yu

1. The Paradox of the Shanghai Biennale

pp.134–83

In November 2000, Nikita Yingqian Cai 蔡影茜, a student from Fudan University, visited the third edition of the Shanghai Biennale (SB2000) at the Shanghai Art Museum 上海美术馆 (SAM). Like most visitors, Nikita was excited about her first encounter with an art biennial, but oblivious to a paradox that was already associated with SB2000. It was hailed as 'a groundbreaking event for the legalisation of contemporary art in China';[1] whereas, as an exhibition, it was considered 'a compromise of hugely different aesthetic positions and judgments'.[2] Some critics even called it 'an eclectic pastiche' rather than an embodiment of 'cultural hybridity', as it claimed itself to be.[3] The general consensus was that SB2000 was an important historical event but not a great exhibition – a paradox that persists in the biennial's legacy.

However, Nikita Yingqian Cai's vivid recollection of SB2000 two decades after her visit casts a refreshing light on the biennial as a potent site of spatial experience:

p.22

> *The Shanghai Biennale took place at a neoclassical building, a labyrinth-like colonial mansion that used to be Shanghai Race Club 上海跑马总会, built in the 1930s. It was my first time seeing installations and video works. However, what left the strongest impression on me was not any one work, but an ambiguous atmosphere that permeated the exhibition. While Shanghai's future was projected through the spectacular Pudong skyline, its colonial past was simultaneously being called upon and haunted the present. After I left the museum, the unknown haunting lingered.*[4]

Nikita's experience prompts us to go beyond the one-dimensional understanding of SB2000, and to consider it as a spatial construct situated in an entangled space of Chinese and global art worlds. This essay sets out to examine disparate ways in which the 'global-local' paradigm was understood, reimagined and practiced in the institutional formation of SB2000, the cu-

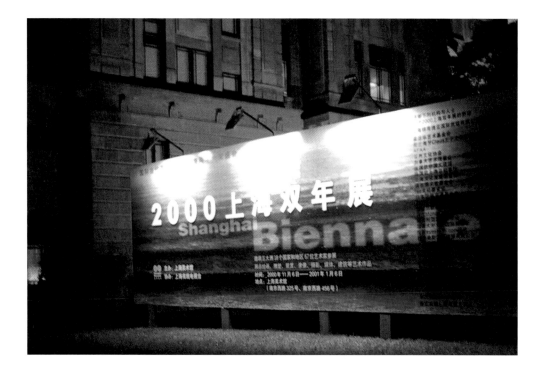

ratorial processes and exhibition display; how the disparity of the local was constituted within and connected to various national, regional and global networks; and how the biennial's four curators resorted to constellations of works to articulate divergent forms and sensibilities of the local and the translocal. This study suggests that SB2000 signalled the crisis of using the global-local as an abstract, monolithic and generalising curatorial currency; further, it heralded more specific and pluralistic approaches to the local in the subsequent decade.

SB2000 was organised at the tail end of the 1990s, which was, for China, a decade of accelerated marketisation and increased participation in globalisation, when exhausted vestiges of nationalist and colonial perspectives unravelled in the West; when biennials and triennials emerged in non-Western centres, in an embrace of cultural pluralism and diversity; and when many Chinese artists had already broken free from the official art system to circulate in international networks. Situated in a complex web of relational contexts, SB2000 represented a Herculean effort for a Chinese state institution, the Shanghai Art Museum, to 'make tracks into the international biennial model',[5] and, as Wu Hung 巫鸿 assessed at the time, it was 'a major victory of reformist curators and museum directors within the country's public exhibition system'.[6] For the first time at a Chinese state museum, curatorial responsibility was identified by name; works by internationally established non-Chinese artists were included; videos and installations were exhibited; and a thematic title was put forth, 'Shanghai Spirit' 海上·上海. Sixty-seven artists from around the world were invited to exhibit by the international curatorial team, comprised

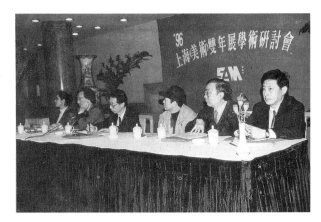

Symposium at the first
Shanghai Biennale, 1996.
Courtesy Asia Art Archive

of Hou Hanru 侯瀚如, based in Paris; Toshio Shimizu, based in Tokyo; and two SAM curators, Zhang Qing 张晴 and Li Xu 李旭.

In addition to the obvious features that qualified it as a global art event, SB2000 engaged a set of globally recognisable, exchangeable 'curatorial currencies', in particular the paradigm of the global-local 全球本土.[7] The biennial's curatorial premise had two central dispositions. On the one hand, it sought to grant primacy to China's own interpretative system in opposition to the hegemony of Western institutions in exhibiting contemporary art; on the other hand, it tried to provide a non-Western-centric global vision in which the city of Shanghai would be the very embodiment of openness, plurality and the constant cultural hybridisation of the global and the local.[8] However, the two dispositions may have contradictions. As Gao Shiming 高士明 has pointed out, the biggest conundrum for Chinese intellectuals around 2000 was 'a double-sided battle in the liminal space of the global and the local, and how to simultaneously resist both nationalism and globalisation's tendency to erase cultural specifics'.[9] The Shanghai Biennale in 2000 was a problematic paradox not only because it was considered an important 'failed' exhibition, but also due to various incongruent visions and conflicting forces operating behind its organisation and curatorial vision. The central point of contention was the very definition and boundary of the local in relation to the state, the official art system in China and the expectations of the global art world.

2. In the Space of Encounter Between the State and the Global

The Shanghai Biennale's situatedness between state cultural production and the global art world engendered a very specific local condition for the curatorial work. The initiation of the Shanghai Biennale can be traced to the early 1990s. It was largely derived from Shanghai Art Museum's internal reforms to address both the transformation of Chinese society and the globalisation of the art world. Founded in 1956, SAM was a municipal cultural institution under the administration of the Shanghai Cultural Bureau 上海市文化局 and closely associated with official art institutions including the Shanghai Artist Association 上海市美术家协会, Shanghai Ink Painting Academy 上海画院 and Shanghai Oil Painting and Sculpture Academy 上海油画雕塑院. Its mandate was primarily focussed on exhibiting and collecting twentieth-century Shanghai-style painting, and the museum also occasionally served as a propaganda outlet to advocate government policy through exhibitions. It is noteworthy that, prior to 2000, curatorial positions were never created within the museum's organisational structure; as at all Chinese state museums, curatorial responsibilities were collectively shared and rarely assigned to individuals. By the late 1980s, the forces of change had been brewing at all levels of this old-fashioned institution. Younger staff members, such as Zhang Jianjun 张健君, executive assistant to the museum director, and Li Xu, the future co-curator of SB2000, were actively involved in the 'unofficial' art scene during the '85 New Wave,[10] and provided a grassroots momentum to push the museum to accept more progressive art forms.[11]

International biennials and triennials were by no means new to SAM's senior management. For the inaugural Asia Pacific Triennial (APT) in 1993,

Queensland Art Gallery invited SAM as an institutional partner. Li Xu accompanied the APT curator during his research tour to Shanghai and helped select artists. Long-time SAM director Fang Zengxian 方增先, also an esteemed traditional ink painter, was invited to talk about Chinese modern painting for an APT documentary. This brief but important institutional encounter and exchange aroused Director Fang's interest in starting a biennial at SAM, so that the Chinese public, according to him, could learn more about Western avant-garde art and think about the future of Chinese painting.[12] He would later remember that, 'to a certain extent, the Shanghai Biennale was born out of my personal curiosity about Western modern art as a traditional ink painter'.[13] By comparison, SAM executive director Li Xiangyang 李向阳 was more concerned with the museum's financial well-being. When he joined SAM in 1994, after having served as a military propaganda painter, Director Li was immediately struck by the museum's dire financial situation. Nation-wide market reforms in the 1990s not only marginalised the social role of state museums, but also left many struggling to survive without more government funding. SAM heavily relied on space rental for revenue and churned out dozens of commercial exhibitions a year. About taking the biennial as a possible opportunity to rejuvenate SAM, Director Li has remarked: 'Starting our own biennial was like building a brand. It would modernise the museum, leverage our public profile, professionalise the staff and, more importantly, give us a legitimate reason to fundraise.'[14]

Although Director Fang and Director Li were key decision-makers at SAM, one of the most influential strategists behind the Shanghai Biennale was Xu Jiang 许江, director of China Art Academy 中国美术学院 and deputy director of Zhejiang Provincial Artist Association 浙江省美术家协会. Xu Jiang was a prominent Chinese art official with an international outlook, savvy understanding of Chinese politics and extensive resources and networks in China's official art system. While Fang Zengxian and Li Xiangyang's priority was to revitalise the museum, Xu Jiang was already focussed on incorporating the Shanghai Biennale into state-sponsored cultural production.[15] In 1992, the declaration, by Deng Xiaoping 邓小平, that Shanghai was 'Head of the Dragon' not only spearheaded the acceleration of marketisation but also promoted Shanghai as a local city-state.[16] The early adaptive governance of the local city-state and its seeking of international approval made Shanghai an ideal location for state-sponsored cultural production and open appropriation of contemporary art for state developmentalism.[17] Xu Jiang's political savvy made him understand that only by adhering to the government's cultural mandate of (re)asserting Shanghai's global identity could the Shanghai Biennale be legitimated as a long-term platform. In other words, the Shanghai Biennale could be successful only if it were to be incorporated as a signature event of the city-state of Shanghai. After two editions of the Shanghai Biennale, in 1996 and in 1998, that were focussed on oil painting and ink painting respectively, the inclusion of experimental art forms and international artists at the third edition was strategically aimed at strengthening Shanghai's global identity in competition with Western economic and cultural centres.

Xu Jiang's decision to invite Hou Hanru as curator was a key step to the Shanghai Biennale's internationalisation. In the summer of 1999, Director

From top: 2000 Shanghai Biennale internal planning meeting with Shanghai Art Museum's Executive Director Li Xiangyang (far left), artist Huang Yong Ping (standing) and other members of the Artistic Committee; Li Xiangyang's speech at the opening ceremony; Huang Yong Ping's speech on behalf of participating artists at the Coca-Cola sponsored 'gala night'. Courtesy Hou Hanru and Asia Art Archive

Li Xiangyang and Xu Jiang travelled to the Venice Biennale, where they met up with Hou Hanru, who had curated the French Pavilion. Hou Hanru had a well-established curatorial pedigree and influential international contacts, developed over the previous decade. He was representative of a generation of globetrotting curators who acted as professional cultural mediators for different local, regional and national identities within an expanding global contemporary art system. Being a Chinese national also made him an ideal choice. The selection of the other curators involved balancing an international profile and institutional suitability. Toshio Shimizu, the only non-Chinese curator on the team, was also the only foreign curator with whom SAM had an in-depth working relationship. Shimizu had been invited to curate an exhibition of Japanese installation art at SAM in 1988. Director Li Xiangyang once remarked that SAM was not ready to collaborate with a Western curator in 2000; therefore a reliable Asian curator, namely Shimizu, was preferable to more famous options. Coincident with assembling the international team was reassembling the Artistic Committee 艺术委员会.[18] The same group of progressive art officials who had inaugurated the Shanghai Biennale set up the Artistic Committee as a control mechanism for later editions. The Committee's members had the power to nominate artists and also to advise curators to revise artist lists and remove 'unsuitable' contents. The process of censorship was often mediated through friendly persuasion and negotiation. Insistence on respecting the 'Chinese national condition' 中国国情 was consistently employed as an excuse.[19] For SB2000, the Committee was comprised of senior administrators from SAM, Shanghai Oil Painting and Sculpture Academy, Shanghai Chinese Painting Academy and Shanghai University Art Academy. Most of the Committee members were academic painters, which explained the relatively strong presence of academic painting at SB2000.[20]

In 1997, Director Li Xiangyang paid a visit to artist Chen Zhen 陈箴 at his Paris apartment, and asked him about his experience with international biennials. Later that day Li wrote in his diary:

> *Biennials in the West follow a curator-led system. Curators are responsible for everything. But we are creating an international biennial platform with Chinese characteristics, so we shouldn't follow the West. We should decide on the biennial's theme, decide on the ratio of Chinese and foreign artists and keep a balance of different art styles and art forms. We need to keep the power of decision firmly in our own hands.*[21]

The pronoun 'we' referred to the collective body of governance that included SAM and the Artistic Committee. Curators were neither excluded from it nor considered as autonomous decision-making agents in it. Director Li's cautiousness was partly derived from a fear of losing control due to the lack of institutional experience for organising a biennial; at the same time, the tension between asserting a 'Chinese' subjectivity and becoming 'global' was also salient. Behind the seemingly unifying vision of 'Shanghai Spirit' was the anxiety and pragmatic concern over how to navigate among multiple art spheres, and how to balance priorities between the global art world and the cultural production of the state. The conflict and entanglement between the

state and the global presented immediate institutional complexities for the curators of SB2000, and engendered a challenging local condition for their work.

3. Incongruent Visions Behind the Global-Local

The four curators, Hou Hanru, Toshio Shimizu, Zhang Qing and Li Xu, had incongruent views regarding the connotations of the global-local. The differences were invariably reflected through their display strategies. According to Li Xu, the curators more or less divided their artist selection based on their 'regional expertise'. Zhang Qing and Li Xu were responsible for working with Chinese artists; Toshio Shimizu for nominating Asian, African and non-Western artists in general; Hou Hanru for 'international artists who circulate around the world'.[22] Hou Hanru at the time explained his criteria more specifically. He remarked that there were three main considerations: 'The first grouping reflects the spaces and changes of the city. … The second grouping of artists reflects the phenomena of global dislocation. … The third grouping is connected with new technologies.'[23] Zhang Qing and Li Xu were active as critics and curators within the Chinese art scene throughout the 1990s. Like many Chinese critics at the time, their understanding of the local had a nationalist undertone. As Zhang Qing stated in his catalogue essay, the sociopolitical impact of SB2000 was a declaration of independent identity in pursuit of 'a uniquely Chinese contemporary art'.[24] Such a view, widely shared among Chinese critics, was generated from their concern over the Western-centric mediation and the international art scene's problematic canonisation of contemporary Chinese art. SB2000 was seen as an opportunity to reclaim the agency that Chinese critics had lost during Chinese art's entry into the global arena; in other words, it promised 'winning back the power of discourse' 赢得话语权 from the West.[25] In their China-centric vision, Zhang Qing and Li Xu interpreted the global-local paradigm largely as a China-West binary. Zhang's catalogue essay, 'Beyond Left and Right: Transformation of the Shanghai Biennale', tried to give this position a more international flavour by extrapolating it to 'redefine Asian culture and draw on its essence in the attempt to elevate Asian nations and cultures to the forefront of mainstream discourse'.[26] Li's essay, 'Made In China', severely criticised Chinese contemporary artists for ingratiating themselves with Westerners by conforming to Western tastes; its publication in the catalogue was eventually cancelled due to its bluntness.[27] Regarding the selection of artists, Zhang Qing and Li Xu charged themselves with the responsibility of selecting Chinese works 'based on the logic of Chinese art's development'.[28] In the exhibition, the privileging of Chinese artists was clearly reflected on the ground floor: the colossal installation *Bank of Sand, Sand of Bank* 沙的银行或银行的沙 by Huang Yong Ping 黄永砅 and oversize paintings by Fang Lijun 方力钧, Yan Peiming, Sui Jianguo 隋建国, Liu Xiaodong 刘小东 and Zhao Bandi 赵半狄 dominated the prominent central halls. Only three non-Chinese artists were featured on the ground floor: works by Chatchai Puipia, Anish Kapoor and Tatsuo Miyajima were inserted in between Chinese artists' large-scale works, contributing to the token look of 'a non-Eurocentric global culture'.

pp.140–44

pp.143–44

Toshio Shimizu, the only non-Chinese curator on the curatorial team, attempted to invert global art hierarchy through a West versus non-West binary.

A Louvre-trained art historian, Shimizu, in the 1980s, mainly curated European and American masters' solo exhibitions. However, towards the late 1980s, his curatorial work became significantly influenced by Japanese art institutions' rising interest in 'Asia' as a research, exhibition and collection framework. Having gained knowledge about 'non-Western' artists through his work as a committee member at the Asia Pacific Triennial and various government-sponsored research trips to biennials/triennials, Shimizu chose to focus on artists from 'East Asia, Southeast Asia, Africa and Oceania' at SB2000.[29] A particular highlight of Shimizu's curatorial work was his attempt to foreground local-to-local connectivity enabled by technology. In a prominent hall on the second floor of SB2000, he installed Mariko Mori's *Beginning of the End: Giza, Egypt* (2000) side by side with Zhang Peili's 张培力 *Broadcast at the Same Time* 同时播出 (2000). Zhang's work had 26 television sets placed in a circular setting. On each screen was a news anchor broadcasting live from one of 26 locations around the world, all solicited on the internet. Mori's work was arranged as an enclosed circular structure with four-channel video documenting her performances in major cities and at archeological sites. Shimizu displayed these two circular installations in close proximity and allowed the volume of their audio projections to extend far; the works' mutual penetration through sound signified what Shimizu considered as 'the increased mobility of data transfer in the age of globalisation, where information flow is no longer restricted by geographical borders'.[30] According to Shimizu, this display was a dialogue between two East Asian video artists, and underlined the virtual parity between locations around the globe in a decentralised world.

Huang Yong Ping and Hou Hanru during the installation of *Bank of Sand, Sand of Bank* at the third Shanghai Biennale, 2000. Courtesy Hou Hanru and Asia Art Archive

Opposite: Huang Yong Ping, *One Man, Nine Animals*, 48th Venice Biennale, 1999. Photography: Fei Dawei. © ADAGP, Paris and DACS, London 2020. Courtesy Asia Art Archive

Keeping a far distance from a nation-state focus as well as a regional one, Hou Hanru articulated his understanding of the global-local as a critical positionality of cultural displacement. As a member of the Chinese diaspora living in Europe as a curator, he not only professionally commented upon but also personally embodied the post-1990 breakdown of identity in the flux of migration, displacement and global circulation. Drawing on various post-modern theories and informed by his own curatorial practice, Hou Hanru formulated the concept of the 'mid-ground' as a conceptual space opened up by the perpetual movement of global interactions, negotiations and cultural hybridisation, both beyond national boundaries and separate from the binary of East and West. He envisioned that 'a truly global art' would only emerge from the perpetual tension and movement between the global and local.[31] At SB2000, Hou Hanru's key approach to concretising the global-local was through activating Shanghai's colonial memory and extrapolating it into a critique of the present.

pp.140–41 The most iconic work at SB2000 was Huang Yong Ping's installation *Bank of Sand, Sand of Bank*, the centrepiece installed on the ground floor – one of two site-specific installations the artist was commissioned to make for the occasion. The other work was an extremely subtle and barely noticeable in-tervention called *Lampshade* 灯罩 (2000). Hou Hanru was closely involved in the conception, production, display and interpretation of these works. According to him, during a research trip to Shanghai in early 2000, Huang Yong Ping immediately became aware that SAM's building, the British-designed Shanghai Race Club, was in close proximity to the former HSBC headquarters. Both situated at the heart of the former British Concession and intricately tied to Asia's colonial history, the two sites had been epicentres for the activities of British bankers, foreign tradesmen and compradors in the first half of the twentieth century. During the Communist period from 1949 to the early 1990s, the lavish colonial icon housed the municipal government of Shanghai. In 1992, it became the Pudong Development Bank, a state insti-tution that financed the development of Pudong New Area. During SB2000, visitors entering SAM's foyer and immediately turning right encountered a colossal sand-replica of the HSBC building. Poised in a state of perpetual flux and potential ruin, the sandy structure slowly disintegrated over the three-month run of the biennial. The image and process of a colonial structure slowly collapsing within another colonial structure gave a critical edge to the metaphor of ephemerality and simultaneously conjured up a dystopian vision of Shanghai's development.

In the foyer area at SAM's northern gate, Huang Yong Ping removed the shade of a ceiling lamp and replaced it with a new, hexagonally shaped shade that resembled a pith helmet, the popular headgear of Victoria-era colonial explorers and officials. The image of the pith helmet had first emerged in Huang's work following the Hong Kong Handover, in 1997, and had morphed into various works as a visual reference to the British co-lonial legacy. According to the artist, the pith helmet lampshade was meant to reference to China's 'frequent change of hat', while the bank was once again 'the fulcrum around which the market moves'.[32] SB2000 afforded

Hou Hanru and Huang Yong Ping opportunity to circulate, adapt and evolve their ongoing evaluation of postcolonialism based on the geo-historicity of Shanghai. Huang's two installations evoked Shanghai's colonial historiography for the first time in Chinese contemporary art, and teased out the hidden connections between colonial capitalism and neoliberal developmentalism. By keeping the work in the central hall, Hou Hanru both activated historical memories and simultaneously defamiliarised the local audience from their own city.

'Urban Laboratory', third Shanghai Biennale, 2000. Courtesy Atelier FCJZ

Another case study of Hou Hanru's curatorial rendering of the global-local was the 'Urban Laboratory', a small group exhibition he curated within the biennial. For this on-site experiment, Hou Hanru circulated and evolved the curatorial thinking he had been developing since 'Cities on the Move'.[33] A groundbreaking itinerant exhibition Hou Hanru co-curated with Hans Ulrich Obrist from 1997 to 1999, 'Cities on the Move' had addressed, broadly, Asia's modernisation through the hyper-growth of Asian cities, and, more importantly, brought together local and international while largely bypassing the national,[34] exemplifying a key shift in the way contemporary art was being presented internationally. The curatorial premise of 'Urban Laboratory' again focussed on Asian urban locality, modernity and modernisation through a lens of global connections. Located on the third floor of SAM's old building, the site was fitted with immovable display cabinets, formerly used to exhibit Chinese traditional paintings.[35] Hou Hanru's curatorial process started precisely from the spatial constraints of the exhibition site. He chose to collaborate again with Yung Ho Chang 张永和, the Beijing-based architect who had designed the exhibition spaces for 'Cities on the Move'.[36] Since the mid- to late 1990s, Yung Ho Chang had been experimenting with urban micro-interventions; for example, transforming a

pp.172–79

p.74

Installation views, 'Cities on the Move', Secession, Vienna, 1997.
Above: Work by Heri Dono and others. Photography: Hou Hanru.
Courtesy Asia Art Archive.
Below: display structure designed by Yung Ho Chang. Photography: Margherita Spiluttini.
© Architekturzentrum Wien, Collection

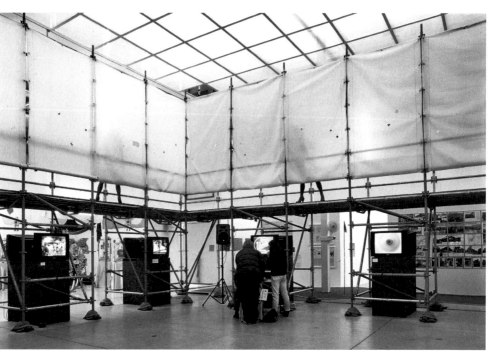

passageway between two buildings into Xishu Bookstore in Beijing.[37] Taking a similar spatial strategy for SB2000, he transformed the display cabinets for Chinese paintings into a life-size model of a traditional Shanghai *linong* (row) house, an immersive structure with a long passageway in the middle. In addition to Yung Ho Chang, Hou Hanru chose two more artists he had collaborated with for 'Cities on the Move': Aglaia Konrad and Philip-Lorca diCorcia. Hou also chose Bodys Isek Kingelez, a self-taught Kinshasa-based artist, with whom he had worked at the 1997 Johannesburg Biennale. Bodys Isek Kingelez was known for making fantastic utopian models using everyday materials and found objects; while exploring urgent questions around urban growth and economic inequality, his works offered personalised utopian visions for postcolonial Africa. Since his participation in 'Magiciens de la Terre' in 1989, Kingelez's 'extreme maquettes' began to circulate widely in global biennials during the 1990s. Having climbed up to the third floor, visitors first encountered Kingelez's maquettes and the installation *Floating Forest* 漂浮着的森林 by Wang Qiang 王强. In contrast with Kingelez's dazzling maquettes imbued with postcolonial dreams, Wang Qiang's work radiated a dystopian suspension of an uncertain present. Nearby, inside the display cabinets of the 'Urban Laboratory', were Konrad's and diCorcia's urban photographs; design plans for micro-urban interventions by Yung Ho Chang; and photographic compilations by Hong Hao 洪浩, of planes taking off and landing. Outside of the immersive structure, Hou Hanru hung five scrolls of classical landscapes by Taiwan ink painter Yu Peng 于彭. Yu's dense, unorthodox brushwork presented timelessness nature in a space of disappearance. Compared with the cacophony of the Asian hyper-urbanity of 'Cities on the Move', 'Urban Laboratory' was left radically empty.[38]

pp.172–73

pp.174–77
pp.178–79

pp.180–81

pp.176–77

p.178

Hou Hanru ingeniously incorporated Yung Ho Chang's micro-urban interventions as part of his own curatorial experimentation. 'Urban Laboratory' was a perfect embodiment of the cultural hybridisation in Hou Hanru's concept. Captivatingly, each work registered the distinct temporalisation of global localities, including postcolonial utopianism in an African postcolonial state; the suspension of forwardness in an enclosed passageway; the anachronistic feeling in an Asian metropolis; and the perpetual urgency of the present. All of these contemporary artworks replaced the traditional art for which the cabinets were designed, and collectively conjured up a sense of anachronisticity. If the neoliberal development of the 1990s was indeed guided by the temporal regime of universal progress, 'Urban Laboratory' suggested desynchronisation to offset this relentless forward motion. It is in this sense that 'Urban Laboratory' served as a subtle and yet radical intervention at SAM, a Chinese state museum that had voluntarily incorporated itself into Shanghai's market-driven, state-sanctioned urban growth.

Whether based on a China-West binary; a regional framework of Asia; or an idealised perpetual movement involving cultural negotiation and hybridisation, the disparate curatorial approaches to the tension and dynamics of the global-local at SB2000 demonstrated different geopolitical currents accumulating in the national, regional and global networks of 2000. Despite working within various institutional constraints that included censorship, all four

From top: Cai Guo-Qiang, *Year of the Dragon No.1*, 2000; Lee Ufan, *Correspondence*, 1998, and Wang Huaiqing, *Feet*, 2000; and Wang Huaiqing, *Like a Chair*, 2000. Installation views, third Shanghai Biennale, 2000. Photography: Chinese-art.com Archive at Asia Art Archive (above and below) and Hou Hanru (middle). Courtesy Asia Art Archive

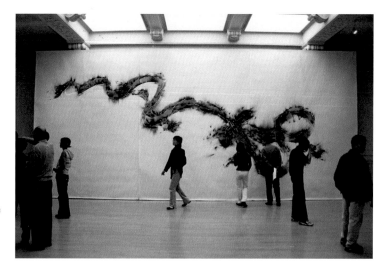

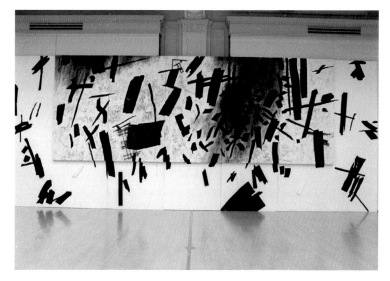

curators were still active agents who manifested their own curatorial visions through their artist selections and display of works. Beyond Huang Yong Ping's site-specific installations, the juxtaposition of Zhang Peili's and Mariko Mori's video works, and Hou Hanru's immersive 'Urban Laboratory', there were other curatorial attempts to activate local experience, for example, in the installation by Cai Guo-Qiang 蔡国强 at propaganda stands near to SAM's main building, in On Kawara's work at a local kindergarten and in Lee Bul's karaoke-based interactive video installed on the museum's top floor. The critiques that dubbed the biennial an 'eclectic pastiche' precisely missed these forms and sensibilities of locality and trans-locality, which punctuated SB2000 throughout.

p.139
p.181
pp.164–65

4. Inconvenient Presence: Chinese Academic Art in Juxtaposition

Due to the intervention of the Artistic Committee, a rather unique characteristic of SB2000 was the relatively strong presence of mainstream Chinese academic art. Amongst the 67 participating artists, around ten were ink or oil painters who worked for Chinese official art institutions and exhibited almost exclusively within the Chinese official art system. SB2000 gave them the unique opportunity to be juxtaposed with international contemporary artists. Li Xu recalled that, during a preparation meeting, SAM director Fang Zengxian, an influential ink painter himself, reminded everybody that painting, especially academic ink and oil painting, should not be marginalised at the biennial. According to him, the emphasis on painting not only provided continuity with the previous two painting-focussed biennials in 1996 and 1998, it should also be a general characteristic that distinguished the Shanghai Biennale from other international biennials.[39] Nevertheless, independent art critics and artists who anticipated a more radical break from China's official art system criticised the inclusion of academic painters as an obsequious endorsement of the status quo.

Since 2000, following larger social, political and economic shifts loosely defined as 'artistic globalisation', the discipline of art history has witnessed a strong trend towards expanding and including modern artistic practices with origins different from the cultural configurations of Western Europe. With the clear boundary between modern art and contemporary art now highly debatable, it seems that the question of the contemporary is increasingly unthinkable without a firm idea of what was at stake in the modern. The modernity in question for art historians is far from universal, but increasingly rendered in the plural. In critiquing the definition of 'Contemporary Chinese art' as trends that 'self-consciously distinguished themselves from official art, mainstream academic art and traditional art (although also constantly interacting with these categories)',[40] Francesca Dal Lago has argued that the retreat from the discussion of Chinese academic art and ink art may 'endorse a canonised, biennale-proofed, homogenised global spectacle that is becoming the defining element of the style of the art of this time'.[41] So, can we look at the inclusion of Chinese academic paintings at SB2000 not merely as a compromise to the official art system, but also a potentiality, to complicate the genealogies of the contemporary as such? Can we see academic art as a form inscribed with globalised local specificity? As I review SB2000's exhibition display in the light of recent art historical debate, what emerges as the most meaningful display are precisely those juxtapositions

of Chinese academic art and various art forms not generically validated by a Western-centric modernist genealogy.

p.149

On the second floor of the SAM building, visitors initially encountered a series of paintings by South African-born, Amsterdam-based artist Marlene Dumas. Her monochromatic palette and thin washes of ink both resembled and contrasted with traditional Chinese painting. Not far from Dumas's

pp.152–53

works were several abstract oil paintings by French artist Bernard Frize. The fluid rendering of paint evoked comparison with Chinese ink painting's *xieyi* technique. According to Li Xu, curators selected works by non-Chinese painters to reflect a visual closeness to Chinese ink practice. Past Dumas's and Frize's works was the so-called 'White Hall', a pristine exhibition space with a hardwood floor and white stucco ceiling. Here, Toshio Shimizu and Zhang Qing collaboratively curated what they privately called 'trans-Asian

pp.76 & 158–59

dialogue' 跨亚洲对话 by juxtaposing three artists: Cai Guo-Qiang, Lee Ufan and Wang Huaiqing 王怀庆.[42] While Cai Guo-Qiang and Lee Ufan were already international names, Wang Huaiqing was relatively unknown outside China. An oil painter at Beijing Painting Academy 北京画院 and a member of China Oil Painting Society 中国油画学会, Wang was known in the academic art circle for merging abstraction with an 'Eastern' sensibility embodied in a lexicon of deconstructed Chinese architectural elements. All three artists were equipped with solid training in calligraphy, a post-Minimalist sensibility and desire to experiment via different artistic mediums.

pp.76 & 158

The centrepiece in the hall was certainly Cai Guo-Qiang's drawing in gunpowder *Year of the Dragon No.1* 龙年. The work featured a line of gunpowder residue, resembling a single, powerful calligraphic stroke. Facing Cai's work across the hall was Lee Ufan's painting *Correspondence*: large monochromatic brushstrokes at intervals on a white background. Loaded with pigment, the vertical and horizontal brushstrokes scattering across the canvas seem unordered but reveal an open reciprocal relationship, between the grey marks and the white canvas, between fullness and emptiness. Appearing displaced beside Lee Ufan's work were oil paintings by Wang Huaiqing, part of his ongoing experimentation in dissembling Ming-style furniture. Wang's work brought a sense of unnamable melancholy and of cultural crisis in disconnection from tradition.

The 'trans-Asian dialogue' thus juxtaposed the simultaneous trajectories of three East Asian artists operating in different art spheres. Lee Ufan's practice grew out of the collapse of the colonial world order and anti-authoritarian tumult in postwar Korea. In the 1980s, Lee bridged international conceptual language with Asian metaphysics through repetitive gestural marks, a monochrome palette and iterative brushstrokes. While the post-War period was important for Lee Ufan, Wang Huaiqing's initiation into formal experimentation was situated in a revival of modernism following the Cultural Revolution. His penchant for Cubism and Minimalism was consciously deployed to resist Socialist Realist dogma. Also in the early 1980s, Cai Guo-Qiang graduated from Shanghai Drama Academy and went to Japan. It was in Japan that Cai started to master his use of gunpowder, a quintessential Chinese material that he recast to stake his place on the emerging global art scene. In the 1990s,

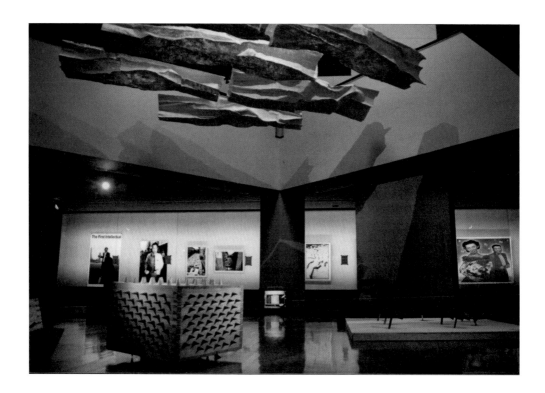

Cai Guo-Qiang's increased participation in the global system accelerated his production, and enabled him to do large-scale installations that exposed the dialectics of local history and globalisation.

Another noteworthy juxtaposition was between Australian Aboriginal painter Emily Kame Kngwarreye and Shanghai-based ink painter Chen Peiqiu 陈佩秋. Kngwarreye, who belonged to the Anmatyerre language group, lived from 1919 to 1996 in an isolated desert region in central Australia. Deeply rooted in and inspired by ceremonial rituals in her own country of Alhalkere, Kngwarreye only began painting oil and acrylic on canvas towards the end of her life. She gained international fame posthumously, after representing Australia at the 1997 Venice Biennale. Shimizu selected Kngwarreye 'to represent Oceania' at SB2000.[43] However, her works' historical resonance was more fully realized in juxtaposition with the paintings of 78-year-old Chen Peiqiu. Kngwarreye's two oil paintings and Chen's landscape ink paintings were displayed side by side on the third floor, in an area dedicated to painting. Kngwarreye's *Awelye* (1994) is covered with her signature stripes and ritualistic tracings, evoking the abstraction of her native land's rivers, mountains and terrain. The other painting, *Anooralya Awelye* (1995), depicts curvilinear structures that resemble meandering tendrils. By comparison, Chen Peiqiu's practice is situated in the twentieth-century reform of China's modern ink art of the Jiangnan region. Her freehand brushwork could be traced to her early training in drawing from life and directly copying modern ink masters such as Pan Tianshou 潘天寿. While nature in Emily Kame Kngwarreye's brush strokes is infused with

Installation view, 'Reinterpretation: A Decade of Experimental Chinese Art (1990–2000)', first Guangzhou Triennial, 2002. Courtesy Guangdong Museum of Art

Next page: Installation view, 'Farewell to Post-Colonialism', third Guangzhou Triennial, 2008. Courtesy Guangdong Museum of Art

pp.159–60

her cosmic belief and ancestral lineage, nature for Chen Peiqiu is mediated through a highly codified system of literati painting, inherited from longstanding artistic conventions and re-adapted for a national art form.

It is noteworthy that neither Emily Kame Kngwarreye nor Chen Peiqiu had a Western modernist pedigree. However, Kngwarreye's language of abstraction was often seen as resonating with the broader international concept of modernism. The kind of Chinese modern ink art that seeks to experiment with reference to the historical lineage of ink painting has long been excluded from the global canon of modern and contemporary art. Art historian Reiko Tomii once remarked: 'If we now examine modernism in terms of multiple modernisms and alternative modernities, don't we also have to consider contemporary art in terms of multiple and alternative contemporarities?'[44] The kind of artistic production represented by ink painting is exactly what can help to break through a mono-cultural idea of the contemporary in order to integrate local art forms that are not generically validated by a modernist genealogy. Reflected upon two decades later, these constellations of global contemporary art and Chinese mainstream academic art prompt us to re-conceptualise the epistemological framework of the contemporary. How might we think of simultaneity as an inherent aspect of the contemporary – one that could suggest 'an unfolding, existing and living in the same time'?[45] How might we construct the global terrain of the contemporary as 'coeval and in exchange with', instead of simplistically emanating from, Euro-American contemporaneity?[46] The relationship between any local art form and Western modern (and postmodern) art is not that of a linear or temporal evolution, nor does it take place within a monolithic cultural system.

5. The Crisis and Reincarnations of the Local: Legacies Recuperated

This essay unpacks SB2000's neglected legacies by tracing its institutional formation, curatorial trajectories and display strategies. We first recognise the progressive Chinese art officials' vision and courage in establishing the Shanghai Biennale within the conservative political culture of the 1990s, and transforming it into an international event in 2000. We also should not ignore the fact that this progressive manoeuvre established the mechanism of control and censorship in order to ensure the Shanghai Biennale's long-term legitimacy and sustainability as an official art platform. Behind the seemingly unifying vision of 'Shanghai Spirit' was the constant balancing of its priorities – between the global art world and the cultural production of the state. The complex entanglement between the state and the global proved a formidable challenge for the curators, and the curatorial currency of the global-local was thus simultaneously constituted within and connected to disparate local, national and global networks. Secondly, despite working within institutional constraints, the curators were active agents who sought to manifest their understandings of the global-local paradigm through artist selection, commissioning of new works and spatial display. Their incongruent visions and approaches – whether based on a China-West binary, a trans-Asian dialogue or an over-idealised vision of global cultural hybridisation – demonstrated divergent geopolitical currents accumulating in the national, regional and global networks of 2000.

The curatorial currency of the global-local was thus simultaneously constituted within and connected to disparate art worlds. Thirdly, the curators created intriguing juxtapositions between Chinese academic painters and 'global' artists. Although fragmented and somewhat diluted in the overall biennial, these constellations may still evoke questions on locally specific modernities and prompt us to reconsider the epistemological framework of the contemporary as something not solely emanating from Euro-American modernity.

SB2000's most profound curatorial legacy, however, may not lie in what SB2000 has archived in the biennial itself, but in how it provoked new curatorial practices that would further engage local histories and knowledge. On the site of SB2000, Wu Hung immediately realised that institutional censorship and control largely prevented the curators from meaningfully engaging with the local experimental art scene.[47] Shortly after visiting SB2000, Gao Shiming 高士明 published an acerbic review in an art journal in Taiwan and bluntly criticised SB2000 as being unspecific and unconvincing, and of lacking an understanding of China's historical and social complexities. He then called for 'unweaving a binary-based global-local' and reimagining a non-binary local.[48] In the immediately subsequent years, their critiques were transformed into concrete curatorial actions through a range of spatial and locational lenses. In 2002, as the curator of the inaugural Guangzhou Triennial titled 'Reinterpretation: A Decade of Experimental Chinese Art (1990–2000)' 重新解读: 中国实验艺术十年 (1990–2000), Wu Hung p.79 presented a historical retrospective on the 'underground' experimental cultures of the 1990s, as situated in specific Chinese local contexts. Gao Shiming, working within the institutional framework of China Art Academy, set out to investigate trans-Asian experiences through research initiatives such as 'Edges of the Earth: Migration of Contemporary Asian Art and Geopolitics' 地之缘: 亚洲当代艺术的迁徙与地缘政治 (2002–04). Gao's ongoing efforts to connect and compare third-world, local conditions culminated in the third edition of the Guangzhou Triennial, 'Farewell to pp.80–81 Post-Colonialism' 与后殖民说再见, in 2008, co-curated with Sarat Maharaj and Johnson Chang. Explorations of globalised locality have also continued in Hou Hanru's work. As co-curator of the second Guangzhou Triennial, 'Beyond: An Extraordinary Space of Experimentation for Modernization' 别样: 一个特殊的现代化实验空间 (in 2005, curated with Hans Ulrich Obrist and the museum's in-house curator Guo Xiaoyan), Hou Hanru explored the cultural potentiality of the Pearl River Delta as an urban laboratory detached from the political order of the nation-state. Whether or not such mega-curatorial projects met their grand promises, they were nonetheless progressive attempts to engage with specific localities and politics of place in conceptualising both contemporary art and contemporaneity at the time. In this sense, SB2000 signalled the crisis of using the global-local as an abstract, monolithic and generalising paradigm in the 1990s, and heralded more specific, concretised and pluralistic approaches to the local through exhibitions and discursive events in the subsequent decade.

Let's go back to the opening scene of this essay, to again find Nikita and her feeling of the 'unknown hauntings' of the biennial site. As this college

student wandered around the exhibition in 2000, she deeply and urgently felt the metaphorical entwinement of Shanghai's colonial past and the rapidly developing present. Two decades later, Nikita has become the chief curator of Guangdong Times Museum 广东时代美术馆. What is hidden within local, historical textures still resonates with her. Most recently, she has initiated 'All the Way South' 一路向南, a curatorial project to retrace and consolidate circuits between the Pearl River Delta and the entangled geographies of the Global South. The project 'situates artist research and production in a rich and complex constellation of Souths by revisiting, reinterrogating and recuperating undercurrents of culture across national and ideological borders'.[49] If the early phase of 'global' art – marked by international travel, migrations of artists and superstar curators overseeing spectacular biennials and triennials – has ended in the wake of environmental crises, global pandemics and de-globalising trends, what is also done with is the monolithic, binary-based paradigm and the lingua franca of the global-local. Instead, a perspective on local-local circuits; emphases on porous, plural, and flexible networks; and decentred modes of mobilisation are emerging as strong currents in recent artistic, curatorial and institutional practices. It is perhaps in Nikita's search for south-south resonances, in her ongoing fascination with the 'unknown hauntings' of the local, that the reverberations of SB2000's legacy can, unexpectedly, be felt.

Notes

1 Zhu Qi, 'Shuidou Buyuanyi Ziji Bushi Dangdai Yishu: Ji Disanjie Shanghai Shuangnianzhan' (Nobody Is Happy if He Is Not Contemporary Art: On the Third Edition of Shanghai Biennale), in *Jin Yishu* (Art & Collection), December 2000, pp.62–67.

2 Wu Hung, 'The 2000 Shanghai Biennale – The Making of a Historical Event', *Art Asia Pacific*, issue 31, 2000, pp.43–49.

3 Xie Hai, 'Yi Yishu de Mingyi Youxi: Zhishuo Shanghai Shuangnianzhan' (Game in the Name of Art: A Review of the Shanghai Biennale), *Yishu Tansuo* (Art Exploration), no.1, 2001, pp.35–39.

4 Nikita Yingqian Cai, conversation with the author, November 2019.

5 Qi Lan, 'Caocuang Zhichu: Shanghai Shuangnianzhan Zaoqi Licheng: Li Xiangyang Fangtan' (The Beginning of the Shanghai Biennale: Interview with Li Xiangyang), in *Yishu Dangdai* (Art Contemporary), August 2016, pp.38–41.

6 Editorial commentary in Wu Hung (ed.), *Chinese Art at the Crossroads*, London: Institute of International Visual Arts, p.221. Wu's remark appears in an introduction to the fourth section of the volume, which is devoted specifically to commentary on the 2000 Shanghai Biennale.

7 'Local' has four similar translations in Chinese: 本土, 本地, 地方 and 在地. In the curatorial discourse of SB2000, the relationship between the global and the local was the centre of discussion and 全球本土 was more commonly used. The usage of 'glocal' 全球在地化 gained popularity only after 2000.

8 Hou Hanru, 'Haishang Dao Shanghai: Yizhong Teshu de Xiandaixing' (From Over the Sea to Shanghai: A Special Modernity), preface to *2000 Shanghai shuangnian zhan* (Shanghai Biennale 2000; exh. cat.), Shanghai: Calligraphy and Painting Publishing House, 2000, unpaginated.

9 Gao Shiming, 'Bentu de Zhaijie yu Chongjian, Huo Jijiang Daolai de Lishi' (The Unweaving and Rebuilding of the Local, Or, A Be-coming Future', *Dangdai Yishu Yu Touzi* (Art and Investment), no.10, 2009, pp.16–20.

10 Since many Chinese contemporary artists hold positions at state-owned institutions and academies, the boundary between official art and unofficial art can be difficult to draw. But there seems to be a general understanding that 'unofficial' art engages in social critique and media experimentation more than does conventional academic art.

11 Zhang Jianjun, interviewed by the author, November 2018.

12 'Zhuiyi Fangzengxian' (Remembering Fang Zengxian), http://artlinkart.com/cn/article/overview/bddeytqr/latestupload (last accessed on April 5, 2020).

13 *Ibid.*

14 Li Xiangyang, interviewed by the author, August 2019.

15 Bai Jiafeng, 'Bentu muti, Kuajie fangfa, Chengshi mingti: Xujiang yuanzhang shuli Shanghai Shuangnianzhanzhilu' (Native Matrix: Interdisciplinary Approach, Urban Thematic: Interview with Xu Jiang on the History of the Shanghai Biennale), *Yishu Dangdai* (Art Contemporary) no.8, 2016, pp.26–31.

16 See Jenny Lin, *Above Sea: Contemporary Art, Urban Culture, and the Fashioning of Global Shanghai*, Manchester: Manchester University Press, 2018, pp.78–80.

17 Zhou Ying, 'Building a Discourse: Capturing a Moving Target of Shanghai's Art Boom', *Art Journal*, vol.78, no.3, 2019, pp.137–39.

18 Li Xiangyang, interviewed by the author, August 2019.

19 Xu Hong, 'Xuanze, Huobeiyuanze yu Shuixuanze: Quanqiuhua Yujing Zhongde Shanghai Shuangnianzhan' (To Select, To Be Selected and Who Selects: The Shanghai Biennale in the Context of Globalisation), *Meishu Yanjiu* (Art Research), no.3, 2001, pp.18–20, and published in translation in this volume, **pp.236–41**.

20 The Artistic Committee for SB2000 included: Xu Jiang 许江, Fang Zengxian 方增先, Li Xianyang 李向阳, Zhou Changjiang 周长江, Wang Jieyin 王劼音, Wang Dawei 汪大伟, Chen Bongke 陈邦可, Zhang Peicheng 张培成, Zhang Leiping 张雷平, Qiu Ruimin 邱瑞敏, Chen Rong 陈龙, Hu Zhirong 胡志荣 and Shi Dawei 施大畏.

21 Li Xiangyang, *Ai Guo Zheyiyang* (I Once Loved This Profession), Shanghai: Wenhui Publishing House, 2006.

22 Li Xu, interviewed by the author, August 2019.

23 Zhu Qi, 'We've Become True Individuals: An Interview with Hou Hanru by Zhu Qi' (2000), available at http://www.paiorg.com/?act=app&appid=247&mid=9631&p=view (last accessed on 25 March 2020).

24 Zhang Qing, 'Chaoyue zuoyou: Zhuanzhe zhong de Shanghai shuangnian zhan' (Beyond Left or Right: Transformation of the Shanghai Biennale), preface to *2000 Shanghai shuangnian zhan, op. cit.*, unpaginated.

25 'Winning back the power of discourse' was a common phrase that Chinese art critics and curators used especially frequently in the 1990s.

26 *Ibid.*

27 Li Xu, interviewed by the author, August 2019.

28 *Ibid.*

29 Toshio Shimizu, interviewed by the author, October 2019.

30 *Ibid.*

31 Hou Hanru, *On the Mid-Ground* (ed. Yu Hsiao-Hwei), New York: D.A.P./Distributed Art Publishers, 2003.

32 'Huang Yong Ping: In Conversation with Tianyuan Deng' (4 May 2018), *Ocula* [online magazine], available at www.ocula.com/magazine/conversations/huang-yong-ping (last accessed on 22 April 2020).

33 'Cities on the Move' opened at Secession, Vienna, 27 November 1997–18 January 1998 and travelled to sites including CAPA museé d'art contemporain de Bordeaux, 5 June–30 August 1998; P.S.1 Contemporary Art Center, New York, 18 October 1998–10 January 1999; Louisiana Museum of Modern Art, Humlebaek, 29 January–21 April 1999; Hayward Gallery, London, 13 May–27 June 1999; various venues across Bangkok (co-curated by Ole Scheeren with Thomas Nordanstad), 9–30 October 1999; and Kiasma, Helsinki, 5 November–19 December 1999.

34 See David Teh, *Thai Art: Currencies of the Contemporary*, Singapore: NUS Press, 2017, p.34.

35 The biennial had two venues: the primary one was SAM's newly renovated building, at 325 West Nanjing Road, originally the Shanghai Race Club, built in 1933; the second was SAM's old location, at 456 West Nanjing Road, a modern building that the museum had occupied since 1956.

36 For the iteration of 'Cities on the Move' that took place at Secession in Vienna, Yung Ho Chang installed a bi-level scaffolding structure for works to be installed upon. See Bruce Altshuler, *Biennials and Beyond – Exhibitions that Made Art History: 1862–2002*, London: Phaidon, 2013.

37 See *Feichang Pingchang – Zhang Yonghe Jiqi Feichang Jianzhu Gongzuoshi Shinian Sanyi* (Special Quotidian – Yung Ho Chang and His Feichang Atelier), Beijing: Beijing Modern Commercial Press, 2003.

38 See **Zhu Qi, 'We've Become True Individuals',** *ibid*.

39 Li Xu, interviewed by the author, August 2019.

40 Wu Hung (ed.), with the assistance of Peggy Wang, *Contemporary Chinese Art: Primary Documents*, New York: Museum of Modern Art, 2010, p.xv.

41 Francesca Dal Lago, 'The "Global" Contemporary Art Canon and the Case of China', *ARTMargins*, vol.3, no.3, October 2014, pp.77–97.

42 Li Xu, interviewed by the author, August 2019.

43 Toshio Shimizu, interviewed by the author, October 2019.

44 Reiko Tomii, '"Historicizing" Contemporary Art: Some Discursive Practices in *Gendai Bijiutsu* in Japan', *Positions*, vol.12, no.3, 2004, pp.611–41.

45 See Atreyee Gupta's discussion of the notion of contemporaneity in 'An Expanded Questionnaire on the Contemporary', *Field Notes*, no.1, 2011, available at https://aaa.org.hk/en/ideas/ideas/an-expanded-questionnaire-on-the-contemporary-part-iii/type/essays (last accessed on 28 April 2020).

46 Terry Smith, *What Is Contemporary Art*, Chicago: University of Chicago Press, 2009, p.109.

47 Wu Hung, conversation with the author, September 2019.

48 Gao Shiming, 'Haishang Shanghai Lizu Hefang' (Shanghai Biennale: Based on What), *Art & Collection*, December 2000, pp.72–75.

49 See http://www.timesmuseum.org/en/journal (last accessed on 28 April 2020).

加拿大的林荫庭 (Ken Lum) 在他的作品中
要用一段 "文革" 期间《文汇报》上的一
篇有关《海瑞罢官》的文章，为此，主办方
与侯瀚如、林荫庭一起商量，是否能换一段
文字而不影响其作品，而林荫庭思考之后
将此段文字改为鲁迅的《为了忘却的纪念》
中的一段文字。为了让作品不给观众产生
不必要的歧义，所以，再一次与林荫庭商量
改换文字，最后，经林荫庭同意，集体创作
了一段虚拟的 "天气预报"。总之，为了展
览的整体目的和效果，策划人与艺术家在
作品协调与调整方面的工作进行至开幕之
前的每一分钟。

张晴
原上海双年展办公室主任，第三届上海双
年展策展人之一
引自《光明永在前》，2016年

In his work, the Canadian artist Ken Lum wanted to use a paragraph from an article in the *Wenhui Daily* newspaper about the Peking Opera *Hai Rui Dismissed from Office*, which dates back to the Cultural Revolution period. The organisers discussed with Hou Hanru and Lum whether it was possible to replace the paragraph with something else while not affecting the whole work. After some thought, Lum decided to replace it with a paragraph from Lu Xun's article 'Remembrance for the Sake of Forgetting'. In order to avoid imparting any unnecessary ambiguity to the audience, another discussion was held on changing the paragraph. At last, with Lum's approval, a fictitious 'weather forecast' was created by a group of people. To sum up, for the overall purpose and effect of the exhibition, the curators and the artists worked to coordinate and adjust the works up until the very last minutes before the show opened.

~Zhang Qing, former head of office for the Shanghai Biennale, co-curator of the 2000 Shanghai Biennale. From 'Light Is Forever Ahead: Curatorial Notes of the 2000 Shanghai Biennale', 2016

Voices

2000年上海双年展开幕后，因有人把同时在上海东廊举办的 《不合作方式》 当成 "外围展" 来宣传，导致双年展在体制内受到了很多质疑和压力，甚至有夭折的可能，尽管主办方做了许多解释工作，效果却不理想。次年春天，时任上海美术馆馆长的方增先想到了收集北京艺术界的意见汇总上报的主意，于是指派我（时任上海美术馆学术部主任）和在同一部门工作的妻子江梅赴京调研。他建议我们以度假方式前往，借朋友间的走动聊天来听取各方声音。为了收集到最真实的意见，不要当场录音或做笔记，而是事后根据回忆整理成书面材料。我和江梅制订了一个涵盖官方机构（中央美院、中国美术馆、中国艺术研究院等）、民间机构（画廊、网站等）以及广大批评家、艺术家的调研范围，到京后每天奔走于各种场合，晚上回到酒店后逐一回忆每次谈话的内容做成笔记，那次京城之行大概奔走了五天左右，回沪后形成了一份详尽的调研材料。由于当时的调研是以特殊方式进行的，所以没有留底，记得绝大多数调研对象都高度评价了上海双年展的学术性和国际性，赞扬上海在中国当代艺术的发展上带了个好头，并对未来的发展提供了宝贵建议。有些人甚至认为上海的开放性出乎意料，某些尺度很大的民间展览居然也允许展出了。后来那份材料被递交到上级主管部门，双年展也就有了后续。2002年那届之后，上海双年展开始成为"上海国际艺术节"的重点宣传对象。

李旭
策展人，原上海美术馆学术部主任
翁子健访谈，2020年3月

After the 2000 Shanghai Biennale opened, it had to endure much questioning and pressure, and even the spectre of being banned – all because of the contemporaneous exhibition 'Fuck Off' at Shanghai's Eastlink Gallery, which was publicised as a satellite event. The organisers did quite some explaining, to little avail.

The following spring, Fang Zengxian, director of the Shanghai Art Museum at the time, had the idea of canvassing Beijing's artistic circles and reporting their views. He asked me, as head of the academic department at the Shanghai Art Museum, and my wife, Jiang Mei, who worked in the same department, to go on a research trip. He suggested that we go to Beijing as if on vacation, so that we might hear all sorts of opinions from our friends. To ensure that we would obtain their candid views, we compiled written materials retroactively, from memory, rather than recording conversations or taking notes during them. Jiang Mei and I drew up the scope of our research, which covered official establishments (the Central Academy of Fine Arts, the National Art Museum of China, the Chinese National Academy of Arts); private organisations (galleries and websites); and a broad selection of critics and artists.

After arriving in Beijing, we held conversations throughout the day; in the evening, at our hotel, we converted each conversation to written notes. The whole trip lasted about five days, and we compiled an exhaustive research report upon returning to Shanghai. Because the project was done in a special way, we did not keep any primary sources. I recall that most of the people we talked to positively assessed the academic and international nature of the biennale; praised Shanghai for leading the development of China's contemporary art; and offered precious advice for the future. Some even went so far as to say that Shanghai's openness surprised them in allowing for some unconventional, privately organised exhibitions. Later, the report was submitted to our supervisors, and that's how the Biennale could continue. After the 2002 exhibition, the biennale gradually became a focal point of publicity in the Shanghai International Arts Festival.

~Li Xu, curator, former head of the academic department at the Shanghai Art Museum. Interviewed by Anthony Yung, March 2020

艾老师很直接说希望我拿《十二花月》参展，我讷讷的回答这个作品得拍一年十二个月，还没拍完。他建议我拿已经拍出来的那几张先展。我很犹豫，可是还是说作品都还没做完怎么拿出来展呢。他沉默了半饷，说："陈羚羊啊，你可真是大智若愚。"后来我就说，有〈卷轴〉这个作品已经做完了，而且没有拿出来展过。他听了很高兴，于是决定以它参加《不合作方式》。

此次会面，让我印象深刻的有两件事。一是艾老师那句"大智若愚"，因为我很久都想不明白为何他这么说；二是艾老师在会客室大门进去的正当中，地上放了一隻不大的鸟笼。鸟笼裡有一隻小鸟，鸟笼外有一隻小猫。猫一直在围着鸟笼转圈，伸猫抓入笼试图抓到那隻鸟，而鸟也被迫一直在笼裡跳来跃去，不想被抓到。这个场景贯穿了整个面谈，艾老师似乎没有对此放丝毫的注意力，现场所有的人似乎也没有在意，所以我也没好意思表现出我对此的注意力。二十年之后回想此景，我想，无论当时艾老师是否故意［设定这个场面］，都不影响我认为他是一位非常懂得做气氛摄人心的艺术家。

陈羚羊
艺术家，参加《不合作方式》
翁子健访谈，2020年1月

When Ai said quite directly that he hoped I would exhibit *Twelve Flower Months*, I replied rather haltingly that it would take twelve months to complete photographing the series and that I wasn't there yet. He then suggested that I exhibit the few pieces that had been photographed. I was very hesitant, but managed to ask how I could exhibit a series that hadn't been completed. After a pause, he said, 'Chen Lingyang, in your case, great intelligence may look stupid.' Later I said that I had completed another work, called *Scroll*, which hadn't been shown publicly. He was happy to hear that, and it was decided that *Scroll* would be exhibited in 'Fuck Off'.

Two things impressed me at this meeting. First, Ai's remark that my 'intelligence may look stupid', because for a long time I couldn't figure out why he would say so; second, a medium-sized birdcage in the middle of Ai's meeting room. There was a small bird within, and a kitten without circled the cage and reached its paw in to try to catch the bird, which fluttered about in fear. This scene accompanied the entire interview, and Ai didn't seem to pay any mind to it, nor did anyone present, and so I didn't think it appropriate to show that I was paying attention to it. Thinking back on this twenty years later, I think whether or not Ai did it on purpose doesn't sway my impression of him as an artist versed in creating an affective ambience.

~Chen Lingyang, artist, participant in 'Fuck Off'. Interviewed by Anthony Yung, January 2020

Voices

所谓 "不合作方式"，对于参与者来说，不
在于展示艺术家及其作品的装置、行为等
利用多种媒介的实施过程，而是呈现在中
国当代现实文化情景中，有这么一类人的带
有不事媚俗的个性化生存状态、生存方式
和生存选择。隐喻的、象征的或直接的违
抗、抵制、怀疑、疏离、消解、无奈、厌倦、
荒诞、偏执、反讽等等方式既是他们存在的
特征，也是他们所采取的某种文化立场和
文化策略。

这种"另类"的、"异数"的和"不确定"的
表现与参与，使其在差异中探讨并存的可
能性，以及共享生存自由的基本原则。因
此，在这次活动中，艺术家及作品，不存有
世俗上的被挑选、被展示、被接受的希冀，
也不存有某种规定性的限制和被谅解的祈
求。

对于受众来说，我们怀疑在这次活动中观
者存在的必要性，以及在"看"与"被看"
过程中的不同反应。因为我们认为参与者
及他们的"作品"不是被选择、认同、评判
的对象。所以，我们不向观者发出邀请，不
举行任何形式的宣传、炒作。从而也无所谓
开幕、展出、研讨、评介等目前流行的展览
形式的要求，或被取缔的顾忌与担心。

〈关于 《不合作方式》活动的策划方案〉，
冯博一起草，2000年9月

For its participants, the so-called 'uncooperative approach' in the theme of this event does not refer to the display of how artists create artworks with different media, such as installation and performance. It aims at representing the survival status, survival modes and survival choices of a group of people who do not conform to the kitsch of the contemporary culture of China. Such representation may be metaphorical and symbolic, or it may be recognised as direct disobedience, resistance, doubt, alienation, dissolution, helplessness, boredom, absurdity, paranoia, irony, etc. These are not only the characteristics of their existence, but also a certain cultural position and cultural strategy adopted by them. This 'alternative', 'different' and 'uncertain' manifestation and participation make it possible to explore the possibility of coexistence in difference and to share the basic principles of freedom of existence. Therefore, in this event, artists and works have no secular hopes of being selected, displayed and accepted, nor do they have some kind of prescriptive restrictions or requests for understanding.

In terms of its reception, we doubt the necessity of the viewer in this event and the different reactions in the process of 'seeing' and 'being seen'. We don't consider participants and their 'works' as objects that are to be selected, identified or judged. Therefore, we will not invite anyone, nor do we hold any form of publicity or speculation. All those currently popular exhibition formalities, such as an opening, exhibition period, forum, review, or fears of being banned, won't matter.

~Curatorial proposal for 'Fuck Off', drafted by Feng Boyi, September 2000

大胡子（艾未未先生）邀请了我参加这次展览，我当时是他的工作室助手。我和大胡子讨论了几次，最终形成了现在看到的结果。

我是11月5日上午做活动，之前准备了大概半个月左右。在11月3日，行为现场已全都布置完毕。拍照、录像、现场活动所用的桌子、布单、消毒用的紫光灯、"种草"实物等，已提前准备好，整个布展过程挺顺利的。

最复杂的是找医生。最初的想法是在北京找医生，然后带到上海，最终因费用问题放弃了。考虑在上海当地找比较经济。上海找医生的过程并不顺利。经朋友介绍的几位医生，一听"行为艺术"，连面都没见，直接拒绝了。失望之余，终于又联系上了一位牙科大夫，答应可以见面。经过几次面谈，这位戴眼镜的大夫总算同意了我的请求，但要求先写个声明。大意是：一，不能在任何媒体上出现他的名字；二，手术后如果出现什么意外，责任自负；三，手术费用为五百元。我同意后，双方在声明上签上了名字。至此，这件事情终于落到了实处。这份声明我一直保存着。

杨志超
艺术家，参加《不合作方式》
翁子健访谈，2020年1月

Big Beard (Ai Weiwei) invited me to participate in the exhibition. I was an assistant in his studio at the time. I had a few discussions with Big Beard before the plan was finalised.

My event was scheduled for the morning of 5 November, and the preparatory work took about half a month. The site of the performance was ready by 3 November. Everything from photography and videography to tables, cloths, disinfecting ultraviolet lights and the actual grass to be planted was ready. It was a fairly smooth process to set it up. The most complicated part was finding a doctor. Initially I had thought that I could find a doctor in Beijing and bring him/her to Shanghai, but I had to abandon that idea because of the cost. It made much more sense to find one in Shanghai, but it wasn't easy. My friends had contacted a few doctors, who, upon hearing the term 'performance art' simply declined to even meet. I was saved from disappointment when a dentist agreed to meet me. After a few conversations, the bespectacled doctor finally consented to my requests, but demanded a statement of terms and conditions, the gist of which were: 1. His name was not to appear in any media coverage; 2. Should there be an accident after the surgery, I would be solely responsible; 3. The operation fee was CNY 500. I agreed, and we both signed the statement. At long last, the project [*Planting Grass*] was going to happen. I have kept the statement ever since.

~Yang Zhichao, artist, participant in 'Fuck Off'. Interviewed by Anthony Yung, January 2020

Voices

'Fuck Off': Searching for the Way in which Art Lives as 'Wildlife'
— Liu Ding and Carol Yinghua Lu

pp.184–221

To begin with, here are some basic facts about 'Fuck Off' 不合作方式, a landmark event in the history of contemporary art in China. The exhibition was announced as on view from 4–20 November 2000 at Eastlink Gallery in Shanghai; in fact, it opened a couple of days early for fear of being shut down by the authorities on the opening day. During the exhibition, the Shanghai Cultural Bureau censored a few works that they deemed violent and provocative, and on the fifth day after it opened, they closed its doors. In the remaining days, 'Fuck Off' was not opened to the public but artists and art professionals could gain private access through the organisers.

p.188

Established in 1999, Eastlink Gallery had just relocated to a 400-square-metre space at 1133 West Suzhou Road, situated in a defunct grain barn by the Suzhou Creek. The gallery's owner, Li Liang 李梁, was a friend of artist Ai Weiwei 艾未未 and invited him to have a solo show in his newfound space. Instead, Ai Weiwei proposed a group exhibition. He conceptualised the project and invited curator and critic Feng Boyi 冯博一, a long-term collaborator of his, to join as co-curator. There were 48 artists participating including Ai Weiwei himself. In the same grain barn building, the studio of artist Ding Yi 丁乙, next door to Eastlink Gallery, and an empty space on the ground floor were used to expand the exhibition space to about two thousand square metres in total. As the property of the city's Grain Bureau, the building had been converted from warehouses built in the 1930s to stock animal feed. The exhibition budget was a formidable sum of about RMB 300,000 (equivalent to approximately USD 43,000), to cover expenses to install the works, pay for artists' travel and produce a catalogue with a print run of two thousand copies, which came out before the show opened. The cost was split between Ai Weiwei and Li Liang. A few works made for the exhibition, including the

pp.214–15

installation *November 4, 2000* by Gu Dexin 顾得新 and the unexhibited work *Eating People* 食人 by Zhu Yu 朱昱 (see ahead), were bought directly from the artists after the show's end by Swiss collector Uli Sigg.[1] Li Liang didn't benefit

from such sales financially and has since recalled that his interest in the show was not financially driven.[2] A proposal drafted by Ai Weiwei and Feng Boyi in September 2000 indicates that the exhibition was put together swiftly, in barely three months. In Feng's recollection, he was approached by Ai in August of that year.[3] But in fact, all was not as spontaneous and improvised as it appeared. Ding Yi says that he moved to his West Suzhou Road studio at the end of 1998, and that when he visited Beijing in 1999, Ai Weiwei talked to him about having a large group exhibition the following year, to take advantage of the number of visitors in town for the Shanghai Biennale.[4]

Ai Weiwei has traced the intention of organising such an exhibition as a survey of experimental art of the 1990s – art that existed mainly outside of the so-called official structure and mainstream art world in China – to his preceding activities in artist-led publishing and art gallery directing. In 1993, one year after his return to Beijing from New York, Ai Weiwei started collaborating with Feng Boyi and a few artist friends – Zeng Xiaojun 曾小俊, Xu Bing 徐冰 and Zhuang Hui 庄辉 – on co-editing three self-published books: *Black Cover Book* (1994), *White Cover Book* (1995) and *Grey Cover Book* (1997). Born out of a feeling of necessity, to diversify and expand perspectives for presenting artists' works, these three publications spotlighted the output of experimental, conceptual and performance artists mostly based in China, but with a few profiles of international artists whose work Ai admired, such as Hsieh Tehching, Andy Warhol, Marcel Duchamp, Jeff Koons and so on. Then, in 1999, Ai Weiwei teamed up with Dutch art dealer Hans van Dijk and Belgian businessman and collector Frank Uytterhaegen, both based in Beijing, to co-found the gallery China Art Archive and Warehouse (CAAW). From 1999 onwards, this Beijing gallery actively presented exhibitions of conceptual and experimental artists, often curated by Ai himself. All through its existence, CAAW didn't just represent artists, but also worked to establish a formidable archive of media clippings, exhibition booklets and sketches by artists, amongst other materials.

This series of self-instituting undertakings was part of a wave of artist-led initiatives in exhibition-making and publishing in cities including Beijing and Shanghai throughout the 1990s. An early notable example is 'Garage Show' p.100 車庫艺术展 (22–24 November 1991), an exhibition of mainly installation and conceptual artworks held in the underground car park of Shanghai Education Hall and organised by a group of artists led by Song Haidong 宋海东. Artists that were part of 'Garage Show' and the *Black, White* and *Grey Cover Books* were also featured in the publication *Chinese Contemporary Artists' Agenda (1994)* 中国当代艺术工作计划 (1994), co-edited by artists Wang Luyan 王鲁炎, Wang Youshen 王友身, Chen Shaoping 陈少平 and Wang Jianwei 汪建伟, which comprised nineteen written proposals by nineteen artists, amongst them Song Haidong, Qian Weikang 钱喂康 and Geng Jianyi 耿建翌. Notable also are two themed exhibitions curated by Geng Jianyi at around this time: 'Agreed to the Date 26 Nov. 1994 as a Reason' 同意1994.11.26作为理由 and '45 Degrees as a Reason' 45°作为理由. For each project, he invited artists to realise a work on the day of the exhibition and to document the process for two catalogues of postcards detailing the artists and works featured in each exhibition.[5]

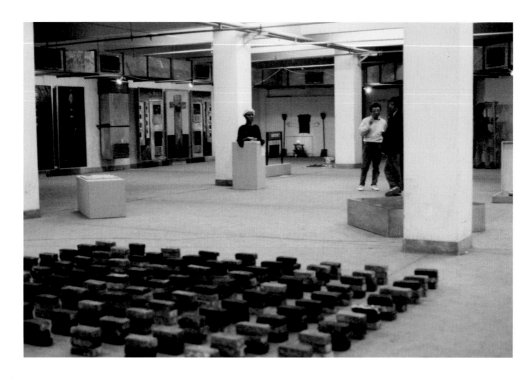

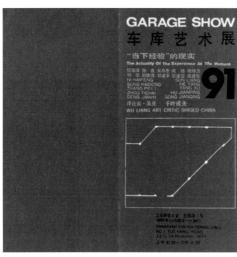

Installation view and invitation,
Garage Show, Shanghai, 1991.
Courtesy Andreas Schmid
(above) and China Avantgarde
Exhibition Archive at Asia Art
Archive

The sense of urgency felt by some artists in China at the time – towards experimentation rather than conforming to the rules of the art system – was evident also in a one-year series of 'non-exhibition form' art events at 'non-exhibition venues'. Co-curated by artist Song Dong 宋冬 and his friend Guo Shirui 郭世銳, manager of an art export company, these began on 5 March 1997 (in solar terms, the day of Jingzhe, or the 'awakening of insects' – an allusion to waking from hibernation and newly born life) and involved the participation of 27 artists from Beijing, Shanghai, Guangzhou and Chengdu. The majority of the works occurred in everyday contexts such as streets, an internet-user centre or a university classroom. The publication *Wildlife: Starting from 1997* pp.102–03 *Jingzhe Day* 野生 1997年惊蛰 始 (1998) was produced as a record of the series, and included a chronology of participating artists' works and events taking place outside of regular exhibition venues between 1986 and 1998.[6] A short text on *Wildlife*'s second page states:

> *Art today is growing increasingly dependent on museums, galleries and exhibitions under various guises, with the result being that art is making fewer and fewer 'mistakes' within this regulating system. In a programme that appears to be so well-defined, even the minutest deviation can cause system-wide paralysis. Computers seem to have a fixation on the word 'ambiguity' and we should experiment in ways to cause 'unexpected encounters' between art and the audience.[7]*

Brief as it is, this manifesto-like statement sums up the contemporary art scene of the 1990s in China and manifests the anxiety some experimental and conceptual artists were experiencing, having been marginalised by the burgeoning art market and the appearance of an art system post-1989.

The failure of the student movement in June 1989 sparked sombre reflections among Chinese intellectuals on the limitations of demanding fundamental and structural change from the political system. While the space for political freedom was unequivocally constrained after 1989, many still believed that ongoing economic development would eventually lead to democratisation in the wider society. In 1992, the highly symbolic 'Southern Tour' of retired Chinese Communist Party leader Deng Xiaoping 邓小平 reasserted an economic agenda for the whole of China: a continuation and acceleration of the programme of economic reform and opening-up that he had enacted first in December 1978.[8] A market economy was the new order that would distinguish the 1990s from the 1980s,[9] as China hurtled ahead on its high-speed journey of relentless economic development for all strata of society.

In the art world, the disillusion of 1989 propelled an aspiration for autonomy, made possible at this moment with the further implementation of a market economy and the gradual rise of an art system encompassing contemporary art practices both within and outside of art academies and state institutions. Despite the conviction of Chinese curators such as Lü Peng 吕澎 who were advocating for the creation of a market for contemporary art to provide a space for its survival given the general avoidance of contemporary art by state institutions after 1989, the art economy itself was a manifestation of state ideology in the post-Mao period, no different from any other sphere of life in

Wildlife: Starting from 1997 Jingzhe Day publication, showing the work of Yin Xiuzhen. Courtesy Asia Art Archive

China. In fact, the ambition to establish a domestic market for contemporary art at the beginning of the 1990s derived from the visions of reformists within officialdom from the early 1980s onwards. Such reformist leanings were actually reliant upon the state and its mandate. To achieve the independence of art through the formation of an art market eventually fostered a utilitarian and opportunist outlook in the art world.

The general perception and historical narrative of this period is dominated by accounts of market success and the international recognition of a limited number of art movements coined and heavily promoted by art critics and dealers. After 1989, more and more artists responded to the discussion, between 1987 and 1988, of the 'purification of language' by prioritising formal quality and technical skill over conceptual concerns and content. They made works that were visibly depoliticised, voluntarily abandoning ideological questions. Some artists chose to represent the revolutionary legacy of Mao and attendant visual culture in a Pop art-derived aesthetic, cynical and indifferent in attitude. Some turned to everyday reality as the source of their artistic themes, for works generally categorised as Cynical Realism (Wanshi xianshizhuyi 玩世现实主义), Political Pop (Zhengzhi bopu 政治波普) and New Generation Art (Xinshengdai 新生代艺术), the latter being a group of academic painters and sculptors whose use of realism and photorealism resisted the grand narratives of both Socialist Realism and Western conceptual art, newly imported in the 1980s. These artists emphasised that they were not taking a political stand, but simply representing reality or appropriating and playing with revolutionary visual languages they had been exposed to in their youth – without criticality. Yet, the market that arrived for their works after 1989 consisted mostly of sympathetic Westerners and Western institutions. After a few international presentations, an overbearing discourse rooted in the post-Cold War ideological perception of 'political art' in China became firmly established. As a result, while the art was depoliticised, the works' narrative alluded to political symbols and signifiers. The tendency towards depoliticisation in the art world and in Chinese society went hand in hand with the projection of political connotations onto the works and their consumption internationally.

Since 1989, around the period when 'Magiciens de la Terre' was held in Paris, Chinese contemporary art would gradually appear more and more frequently in exhibitions organised by Western art institutions as a distinct canon, riding the emerging wave of globalisation. The beginning of the 1990s heralded the arrival of a gradual construct of contemporary art in China. This vision of contemporary art was one strongly influenced by the idea of an art system and industry that could enable and support artistic practices without dependence on state-provided resources and infrastructure. At this time, Chinese artists, curators, critics and dealers actively participated in promoting the 'brand' of Chinese contemporary art abroad, while immersing themselves in the construction of a domestic system based on their own knowledge and understanding of the Western art system. As artists and curators assumed professional identities based on international models in the 1990s, they also reinvented the globally familiar infrastructure for Chinese contemporary art, including commercial galleries with regular cycles of exhibitions and the

Ai Weiwei and others installing work by
Wang Xingwei. Photography: Chinese-art.
com Archive at Asia Art Archive

Previous spread: Installation by Zhang
Dali, 'Fuck Off', 2000. Photography: Jin Le.
Courtesy Asia Art Archive.

expectation that artworks could commercially circulate. In practice, this new infrastructure would intersect and overlap with official bureaucratic structures. The prospect of an expanded infrastructure and the gradual emergence of a considerable domestic market for contemporary art further aggravated the division between those who depended on the official art institutions and those whose work circulated within this new infrastructure.

For Ai Weiwei and many of the fellow artists whose works were conceptually inclined, performance-based, experimental or provocative in nature, the official art system in China, on the one hand, and the new structures for contemporary art that encompassed Western collectors and institutions as well as a budding Chinese art market, on the other, were systems of power that solicited conformity. In either system, they felt, there was no room for their work. Interviewed by Zhuang Hui in 1995, Ai commented:

> *A powerful system is forming around us. The standardisation of language and desires, the monopoly and systemisation of information all over the world are resulting in the thorough disappearance of the power and value of individual willpower and individual spirits. The speed of such disappearance is much faster than the speed of extinction of forests and rare animal species. This is an issue that should terrify human beings.*[10]

Ai's alertness to the rising dominance of both systems of power was not just speculative.

The Shanghai Biennale in 2000 was itself a sign of the merging of both systems. For the first time, Shanghai Art Museum, the organiser of the biennale, adopted the international model of selecting a small group of curators, including Paris-based Chinese curator Hou Hanru 侯瀚如, Japanese curator Toshio Shimizu and two curators on the museum's staff, Li Xu 李旭 and Zhang Qing 张晴, to select artists and works for the exhibition. Compared with the first two editions of the Shanghai Biennale, which focussed entirely on Chinese brush-and-ink and oil paintings, the 2000 edition was groundbreaking in that artists (67 in total) active in the contemporary art worlds of Europe, the US, Africa and Asia were invited to present their works in a state-funded institution. Many recognised and celebrated this development as marking the transformation of contemporary art from outcast of the state system post-1989 to welcomed and legitimised presence in Chinese state institutions. As Lin Yilin 林一林, a participating artist of 'Fuck Off', remembers:

> *The Shanghai Biennale was the first large-scale exhibition of international contemporary art in China at that time, with famous artists from abroad participating in it, especially overseas Chinese artists. The exhibition space was formal-looking and professional; the works were well-made and the curatorial aspect and narrative of the show were excellent. It was a very major provocation to the art circle in China. Unlike today, there were not so many big contemporary art exhibitions. At that moment, artists all had some weird feelings and wanted to be part of what was happening. That's why there were so many satellite exhibitions.*[11]

As one of the twenty or so satellite exhibitions coinciding with the 2000 Shanghai Biennale, it can hardly be suggested that 'Fuck Off' was antagonistic to the emerging art system(s) as such. Nor did the artists claim such a stance. Instead, 'Fuck Off' raised a middle finger precisely at the attitude of those members of the local artist community who appeared eager to embrace and celebrate these new systems of legitimation and authority. Ai came up with 不合作方式, or 'An Uncooperative Approach', as the Chinese title for the exhibition, to articulate the autonomy of the artist and the independence of spirit and approach: 'Such independence should manifest itself in an uncooperative attitude towards popular trends, including both Chinese conditions and Western cultural hegemony. This uncooperative approach is the essence of having an independent spirit.'[12] An American friend made the suggestion of 'Fuck Off' for its English title, and Ai took a liking to its vulgar sound and full articulation of his ideas. (The Chinese title is itself a slightly clumsy sounding translation of an English-language expression.)

For the exhibition, Ai Weiwei and Feng Boyi both brought names of artists to the table to discuss in their selection of works. Their considerations were

Xu Tan, *Web Banner*, 2000. Courtesy Ding Yi

largely based on whether the works were conceptually and artistically distinctive, and did not conform to popular languages – especially those that catered to what Ai described as 'shallow interpretations of Chinese culture and cartoon-like representations of political trends of thought in China, both of which were made for the West'.[13] Ai also considered works supported by the art market as a kind of toxin and refused their presence in the exhibition. While Ai did say that it didn't matter to him if the works had already been exhibited or the artists were very successful already, he did decline Feng Boyi's suggestion of Yin Xiuzhen 尹秀珍 as a participating artist on the grounds that she was already well-represented internationally. Since the early 1990s, she had been working with recycled materials of both everyday and personal significance to create ambitious sculptures loaded with social references and the nostalgia of contemporary cosmopolitanism. Ai Weiwei and Feng Boyi were instead seeking process-based works, provocative performances and recent works of an experimental nature made in the late 1990s, as well as artists of a younger generation.

pp.220–21

Ding Yi, for example, didn't show any of his famous paintings of crosses, but rather an installation: one cubic metre of wax made over a month, presented on a low wooden podium together with the materials and tools for making the wax. Exhibited, it was both a work and a document of the wax experiments carried out. Wang Bing 王兵, a documentary filmmaker later known for such works as *Tie Xi Qu: West of the Tracks* 铁西区 (2003), showed

p.212

a photograph of a workshop in Shenyang, a steel mill that went bankrupt and dismissed about three thousand employees in 1997 as a result of market reforms including the privatisation of state-owned industries that had started in the late 1980s. In Wang Bing's image, the abandoned premises is in a state of disarray. He also presented a video of remnants and traces of the mill, such as group portraits of workers and work permits. Zhang Dali 张大力 filled one

pp.104–05 & 195

of the gallery walls with giant graffiti profiles of his own bald head, which he painted next to *chāi* 拆 characters used to indicate a building's scheduled demolition; Beijing authorities had placed *chāi* on sites over two thousand times between 1995 and 1998.

pp.213, 197 & 211

Apart from such straightforward social commentary were works, considerable in number, by conceptual artists such as Chen Shaoxiong 陈劭雄, Lin Yilin and Zhang Shengquan (known as Datongdazhang 大同大张). Quite a number of works involved the use of animal carcasses and flesh as well as injury and brutality to human bodies, sometimes the artist's own. Zhu Yu, for example, provided a series of photographs documenting himself calmly procuring, preparing and devouring what was identified as a six-month-old stillborn human foetus; these photographs were included in the catalogue but the work was not presented in the exhibition. Many performance artists were also featured, such as Zhu Ming 朱冥 and He Yunchang 何运昌, some of whom staged live

pp.192–93

works at the opening, for example Yang Zhichao 杨志超. He was known for subjecting himself to physical pain, for example imprinting his personal identity number onto his right shoulder with a hot branding iron. At the opening of 'Fuck Off', he had shoots of grass from the Suzhou Creek planted into his back by a doctor without local anaesthesia (*Planting Grass* 种草).

According to the co-curators, the works in the exhibition engaged with

> *allegory, direct questioning, resistance, alienation, dissolution, endurance, boredom, bias, cynicism and self-entertainment, which are aspects of culture as well as features of existence. Such issues are represented here by the artists with unprecedented frankness and intelligence, which leaves behind fresh and stimulating information and traces of existence.*[14]

Allegory was clearly present in Ai Weiwei's own participating work, *F.U.C.K.*, which greeted visitors as they first entered the show. It was an installation that included five hundred posters brought into the exhibition space by a forklift and placed on the floor for visitors to take away. The poster's image featured an enlargement of a photograph by Henri Cartier-Bresson, taken in Shanghai, of a mass of people queueing and also propelling themselves towards a bank building to receive their share of gold during the turbulent transition from Kuomintang (Chinese Nationalist Party, KMT) to Communist rule in December 1948. After the value of paper money plummeted that month, the KMT decided to distribute forty grammes of gold per person. Thousands of panicked people waited in line for hours, and ten died by suffocation. Cartier-Bresson deftly captured the desperation and claustrophobia experienced. Ai Weiwei's work was self-referential in a way, evoking the eagerness of the Chinese contemporary art world awaiting the opportunities being doled out by the official art system and the Western art world.

pp.194–95

Asked how the exhibition was laid out, Ai Weiwei admits that he made it a rule from the very beginning that spaces would be allocated in advance for the works, in order to prevent artists from fighting each other or demanding more than was possible. The first floor was better suited to exhibit art than the ground floor, and overall the spaces felt quite raw. Many works, especially the conceptual, were presented through printouts nailed directly to the wall. There was no particular order to the layout, and many artists and visitors remember the show as a very lively scene, full of energy and commotion.

The catalogue features a double-page group image of all the participating artists: a photographic portrait with some individuals digitally added. A number of the artists have since become financially successful, such as Ding Yi, Wang Xingwei 王兴伟 and Wang Yin 王音. Many performance artists stopped performing and picked up oil painting or sculpture, for example Ma Liuming 马六明, Zhu Yu 朱昱 and Zhang Dali. Some of the artists passed away in the last decade: Peng Donghui 彭东会, Chen Shaoxiong and Zhang Shengquan. Others stopped making art entirely, such as Chen Lingyang 陈羚羊 and Gu Dexin, for different reasons. Ai himself moved abroad. East-link Gallery closed down and the warehouses along the Suzhou Creek have become a creative industry hub populated by design studios, shops, cafes and tourists.

pp.112–13

'Fuck Off' can be seen as a document of a set of practices at a particular moment. Ai Weiwei's artistic practice has often involved research, collecting and documenting, and he is inclined to see the exhibition in such terms: for

Group portrait of 'Fuck Off'
participants, published in
the exhibition catalogue

him, it gathered works, attitudes and approaches from the 1990s that resisted systems of power and the temptation of assimilation and conformity. Riding on the wave of emerging initiatives including both the Shanghai biennale, by such a governmental institution as the Shanghai Art Museum, and the self-organised satellite exhibitions coinciding with it, 'Fuck Off' itself contributed to the heteroglossia of ideas in the art scene at the beginning of the millennium, before they were all assimilated into an almighty art industry. However, 'Fuck Off' had an embedded self-critical attitude that warned against 'the threat of assimilation and vulgarisation', insisting on independence and criticality as basic to the existence of art. It had the intention 'to provoke artists' responsibility and self-discipline, search for the way in which art lives as "wildlife", and raise questions about some issues of Chinese contemporary art.'[15] As a document, 'Fuck Off' is thus ambivalent: it marks the end of the dynamic artist-led initiatives of the 1990s in China as well as the beginning of the path that contemporary art has since taken.

Notes

1 Uli Sigg had visited the exhibition.

2 Li Liang, communication with the authors, February 2020.

3 Feng Boyi, interviewed by Biljana Ciric, 23 November 2013, in B. Ciric (ed.), *A History of Exhibitions: Shanghai 1976–2006*, Manchester: Centre for Chinese Contemporary Art, 2014.

4 Ding Yi, communication with the authors, 2 February 2020.

5 See Liu Ding, Carol Yinghua and Su Wei (ed.), *Accidental Message: Art is Not a System, Not a World* (exh. cat.), Guangzhou: Lingnan Fine Art Publishing House, 2012, pp.44–51.

6 The publication features images of discussions and exchanges amongst participating artists as well as a map of the locations where the works were realised and additional documentation (sketches, concepts and processes). See Song Dong and Guo Shirui (ed.), *Wildlife: Starting from 1997 Jingzhe Day* (exh. cat.), Beijing: Contemporary Art Center, 1998.

7 *Ibid.*

8 The Chinese Communist Party's initial reform policies were announced at the Third Plenum of the Eleventh Central Committee in December 1978. Deng Xiaoping, whose power had been weakened by the 1989 Tiananmen Square protests, visited Guangzhou, Shenzhen, Zhuhai and Shanghai from 8 January–21 February, 1992. During his travels, he delivered speeches to generate support for his reformist platform and economic policies.

9 The Fourteenth Party Congress of 1992 legislated this commitment to reform in the name of a 'socialist market economy' based on the 'theory of building socialism with Chinese characteristics'.

10 Zhuang Hui, 'Interview with Ai Weiwei', conducted on 5 September 1995 and 14 November 1995, in Zeng Xiaojun and Ai Weiwei (ed.), *White Cover Book*, Beijing: self-published, 1995, p.12.

11 Lin Yilin, communication with the authors, 3 February 2020.

12 Ai Weiwei, email to the authors, January 2020.

13 *Ibid.*

14 Ai Weiwei and Feng Boyi, 'About *Fuck Off*', in *Fuck Off* (exh. cat.) Shanghai: Eastlink Gallery, 2000, p.9.

15 *Ibid.*

［〈食人〉］这件作品我准备了两年，但它不是特别为这个展览而做的

我布展完［把照片挂在我的展墙上］后，未未告诉我，我的作品可能会导致整个展览被封掉，他让我把作品撤下来。我说，你怎么处理都行。《不合作方式》开幕之前，我就离开了上海，但没回北京，而是两手空空去杭州找我同学玩去了。

把作品照片从墙上取下来，放进箱子裡，是未未对不展出作品的处理方式。这个方式是后来其他参展艺术家告诉我的。那个箱子是未未他们买回来的，不是我带来的。不过1999年参加《超市》展时，我是自己提着一箱人脑罐头，从北京坐火车来上海的，幸好当年北京火车站还没有行李安检。

朱昱
艺术家，参加《不合作方式》
翁子健访谈，2020年1月

I worked on the piece *Eating People* for two years, but it was not made specifically for ['Fuck Off'].

After I finished the fit-up work [hanging the photographs], [Ai] Weiwei told me that my piece could mean a ban on the entire exhibition. He asked me to remove the photos. I said, whatever you decide. I left Shanghai before 'Fuck Off' opened, but I didn't return to Beijing. Rather, with nothing to my name, I went to Hangzhou to hang out with my classmates.

Removing the photos from the wall and putting them in a suitcase was how Weiwei chose to handle the unexhibited works. I was later told this by other exhibiting artists. The suitcase was purchased by his team and not something I had brought. However, when I went to Shanghai to take part in the 1999 exhibition 'Art for Sale', I took the train from Beijing and carried a trunk of canned human brains with me. Fortunately, there wasn't any security inspection for luggage at the Beijing railway station.

~Zhu Yu, artist, participant in 'Fuck Off'. Interviewed by Anthony Yung, January 2020

Voices

东廊画廊成立前我在悉尼生活和工作,自
己本身参与当代艺术实践,也曾得到过澳
洲文化部的艺术基金项目支持。回上海开
画廊,是希望用自己的经验来帮助国内的
艺术生态发展,因为在1999年国内[的画
廊行业]基本上是空白……[画廊早期]基
本上没有客户,只有偶尔几个西方游客或在
中国的西方人。

[东廊画廊的]第一个空间是在复兴西路70
号,是一栋两层的小楼,几个展览办下来后
就发现空间不合适,我决定在苏州河边上
找老仓库,半年后找到了西苏州路1133号
原粮食局仓库。我需要一个新展览来启动
新空间,原设想邀请艾未未做个展,他提出
做个联展,也就是以后的《不合作方式》。

展览的组织工作我基本上没参与,仅仅推
荐了一些上海的艺术家。展览费用我和艾
未未分担,开幕后他告诉我一共用了三十
万元人民币。我也没有参与销售,因为此展
览的大部分作品应该没有市场机会的。展
览后的第五天或第七天就被政府部门关了,
处理结束后我就把作品运回了北京。

这个展览被封后,上海政府方面处理的结
果让我有些意外,让我继续保留营业执照,
但是出格的展览肯定是不能再办。当时的
十五万元对我来说是一笔巨大的资金,有一
半钱还是借的,所以后续影响是很为难,半
破产的状态下只能继续扛着做空间。好在
当时的人工及租金不是很高,有时申请些上
海的领馆及海外某些艺术基金维持着空间。

我个人也不喜欢、或不懂如何做商业的画廊,
以后的十多年基本上是在非营利的状态下
做了些展览,但是中国大城市的一切成本
越来越高,其他当代艺术画廊和非营利空
间也逐渐多了起来,2015年左右开始就逐
渐歇业,我也觉得是退出的时候到了。

李樑
上海东廊画廊创办人及总监
翁子健访谈,2020年2月

Before Eastlink Gallery was established, I was living and working in Sydney. I was part of the contemporary art scene there, and I had won project support from the Arts Fund administered by the Australian Ministry for the Arts. With this new gallery in Shanghai, it was my hope to help develop China's art ecology with my experience, for in 1999, China had basically a blank scene [in the gallery business]. ... [Early on] we had very few clients except occasional visitors from the West and Westerners based in China.

The first [Eastlink Gallery] space was located at no.70 West Fuxing Road. It was a small, two-storey building. After a few exhibitions, the space was found to be inadequate, and so I decided to look for an old warehouse by the Suzhou River. Six months later I found what used to be the warehouse of the Grain Bureau, at no.1133 West Suzhou Road. I needed a new exhibition to launch the new space. I had thought of inviting Ai Weiwei to do a show, but he proposed a group exhibition, which was realised as 'Fuck Off'.

I was basically not involved in its organisation, other than recommending some Shanghai-based artists. Ai Weiwei and I shared costs, which he told me after the exhibition opened amounted to CNY 300,000. I wasn't involved in the sales either, for most of the works had no expected market potential. On the fifth or seventh day of the exhibition, it was shut down by the authorities, and after all due processing, I transported the works back to Beijing.

After the ban, the Shanghai authorities surprised me with their final decision: that I could keep my business licence, but no more improper exhibitions. CNY 150,000 back then was a huge sum to me, not to mention I had borrowed half of those funds. The ban put me in a difficult situation wherein I had to carry on with my space half-bankrupt. Fortunately, labour and rent were not so expensive at the time, and sometimes I applied for funds from some consular offices and art foundations in Shanghai – just to keep the space going.

Personally, I don't like to run commercial galleries – or, shall I say, I don't know how. During the ten years that followed, for the most part I did exhibitions in a not-for-profit mode. But the cost of everything continued to rise in major Chinese cities, and as other contemporary galleries and non-profit spaces gradually grew in number, Eastlink began, around 2015, to phase out of business. I also felt it was time to exit.

~Li Liang, founder and director of Eastlink Gallery, Shanghai. Interviewed by Anthony Yung, February 2020

Coincidence and Re-collection; Lateness and Insight
— Lee Weng Choy

1. I was there.

For many a writer, memory is a source of primary material; it is the living archive of our selves. For the historian, it's documents that matter. But if memory is also a document of sorts, it is a uniquely limited and unreliable one, even with the indexical weight of saying 'I was there' – and I was, in Shanghai, in 2000, at the Biennale. These days, Hou Hanru 侯瀚如 is the name we most associate with that exhibition, but, to give credit where it's due, Li Xu 李旭, Toshio Shimizu and Zhang Qing 张晴 were the other curators. During that trip, I also saw the infamous 'Fuck Off' 不合作方式 show, organised by Feng Boyi 冯博一 and Ai Weiwei 艾未未. Until recently, I was pretty sure that I didn't go and see 'Useful Life' 有效期 as well. But, then, in London, at an open editorial meeting for the present publication,[1] when I saw some images from the exhibition, which was organised by Xu Zhen 徐震, Yang Fudong 杨福东 and Yang Zhenzhong 杨振中, I got a pretty strong dose of déjà vu.

pp.134–83

pp.184–221

pp.222–35

What, however, can this 'being there' really mean? What can it mean to someone who's based in Southeast Asia and, say, writes art criticism? What can it mean to the people who happen to chance upon and read this text? Notice, I don't ask myself, *What do I remember*? Because I know my own remembrances won't add up to much – even if aided by photographs, documents, or freshly dug up notes, which I didn't take, since I wasn't planning on writing anything. In any case, what about that moment when memory is not yet the stuff that one remembers, but is just the feeling of having been there? To have been at an exhibition, or two, or three.

A shift has occurred in the field of art history. One that I belatedly came to appreciate, in between the time when I was there in China, and now, here in Malaysia, when I am trying to write not about, but around Shanghai. There's a name for this shift: the set of approaches called 'exhibition histories'. To my understanding, those who write these histories do not seek to supersede but to complement other narratives about art, which may focus on artworks, artists, curators, art spaces and institutions, or the discursive, social, economic or political conditions of cultural production and reception, and so on and so

Opening ceremony of the third Shanghai Biennale. Photography: Wu Hung. Courtesy Asia Art Archive

forth. There's a crucial difference, though, isn't there? To say I've seen an artwork in the flesh isn't quite the same as saying I've seen a particular exhibition. In most cases, there will be other chances to see an artwork again, later, in the future. There is only one window to see an exhibition – to have been there. Sure, exhibitions get re-staged sometimes, but then it's not the same thing anymore, since the historical moment is just as much a part of a show as the specific arrangement of artworks, architectures, wall texts and other things. So: What might the relationship be between exhibition histories and, not the *work* of memory, that effort to re-collect and re-member, but this *feeling* – of the 'there-ness' of memory?

2. 'can we be ironic'[2]

Why was I there? Simply: because I was invited by Hou Hanru to speak at the symposium. My presentation was titled '"Bad" art and Singapore'. I began by acknowledging that 'bad art' is a judgmental term, and then clarified that I wasn't actually going to discuss any examples of bad art from Singapore, as my purpose was to raise questions about how we – those of us from Asia who participate in the international art conference circuit – represent art and place, given that that is typically our expected role. I wanted to address the problem of representation by looking at the *idea* of bad art. I mentioned the late theatre-maker Kuo Pao Kun, one of Singapore's most well-regarded artist-intellectuals. Kuo endorsed a notion which his compatriot, architect Tay Kheng Soon, had put forward: What you have in Singapore is modernisation minus the modernity. As Kuo explained, 'although Singapore has learnt to produce and enjoy the physical and economic infrastructure and development

of modern times, it has never enjoyed the commensurate socio-political philosophy, mindsets and worldview'.[3] Singapore's rapid development is well known. Also well known is how its government has dominated almost every aspect of life in the country, privileging the economy above all else, from democracy to the arts. The implication is that without 'modernity' as such, Singapore's culture is incomplete, although Kuo's criticisms were nuanced and did not just blame the authorities. While not entirely disagreeing with Kuo or Tay, cultural theorist C.J.W.-L. Wee has argued that instead of seeing Singapore as lacking modernity's critical and reflexive dimensions, one should read this as characteristic of Singaporean modernity itself.[4]

During my presentation, the interpreter had some difficulty. Apparently, me trying to be ironic wasn't easy to translate. If I recall correctly, someone in the audience misunderstood and thought I was saying that Chinese art was 'bad'. Eventually, Hou stepped in and continued the translation himself.

That I spoke at the symposium is, undoubtedly, a trivial fact. But from such coincidences, essays sometimes get written. To wit, an encounter at the 2018 Gwangju Biennale, where I met Lucy Steeds, senior editor with the *Exhibition Histories* project at Afterall.[5] Steeds and I got to talking, and as a result she commissioned this text. To have been there – in Shanghai in 2000, but also Gwangju in 2018 – seems both irrelevant and yet not entirely inconsequential.

Steeds emails me: 'Late-night thought from London (and probably blinkered), but isn't a point about the Shanghai Biennale of 2000, and the satellite shows, that they made a national claim upon the global or universal?' Steeds notes that such claims were once performed by New York, USA, post-World War II, as the new vanguard of modern art, and earlier by Paris, France, in the nineteenth century, as its centre. Stepping back to the year 1989, she triangulates three major shows: 'Magiciens de la Terre' in Paris, the third Bienal de La Habana and 'The Other Story: Afro-Asian Artists in Post-war Britain' in London. 'For all their differences, these three exhibitions might be said to have transnationalised artistic practice. Didn't the notion of an artist being curated into a show on the basis of their individual cultural trajectory, rather than representing a nation, start there?' In what she acknowledges as a coarse-scale summary, she proposes that these moments from 1989 continued to define global contemporary art shows in the ensuing years. But then, she asks, does this period come to an end, and when? 'Was it with exhibitions like the Shanghai Biennale and satellite shows in 2000?'[6]

For Southeast Asia, 1989 to 2000 was a time when its artists were becoming more widely recognised as part and parcel of the global contemporary art world. At the beginning of the 90s, access to the global was still largely mediated through the nation, and the nation also remained the framework for multiculturalism – this was true whether artists were shown at national or international platforms. Although, it was principally the latter that made contemporary art from the region significant globally. Exhibition programmes in Japan and Australia proved to be instrumental in this regard. To point to just one of these: the Queensland Art Gallery's Asia Pacific Triennial of

Contemporary Art (APT). At the first APT, in 1993, artists were grouped by nation in the catalogue. By 1999, through gestures such as the introduction of a 'Crossing Borders' category, the third APT took on a more deliberate transnational outlook, though it's arguable that APT3 continued to predominantly maintain, rather than challenge, categories of cultural identity.

But I wonder: By the time the Singapore Biennale came around, in 2006, sure, it was nice, important, to have such a major exhibition in Southeast Asia, but did 'we' really need it to stake the claim that 'our' contemporary art had arrived? Hadn't that already happen with the APT, and elsewhere? Did the Singapore Biennale come late in that regard? The APT also deserves credit for promoting China to the global art world – China was arguably the star of the second and third Triennials (whereas Japan was possibly the highlight of the first). But, as contributors to this book explain, the 2000 Shanghai Biennale did something for Chinese art that other, non-Chinese platforms, including the APT, could not do. The exhibition signalled a change of outlook: the Chinese state's embrace of contemporary art and its intent to promote Shanghai as a global, cosmopolitan centre – a re-envisioning of the city's position prior to the communist revolution. Whereas for Singapore art such milestones happened well before 2006.

What about the regional impact of the 2000 Shanghai and 2006 Singapore biennales? Indeed, what did the former mean for Southeast Asia, not only then but now? Would it have meant more to 'us' at the time if more artists

Lee Weng Choy speaking at the third Shanghai Biennale symposium, 'Shanghai Spirit: A Special Modernity', 2000. Courtesy Asia Art Archive

than Montien Boonma, Heri Dono and Chatchai Puipia were there to 'represent'? Should 'we' also count Lani Maestro and Fiona Tan? Both were born in the region, but no longer live here. How should such premises of representation be re-evaluated today? And what about the effects of those two events globally? Following Steeds's point about the exhibitions of 1989 *vis-à-vis* those of 2000, I would suggest that Shanghai's assertion of China onto the global stage – and China as a metonym for Asia – set a precedent that Singapore followed in its claim to be *the* hub for Southeast Asian contemporary art.

Another thing happened in the 90s for Southeast Asia: the Asian financial crisis, which was triggered by the devaluation of the Thai baht in July 1997. C.J.W.-L. Wee notes that the crisis coincided with the first presentation, in Vienna, of the travelling exhibition 'Cities on the Move' (1997–99), which looked at East Asia's rapid urban development through its art, architecture and film, and was curated by Hans-Ulrich Obrist and Hou Hanru. As Wee suggests, the crisis – not the exhibition – may have, at the time, 'punctured the impression of a confident New Asia rising', or at least suggested that 'the very idea of an *emerging* Asia was volatile rather than certain'. However, Wee also argues that if the grand narrative of thriving East and Southeast Asian economies experienced something of a setback, 'the curatorial capacity to *represent* was a compelling issue', and for many in the region 'there could be no turning back' in their belief in their own cultural arrival.[7]

So: How can one make sense of what happened in contemporary art after the events of Shanghai in 2000 – not only for China, but for Southeast Asia, other regions and the 'art world as a whole'?

3. Are we adjacent yet?

Like many postcolonial states, Singapore became a nation with a set of aspirations and a sense of urgency. Was there ever a country whose arrival was accomplished so efficiently and effectively? Once relatively poor, within two generations its GDP per capita had exceeded that of the UK, its former coloniser. Moreover, Singapore once maintained that it could be the model, of capitalism and authoritarianism combined, for the economic development of China.[8] That fantasy has not played out, as constitutive as it may have been for the island city state (population: less than 6 million), if not for the much larger mainland (population: over 1.3 billion). And, like many of the postcolonial cities that host them, a good number of biennales also manifest the rhetoric of visionary ambitions as well as of urgency and crisis. These large-scale international art exhibitions often seem to operate with the utopian presumption that they can help audiences *re-imagine the world*, or, at least, the interrelations between different and diverse peoples and places, countries and continents.

Describing her own interests in exhibition histories, Steeds proposes that the 'practice of exhibition histories does not focus so much on the isolated, intact artwork but, rather, approaches it in conjunction and puts it into question. How does art develop dialogues with adjacent art – and non-art – with a host environment, institutional ideologies and among geopolitically and

historically particular publics?'⁹ For me, the word 'adjacent' stands out here. 'Adjacency' could be understood as a state of mutual coexistence between two or more proximate entities, whether creature, community or country. To elaborate, let me contrast the notion with 'contemporaneity'. In his essay 'Every Other Year Is Always This Year – Contemporaneity and the Biennial Form' (2015), Peter Osborne contends that art today lives in the 'age of the biennial'. He advances a critique of the biennale as symptomatic of neoliberal capitalism, explicating the relations between contemporaneity, the biennale and globalisation. For the first time in human history, capitalism and globalisation have produced the 'new and distinctive temporality of "contemporaneity" – a disjunctive coming together of different social times' across the world.¹⁰

While I agree with much of what Osborne says, I think he overprivileges the biennale *form* and overlooks the multiplicities and specificities of biennale *practices* and *practicalities*. In the same publication that includes his essay, another, by Anthony Gardner and Charles Green, offers what I believe is something of a corrective. In 'South as Method? Biennials Past and Present', Gardner and Green give evidence of a history of biennale practice that is irreducibly heterogenous; various projects in the 'South' were important for how they enabled conversations, collaborations and networks that were less about becoming part of the global contemporaneity than attending to regional adjacencies.¹¹ I would argue that thinking through these adjacencies requires us to think through the multiple practices and practicalities of biennales, and vice versa.

These practices and practicalities also ask us to think through considerations of *scale*. Contemporaneity and adjacency are of different scales: for the former, scale is global, whereas for the latter, think of a neighbourhood, or, at most, a region. Scale, of course, is not about size, but proportion and perspective: how one fits into one's world. Joan Kee argues that the scale of contemporary art has shifted from the international to the global. One suggests a series of lateral multi- or transnational engagements, whereas the other implies the total view from above. And when it comes to contemporary Asian art in particular, Kee notes that the field emerged largely influenced and framed by 'Western' discourses from the late 1980s through the 1990s, which provided 'the institutional acknowledgement of non-Western art in Europe and the debates over the idea of multiculturalism in the North American art world'. Kee suggests that '"contemporary Asian art" is now more convincing as a term used to refer to a system of institutions, images and discourses, rather than artworks or artists', and in good part because of exhibitions such as 'Cities on the Move'. That show 'asked whether a global art world was only possible if we let go of close looking much in the same way that the idea of world literature only makes sense when one doesn't read texts so closely. Does one scale of operation exist only when another disappears? The great lesson of "Cities on the Move", then, was to show how entities (human or otherwise) mattered less than their circulation in a network over which they as individuals have little, if no control.'¹²

With regards to adjacency, for me, a useful model – though certainly not *the* model – is the companion relationships that humans and cats have with each

other. With dogs – another useful model – we look face to face. Alas, for the cat, the direct gaze is a threat. Better to sit next to her, and pretend to mind your own business, unlike the orange tabby, who is actually ignoring you. Then, eventually, when she glances at you and slowly blinks, do what she does. The cat is a figure of intimate familiarity and radical difference at the same time.

My own role in this book could be considered as one of adjacent reflection (or blinking). I neither research exhibition histories nor write on Chinese art; I'm an outsider to both fields, as it were. But, as Anthony Yung emphasised at our London editorial meeting, this book is framed by a set of adjacencies: the Shanghai Biennale triangulated with the satellite shows 'Fuck Off' and 'Useful Life'. And, given the thesis that these events are important not just for Chinese art history, but they have instead larger regional and global significance, a 'by-the-side' perspective is warranted and timely. My hope is to provide that here.

Of course, the notion of adjacency as a happy coexistence amongst neighbours is an idealisation. If only political realities would ever come close. The Association of Southeast Asian Nations (ASEAN) has long had a policy of non-intervention amongst member nations, but is it justifiable to do virtually nothing when a humanitarian disaster or an environmental emergency unfolds? For instance, the Rohingya in Myanmar, or the haze emanating from forests burning in Indonesia? For Southeast Asia, China looms large and, sometimes, threateningly. Writing this essay over the course of 2019, it was impossible to think about the prospects of living adjacently with China without also thinking about the protests in Hong Kong. As *The Guardian* reported in June 2019, 'The protests were initially focussed on a bill that would make it easier to extradite people to China from the semi-autonomous city. But the authorities' harsh policing of the protests, coupled with a refusal by Hong Kong's leader to completely withdraw the bill, mean protesters have returned to the streets time and again.'[13] Ai Weiwei, in an opinion piece for *The New York Times* in July, tried to be sanguine. Since 'Fuck Off' he has become, arguably, China's most visible global art star, even as he has taken on the role of dissident and now lives in exile. 'Some are asking: Can the Hong Kong protesters win? My answer is that if they persist, they cannot lose. This is a struggle over human values – freedom, justice, dignity – and in that realm the Hong Kong people have already won.'[14]

This essay turns on two questions. The first follows from the argument that 1989 ushered in a form of pluralism in contemporary art exhibitions, and asks if the events in Shanghai in 2000 were signs of a further evolution of the very terms of pluralism, across global, regional and adjacent scales. My contention is that those events, and others like them, signal that we are now in a period where it has become untenable to deny the irreducible plurality of contemporary art. The transnationalism and multiculturalism of the post-1989 period, for example, are inadequate frameworks. Even today's critique of neoliberal contemporaneity overlooks the specificities happening on the ground. If no singular vantage point or theoretical position can encompass the entire diver-

sity and disparity of the pluralities 'out there' – with a Euro-American centre not quite holding, but not yet entirely dispersed either – then what we have is an expanding range of stories that may sometimes be incommensurable with each other. These stories may be wide-reaching, competing, contemporaneous and adjacent – *and* they cannot all fit together. Ludwig Wittgenstein offers a wonderful image about incommensurability: the famous rabbit-duck drawing, where you can flip between seeing the ears of a rabbit or the beak of a duck. But it's not as if those who are partial to the 'duck narrative' cannot also see the 'rabbit narrative' – it's not that we are destined to be stuck in our own particular world views; rather, it is that you cannot see both duck and rabbit at the same time. Yet, today, our capitalist world order still teaches us to believe that scale is wholly continuous – you can always scale up, all the way to the global, total view. I believe Kee is correct when she says that sometimes one scale operates only when another disappears. Scale is also where we experience incommensurability – where we experience irreducible difference and plurality.

4. Travelling and unpacking ...

My second question concerns the 'there-ness' of memory and the writing of exhibition histories. One goes to a few of shows in Shanghai, then, after nearly twenty years, wonders, not so much what it was all about, but what it can mean. In today's platforms for international art, geography and ethnicity are privileged, so much so that one could describe this mode of exhibition-making and knowledge production as 'ethno-geographic'. In these instances, to be curated is to be mapped. Modern society's appetite for consuming cultural difference is overdetermined by many desires, but one of them – to command the view from above – is about the power to see diversity and render it and distance as abstract. However, maps are designed not to be comprehensive. A chart annotated with everything in a neighbourhood, from each bush and tree to the names of every cat, dog and companion animal, might be of interest to an artist, curator or writer, but less useful to someone just wanting to navigate the roads. Maps may be necessary for navigation, but navigation is insufficient for representation.

There *is* more to being curated than ethno-geography. One of the functions of art and its public display is to offer other possibilities and forms for the representations of culture and place: different modes of territory-telling, with or without maps. The problem is that many presentations of contemporary art are not the most informative vehicles about the journeys that curators and the curated make. The 'distances between', for instance, are often compressed or elided. And yet, sometimes, as Maria Lind would say, we can experience the 'curatorial', which gives us a situation, not a survey; it does not map a 'there and then', but performs a 'here and now'[15] – and, I would add, a 'now and there' as well as 'here and then', bridging places and histories. We audiences can share in the ways that each artwork inhabits its own contexts, and the curating takes us from the place of art to the space of exhibition, and back again. More than just offering us a chance to 'have been there', exhibitions have the potential to produce a feeling of being *transported*. Perhaps this is one way to think about what the there-ness of a memory of Shanghai can mean.

Decades later, even if you don't remember much else, you still hang on to that particular feeling.

At the start of the essay, I contrasted writers with historians. Let us consider (and perhaps caricature) the work of the former in terms of its centripetal force, and the latter, its centrifugal. The historian's research is outward looking: gathering data, searching for evidence, and so on. The writer's process turns inward: less a kind of 'introspection' than a pulling together of anecdotes, recollections, analyses, arguments, themes, citations, jokes and speculation, as if these thoughts, emotions and sensations were reflecting upon themselves. While this essay may appear as a mess of binaries – from the writer versus the historian, to memory and documentation, contemporaneity and adjacency, and so on – I would like to think that what is at stake instead are doublings. And what's especially interesting about doubles is that they can lead to multiples. I am interested not in simply adding to the story, but in re-writing the story again and again, through anecdotes, interruptions, asides, detours, repetitions, permutations, multiplications – all in service, with both irony and sincerity, of thinking through and about pluralism. There is one more double I would like to mention, which sits at the core of this essay: the plural and the personal.

Although what I've asked myself from the start is not what does it mean for me *personally* to have been there in Shanghai, but what *can* it mean, and for someone like me, who is interested in contemporary art from Southeast Asia. Though maybe it would have been better to ask the question not in terms of any 'me' – any writer, historian or audience member – but, after W.J.T. Mitchell,[16] to have shifted the point of view to ask: What can it mean for the exhibitions themselves? What did, or do these exhibitions want? Besides what they may want from us, what do exhibitions want from each other? What did the Shanghai Biennale of 2000 want from 'Fuck Off' or 'Useful Life'? And what did 'Fuck Off' and 'Useful Life' want? It may be tempting to answer that the former was something official and the other two were forms of protest, or the alternative. However, the essays in this book argue against such diametric interpretations; instead, they discuss the nuances of their different and particular interventions into the Chinese scene.

In the essay 'Biennale Demand' (2008),[17] I start off by rehearsing humanity's seemingly incessant demand for more biennales, then turn to speculating on what is it that biennales demand of us. My suggestion is that what these projects want is not just our attention, time or emotional response, but also our understanding, that is, that we see them within history – *exhibition histories* (though I did not use the term at the time). If exhibitions want exhibition histories, then what do exhibition histories want? Do they also want, like the exhibitions themselves, to transport their readers? I pose the question in all earnestness. I am quite sure that what we have is a wide range of answers: for some researchers, the aim may indeed be to transport the reader back in time and space, to reproduce a sense of what 'being there' would have been like. Whereas for others, the emphasis may be more on providing historical context, and less on creating an experiential dimension. While a survey of re-

sponses and the various motivations behind each is beyond the scope of these modest reflections, I did ask Steeds and David Morris (another *Exhibition Histories* editor at Afterall)[18] for their thoughts, and this is what they had to say:

Steeds: 'For me, exhibition histories are driven by questions in the present, and the way in which we return to these past durational fields is determined by what sorts of answers we seek. Working as an editor for *Exhibition Histories* at Afterall, I would concur that the plurality of that seeking "we" – and the diversity of the concomitant motivations and methodologies – is very important.'

Morris: 'It might sound strange, but I've never felt entirely at ease in exhibitions. I wonder if "being there" need be a natural or comfortable state, and whether it is something we would want to recreate, even if we could. Certainly part of exhibition history for me is to question what special demand exhibitions might have on our attention or study. And following your idea of "transportation", to me the point of any study is that it has to take us somewhere – not reconstructing the past "as it was", but to plot coordinates or move in a different way.'

Let me bring this to a close by recounting a more recent journey to 'China'. In September 2019, I went on a short trip to Hong Kong. The protests were still ongoing, of course. I was invited to participate in a couple of talks, and I also convened a workshop with a few close associates. These past few years, in addition to the many writing workshops I've facilitated, friends and I have come together for a series of more intimate sessions. Friendship is a topic I've written about a number of times, even comparing it with writing. Both are practices of address: they are about learning how to locate and place oneself, and how to be in the world, and to speak, listen, and live with others. At that Hong Kong session, Özge Ersoy, who leads public programmes at Asia Art Archive, shared a text that not only reflects on the current situation in the city, but also asks how to reflect on it. A pivotal moment in her essay turns on a citation from her friend, Karen Cheung, who, like Ai Weiwei, wrote in *The New York Times* about the protests.

Cheung: 'My "real" life – the one where I show up to work every morning, have a drink in the evening with friends, hide underneath the covers reading a book at night or call a handyman for odd jobs – exists in a parallel universe, one in which the city isn't burning.'[19]

Ersoy: 'Every day I keep thinking about the quotation marks she used around the word "real".'[20]

Cheung ends her *Times* piece by imagining another parallel universe, one that she longs and hopes for, 'where kids spend their summers at the malls, singing karaoke and complaining about holiday homework – not organising rallies or worrying about where to stash their gear so their parents can't find it. It's the one where everyone in the city can be out in the streets, and no one has to guess who their allies are.' What are the many scales of protest in

Hong Kong? What is the scale that you experience, when, standing in the street, you recognise the person next to you as an ally? Perhaps more than just being there, what's at stake is also being present, for each other. This is a form of public intimacy. The thing about public intimacy, though, is that it is between strangers, not friends. It is about caring for another who is unknown to you, but whom you feel connected to because you both share the experience of an adjacency created by circumstance and common cause. This observation is not mine, but Simon Leung's. He is an old colleague whom I happened to bump into during my Hong Kong visit.[21] Naturally, conversation turned to our thoughts and observations of what was unfolding in front of us. At one point during his visit, Leung found himself in the middle of a protest, with young girls chanting anti-police songs. He was surprised by how moving and joyous it was.

Upon my return home to Kuala Lumpur, as I was unpacking my bag, I tried to come up with an image to encapsulate the feeling of what it meant to have just been there, during the most dramatic period in Hong Kong's history. Nothing came to mind. I didn't have any encounters like Leung's. What I did recall were some of the ordinary signs that are to me distinctive of every visit to the Special Administrative Region; like the sounds and voices on the CB radio in the taxi as I travelled, alone, from the Airport Express station to my hotel.

Notes

1 The meeting was open to students, colleagues and invited guests, and held at Central Saint Martins, University of the Arts London on 14 October 2019.

2 The header of this section, 'can we be ironic', refers to a gift from the artist Simryn Gill, circa 1996. The phrase could be a motto for her practice. On a plain sheet of paper, with a mechanical typewriter, she repeated the question, albeit without the mark, four times, in four rows, with no spaces between the words or the lines. In the first row, 'can' is typed in red ink, with the rest in black; in the second row, 'we' is in red; in the third, it's 'be'; and the last, 'ironic'. The piece is on display in National Gallery Singapore's permanent exhibition 'Siapa Nama Kamu? Art in Singapore since the 19th Century'.

3 Kuo Pao Kun, 'Knowledge Structure and Play – A Side View of Civil Society in Singapore', in Gillian Koh and Ooi Giok Ling (ed.), State-Society Relations in Singapore, Singapore: Institute of Policy Studies, 2000, pp.210–18.

4 For further analysis of Singapore modernity, see C.J.W.-L. Wee, The Asian Modern: Culture, Capitalist Development, Singapore, Singapore: NUS Press, 2007. I also cited Wee in my Shanghai Biennale symposium presentation in 2000, which is unpublished.

5 Lucy Steeds was invited to moderate the symposium 'The Goldfish Remembers' (8 September 2018), convened by curator David Teh. For his project in the 2018 edition of the Gwangju Biennale, titled 'Returns', Teh wanted to investigate the institutional memory of the Biennale as a whole. Teh also organised a series of less formal conversations, which I was tasked to facilitate during the exhibition's opening and closing (6–8 September and 9–11 November 2018).

6 Lucy Steeds, correspondence with the author, 26 April–2 August 2019.

7 See C.J.W.-L. Wee, 'Asian Contemporary Art and the Question of Contemporary Asia: The Japan Foundation Asia Centre Symposia on Asian Contemporary Art, 1997–2002', paper presented at 'Beyond the New Media: Deep Time of Networks and Infrastructural Memory in Asia', at the conference 'InterAsian Connections VI: Hanoi', Social Science Research Council InterAsia Programme, Vietnam Academy of Social Sciences, Hanoi, 4–7 December 2018.

8 See, for instance, 'Has China outgrown its need for Singapore as a role model?', *South China Morning Post*, 24 May 2017, https://www.scmp.com/news/china/diplomacy-defence/article/2095310/has-china-outgrown-its-need-singapore-role-model (last accessed on 11 August 2019); and Stephan Ortmann and Mark R. Thompson, 'China and the "Singapore Model"', *Journal of Democracy*, vol.27, no.1, 2016, pp.39–48.

9 Lucy Steeds, contribution to 'Why Exhibition Studies?', *British Art Studies*, issue 13, 2019, https://www.britishartstudies.ac.uk/issues/issue-index/issue-13/why-exhibition-histories (last accessed on 20 October 2019).

10 Peter Osborne, 'Every Other Year Is Always This Year – Contemporaneity and the Biennial Form', in Galit Eilat, Nuria Enguita Mayo, Charles Esche, Pablo Lafuente, Luiza Proença, Oren Sagiv and Benjamin Seroussi (ed.), *Making Biennials in Contemporary Times: Essays from the World Biennial Forum No 2*, Amsterdam and São Paulo: Biennial Foundation, Fundação Bienal de São Paulo and ICCo – Instituto de Cultura Contemporânea, 2015, pp.23–35.

11 See Anthony Gardner and Charles Green, 'South as Method? Biennials Past and Present', in G. Eilat et al., *Making Biennials in Contemporary Times*, *op. cit.*, pp.37–45. I discuss both Osborne's and Gardner and Green's texts in my essay 'The Neglected Object of Curation', in Brad Buckley and John Conomos (ed.), *A Companion to Curation*, Hoboken, NJ: Wiley, 2019, pp.306–22.

12 Joan Kee, 'The Scale Question in Contemporary Asian Art', in Furuichi Yasuko and Hoashi Aki (ed.), *The Japan Foundation Asia Center: Art Studies, Vol.2, The 1990s: The Making of Art with Contemporaries*, Tokyo: Japan Foundation Asia Center, 2016, pp.34–41.

13 'What are the Hong Kong protests about?', *The Guardian*, 10 June 2019, https://www.theguardian.com/world/2019/jun/10/what-are-the-hong-kong-protests-about-explainer (last accessed on 11 August 2019).

14 Ai Weiwei, 'Can Hong Kong's Resistance Win?', *The New York Times,* 12 July 2019, https://www.nytimes.com/2019/07/12/opinion/hong-kong-china-protests.html (last accessed on 11 August 2019).

15 Maria Lind, 'The Curatorial', *Selected Maria Lind Writing* (ed. Brian Kuan Wood), Berlin: Sternberg Press, 2010, pp.57–66. See also my essays 'On Being Curated', in Petra Reichensperger (ed.), *Terms of Exhibiting (from A to Z)*, Berlin: Sternberg Press, 2013, pp.61–65; and 'Metonym and Metaphor, Islands and Continents: Reflections on Curating Contemporary Art from Southeast Asia', in Low Sze Wee and Patrick D. Flores (ed.), *Charting Thoughts: Essays on Art in Southeast Asia*, Singapore: National Gallery Singapore, 2017, pp.336–47. In those texts, I discuss being curated, and Lind's notion of the curatorial.

16 W.J.T. Mitchell, *What do Pictures Want? The Lives and Loves of Images*, Chicago: University of Chicago Press, 2005.

17 Lee Weng Choy, 'Biennale Demand" (reprint), in Melissa Chiu and Benjamin Genocchio (ed.), *Contemporary Art in Asia: A Critical Reader*, Cambridge, MA: MIT Press, 2011, pp.211–222.

18 L. Steeds and David Morris, correspondence with the author, 21 December 2019.

19 Karen Cheung, 'The Mask I Wear on the Weekends', *The New York Times*, 30 August 2019, https://www.nytimes.com/2019/08/30/opinion/sunday/hong-kong-protest.html (last accessed on 18 September 2019).

20 Özge Ersoy's essay was written specifically for the small workshop and not intended for publication; quoted with permission. The series of workshops, or 'writing intensives', which I have facilitated or co-facilitated, were initiated by Ben Valentine, who was not present at the Hong Kong session in September 2019. In addition to Ersoy and yours truly, the participants were Zoe Butt, Paul Fermin and Michelle Wong.

21 Conversation with Simon Leung, 13 September 2019. Leung is an artist and a professor of art at the University of California, Irvine. His family is originally from Hong Kong.

Art Exhibitions in Shanghai in 2000

2000年的上海當代藝術展覽

The Third Shanghai Biennale: 'Shanghai Spirit'

第三届上海双年展：海上·上海

Shanghai Art Museum

Shanghai

Biennale

2000

上海双年展

上海书画出版社

2000上海双年展作品分布图

(南京西路 325 号)

1 F

P F

(南京西路 325 号)

2 F

3 F

注： ■ 32 李岫的作品在 5F
■ 2 马修·巴尼的电影放映时间为 11 月 6 日、12 日、19 日、26 日下午 16：00
12 月 3 日、10 日、17 日、24 日、31 日下午 16：00

(南京西路 456 号)

2 F

3 F

Shanghai Art Museum, the main venue of the third edition of the Shanghai Biennale, was a newly renovated building that repurposed the colonial Shanghai Race Club at 325 Nanjing West Road. The main entrance led visitors into Galleries 1 and 2. Outside the venue was a work by Cai Guo-Qiang 蔡国强, *Self-Promotion for the People* 为大众做的自我宣传计划 (2000), which extended from the main entrance to the north entrance.

Once inside the main entrance, visitors
were greeted by Georges Lilanga di Nyama's
Traitor (1999) on the outer walls of Galleries
1 and 2.

Turning right into Gallery 2, visitors encountered
Bank of Sand, Sand of Bank 沙的银行或银行的沙 (2000)
by Huang Yong Ping 黄永砅, a twenty-tonne sand
replica of the former HSBC bank building in Shanghai.
Surrounding the sculpture were paintings by Liu
Xiaodong 刘小东 from the series *Heroes Are Always
Come from Youth* 自古英雄出少年 (2000); a painting by
Yan Peiming 严培明, *Invisible Man 002* 隐形人 002 (2000),
and his red head sculpture; and a photographic series
by Zhao Bandi 赵半狄, *Zhao Bandi and Baby Panda*
赵半狄和熊猫宝宝 (2000).

Liu Xiaodong, *Heroes Are Always Come from Youth.*

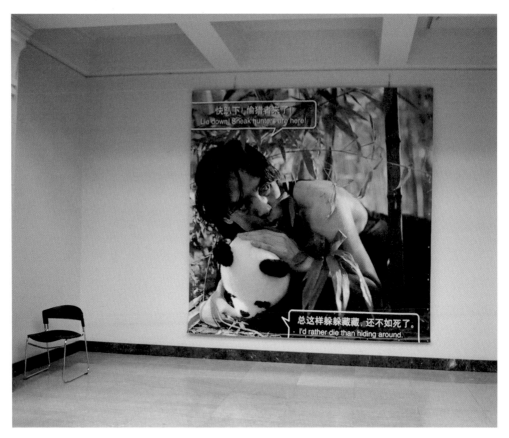

From Zhao Bandi's series *Zhao Bandi and Baby Panda.*

Yan Peiming, *Invisible Man 002.*

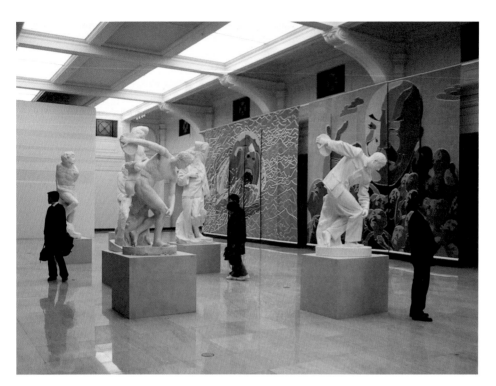

Across the lobby, in Gallery 1, a series of
sculptures by Sui Jianguo 隋建国, *Study
on the Folding of Clothes* 衣纹研究系列,
could be seen alongside large-scale
woodcuts by Fang Lijun 方力钧. Gallery 1
also featured Chatchai Puipia's painting
Across the Brown Eyes and into the Ears
(2000), Anish Kapoor's sculpture *Untitled*
(1997) and Tatsuo Miyajima's installation
Floating Time V1-03 (2000).

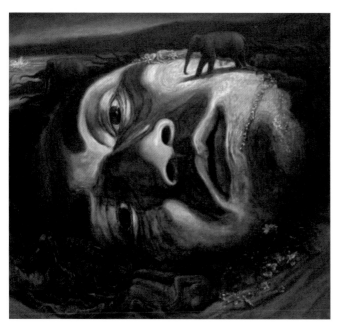

Chatchai Puipia, *Across the Brown Eyes and into the Ears.*

Anish Kapoor, *Untitled.*

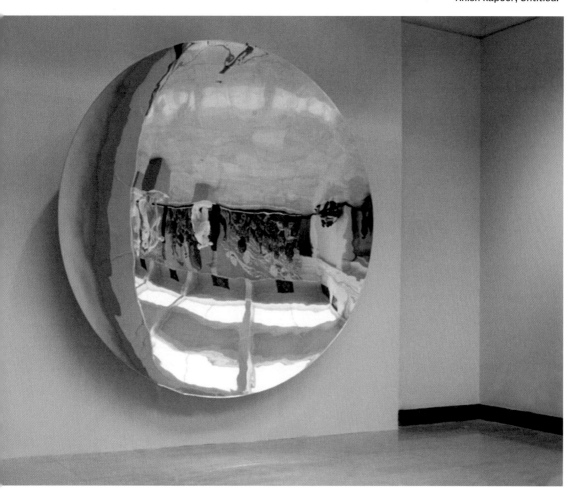

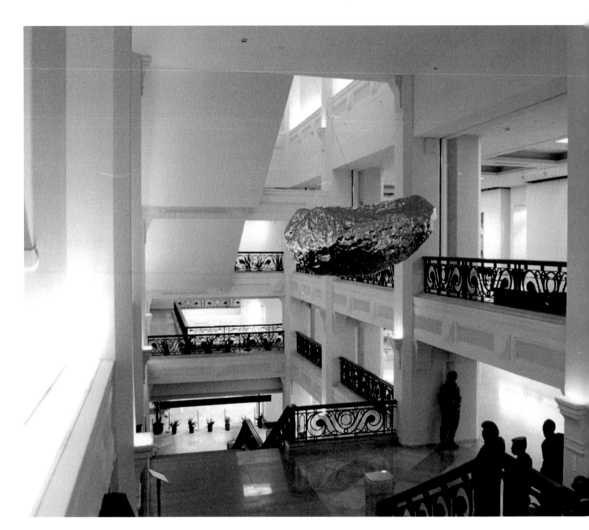

From the ground floor, visitors could access the mezzanine and first and second floors using a staircase near the north entrance. A sculpture by Zhang Wang 展望 hung from the ceiling above the staircase, with a sculptural installation by Liang Shuo 梁硕, *Peasant Workers in the City* 城市农民 (2000), on the mezzanine level. Curator Li Xu 李旭 described Liang's sculptures as 'dealing with the rural migrant workers who come to China's urban centres'. Also on the mezzanine level were Tadao Ando's drawings for and images of architectural works in Naoshima, Japan, and Anselm Kiefer's *Die Hermannsschlacht* (1977).

Work by Tadao Ando.

Anselm Kiefer, *Die Hermannsschlacht*.

Entering the first-floor galleries, visitors were met by Heri Dono's *Angels Caught on a Trap* (1996). Five ink-and-acrylic paintings by Marlene Dumas hung on the walls to the right, behind which was a room showing video works by Zhang Peili 张培力 and Mariko Mori. Further along to the right were paintings by Bernard Frize and Lu Fusheng 卢辅山. A second exhibition room on the right, behind these paintings, featured works by Cai Guo-Qiang, Wang Huaiqing 王怀庆 and Lee Ufan. Visible at the far end of the space was an installation by Chen Yanyin 陈妍音, *Discrepancy Between One Idea* 一念之间的差异 (1995).

Three of Marlene Dumas's ink-and-acrylic
paintings on paper. From left: *As the Water
Falls (The Chinese Were Right)*, *Past and
Present Preserved* and *Before and After –
The Revolution* (all 2000).

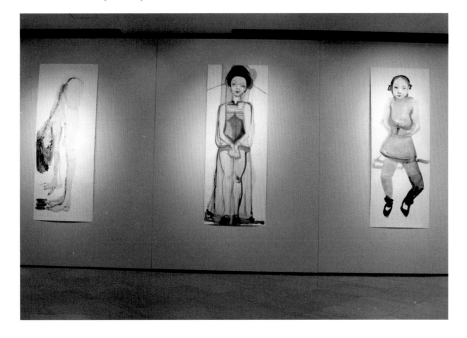

Next spread:
Heri Dono, *Angels Caught on a Trap*.

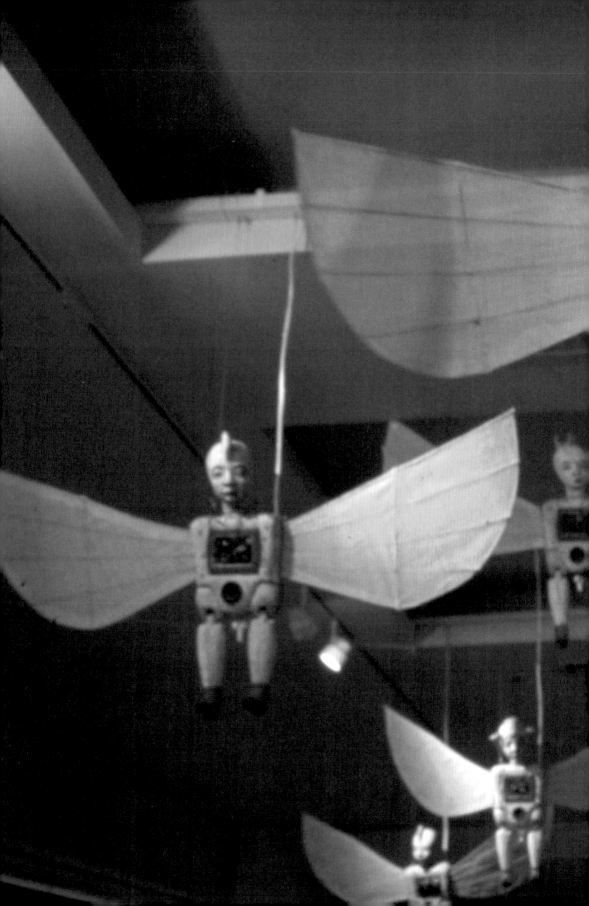

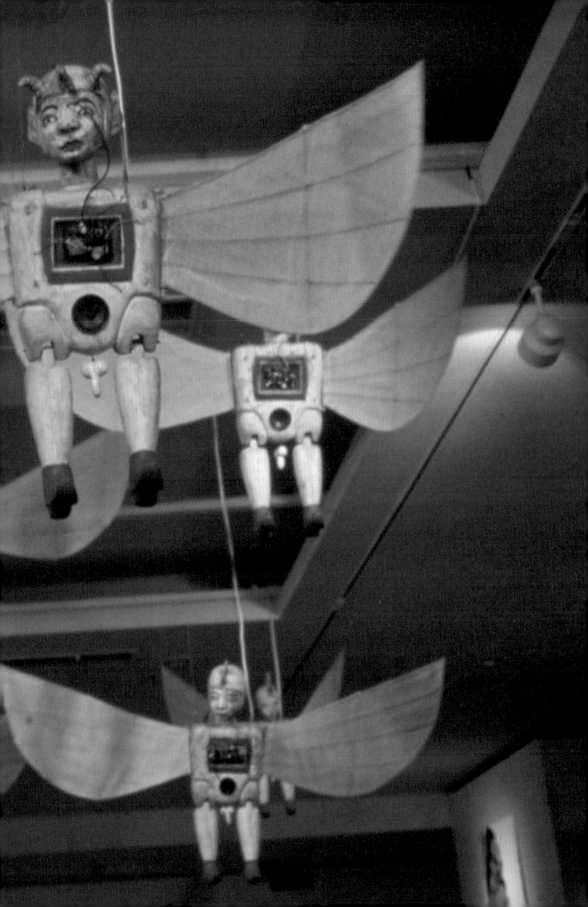

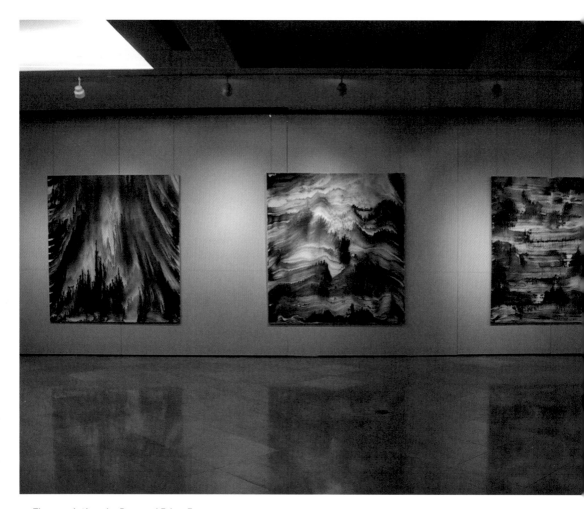

Three paintings by Bernard Frize. From
left: *Rami*, *Gael* and *Emir* (all 1999).

Zhang Peili, *Broadcast at the Same Time*
同时播出 (2000).

Mariko Mori, *Beginning of the End:
Giza, Egypt* (2000).

William Kentridge's animated film
Shadow Procession (1999).

At the far end of the corridor was Chen Yanyin's installation *Discrepancy Between One Idea*.

To the left of Chen Yanyin's work were installations by Shi Hui 施慧 (seen here, *Piao* 飘) and Sarkis, each in a designated room.

Sarkis, *Conversation entre la Domenika et le Vêtement du Chasseur Dozo* (1986–2002).

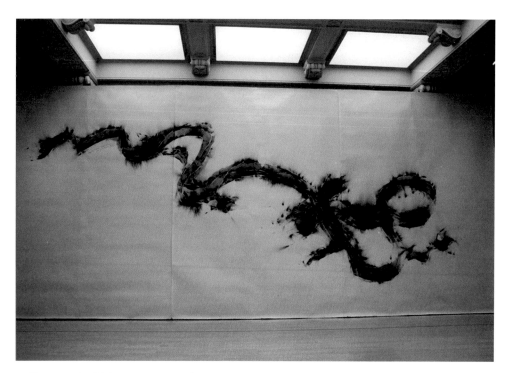

The second exhibition room on the first floor hosted three large-scale works, respectively by Cai Guo-Qiang, Lee Ufan and Wang Huaiqing. Seen here, Cai's gunpowder drawing *Year of the Dragon No.1* 龙年 (2000).

Facing in the other direction from Cai Guo-Qiang's work, Lee Ufan's *Correspondence* (1998, left) and a painting by Wang Hauiqing, *Feet* 足 (2000, right).

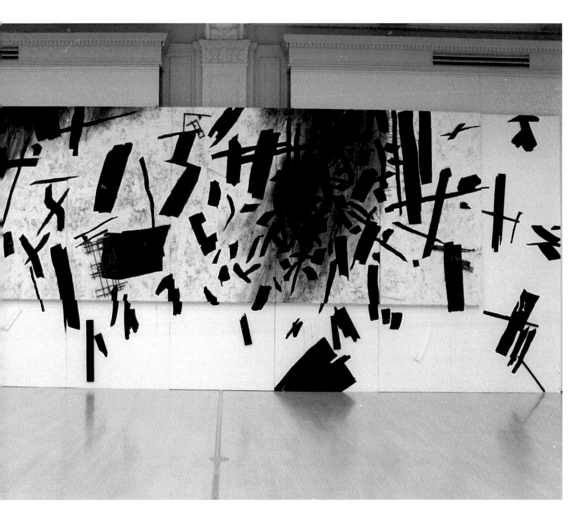

Wang Huaiqing, *Like a Chair* 像似椅子 (2000).

Arriving on the second floor via the north entrance staircase, visitors were greeted by Chinese ink paintings by Chen Peiqiu 陈佩秋 and Chen Ping 陈平. Chen Ping's *Homeland in Dreams* 梦底家山 (1998) appears here to the far right; the adjacent framed series are Chen Peiqiu's landscapes from 1998–99.

159

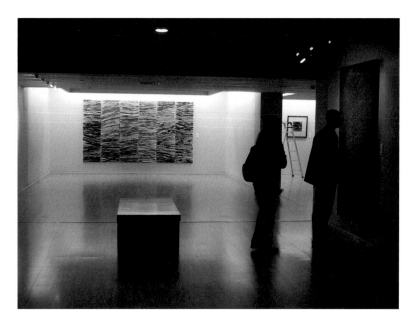

Juxtaposed with Chinese ink paintings were Emily Kame Kngwarreye's oil paintings *Awelye* (1994, back wall) and *Anooralya Awelye* (1995, right).

A long corridor connected a number of spaces on the second floor. Seen here, *They – Recorded for The Future* 她们–留给未来 (2000) by Hai Bo 海波; further along visitors could find installations by Fiona Tan and Ken Lum. Paintings by Wang Yuping 王玉平 are visible in the distance.

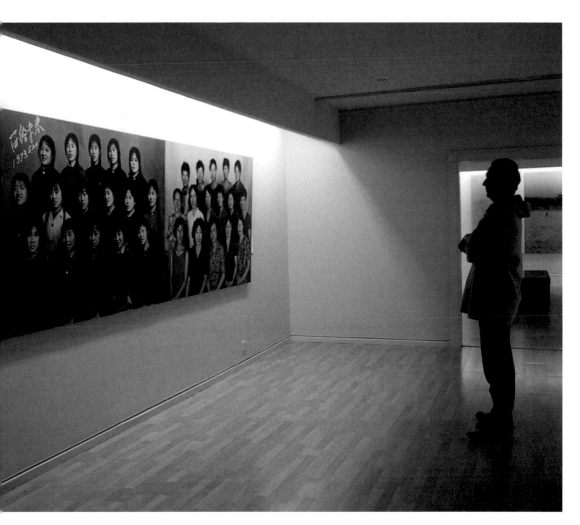

Hai Bo, *They – Recorded for the Future.*

Ken Lum's untitled mirror-and-text
installation stood in the middle of the
second-floor corridor. Two-way mirrors
were installed on one side, reflecting the
text on the other side.

Fiona Tan's *Linnaeus' Flower
Clock* (1998), in a booth.

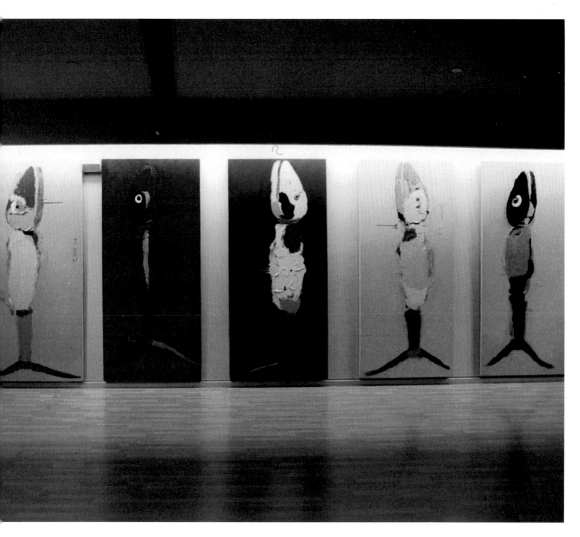

Wang Yuping's painting series *Fish* 鱼 (1999) hung at one end of the corridor.

Lee Bul's video installation *Anthem* (1999)
could be found on the fourth floor.

The view from 456 Nanjing West Road, the former Shanghai Museum. The second part of the biennale was on the second and third floors of this venue. The clock tower shown in this image belongs to the main venue, the Shanghai Art Museum.

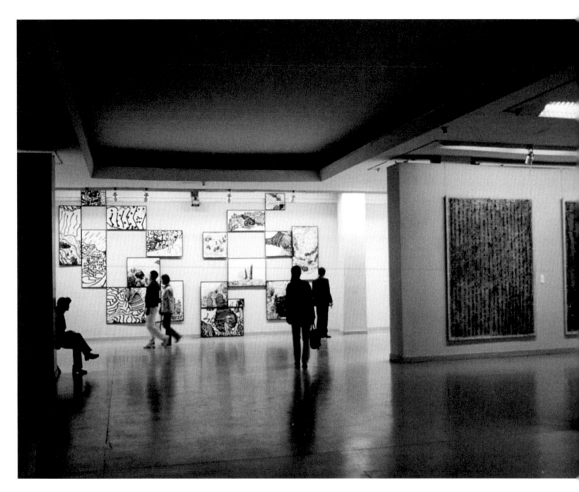

The exhibition hall on the second floor was divided into booths, each hosting a selection of works. Near the entrance was *From Dwelling in the Fuchun Mountains Scroll to Montage* 从富春山居图长卷到蒙太奇 by Zhang Hao 张浩, seen here in the distance. To its right (see facing page) were ink paintings by Li Huasheng 李华生, and in front of them was a booth showing the work of Qu Fengguo 曲丰国 (below).

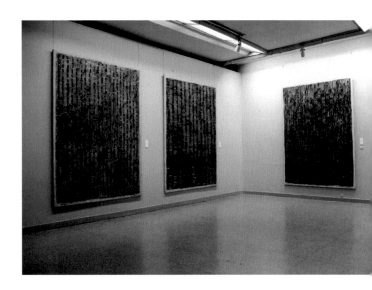

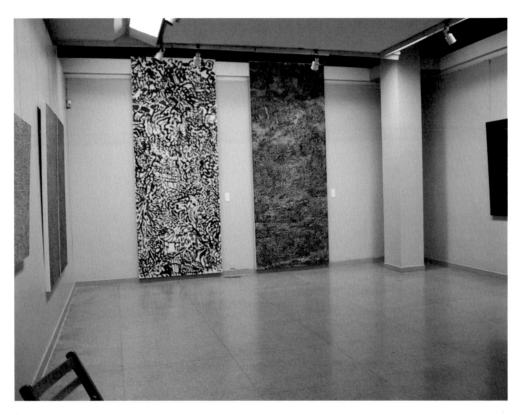

Li Huasheng's ink painting series *99.7–99.10* (1999)
hung next to Zhang Hao's painting installation.

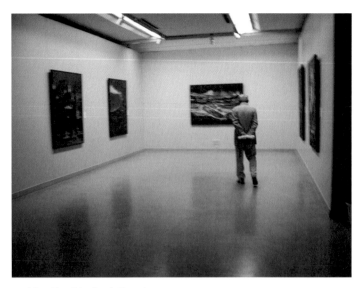

A booth with oil paintings by
Duan Zhengqu 段正渠.

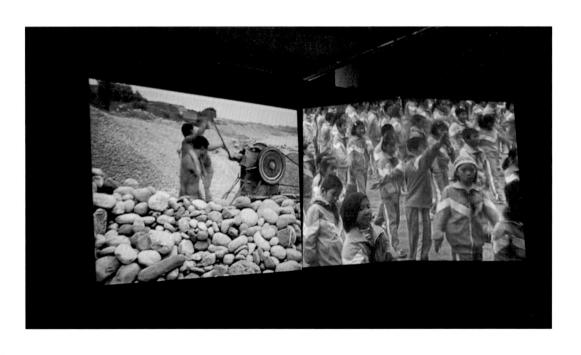

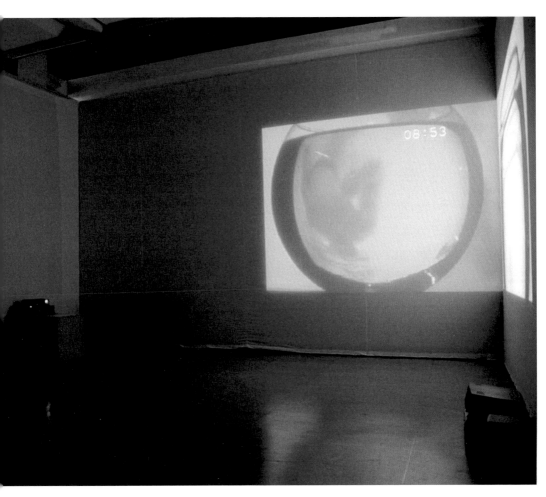

Video installation by Zhao Xiaohu 周啸虎,
Shui Diao Ge Tou 水调歌头 (2000).

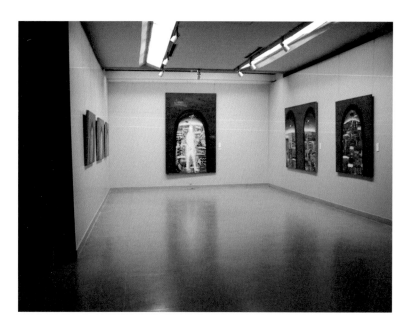

Oil paintings by Fang Shaohua 方少华, including, in the centre on the back wall, 防潮–保护好身体 (which translates as 'Damp Proofing – Protect Your Body', 2000).

Installations by Leung Chi Wo: *Talking Sky* 谈天 and a collaboration with Sara Wong, *City Cookie of Shanghai* 上海城市曲奇 (both 2000).

Near the entrance were installations by
by Liang Shaoji 梁绍基: *Natural Degrees*
自然之度 (1999, above); documentation
from *Natural Degrees* (on the walls
below); and *Babies/Nature Series No. 15*
自然系列 No.15 -- 宝宝 (1999, below right).

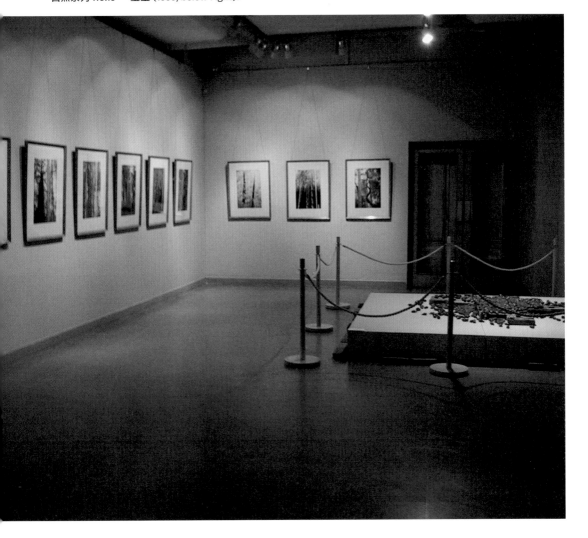

Hall A, on the third floor, was designated as an 'Urban Laboratory' by curator Hou Hanru 侯瀚如. The space was shaped by a series of architectural interventions called *New Shanghai Row House* 新上海长屋, by Yung Ho Chang 张永和, inspired by the spatial layout of traditional Shanghai *linong*. Wooden structures ran across the corridor of Hall A, and the layout of a typical row house floor plan was outlined in vinyl on the floor. The 'Urban Laboratory' display also made use of existing glass-front display cases designed to house ink paintings.

The back of the 'façade' at the entrance of Hall A. Drawings on the floor indicate the two alcoves of a row house's kitchen and bathroom. Works by Aglaia Konrad (left) and Bodys Isek Kingelez (right) are visible through the glass partition.

Architectural drawings of living room furniture.

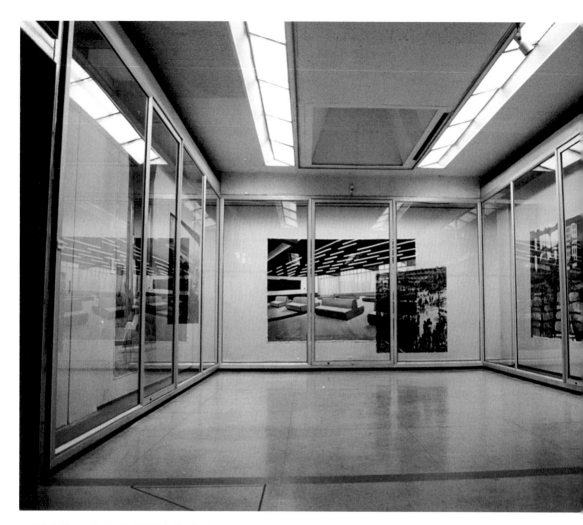

Aglaia Konrad's *Osaka* (1994), in the first
section of the 'Urban Laboratory'.

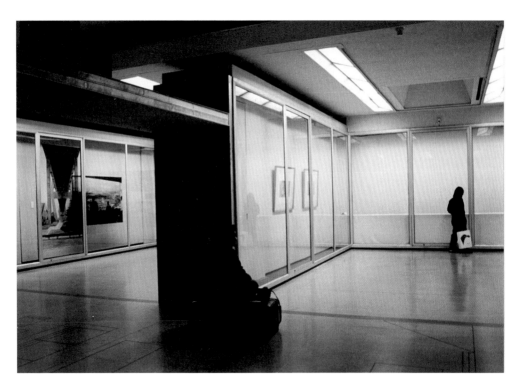

Further along, prints by Hong Hao 洪浩.

Hong Hao, *Selected Scriptures
Page 2123: The New World Physical*
藏经2123页：世界地貌新图 (2000).

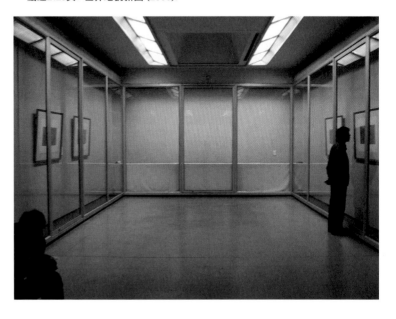

175

Hong Hao, *Go Along the River During
Qingming Festival No.5* 清明上河图之五 (2000).

In the next section of the 'Urban
Laboratory' were photographs
from Philip-Lorca diCorcia's
series *Hong Kong* (1996).

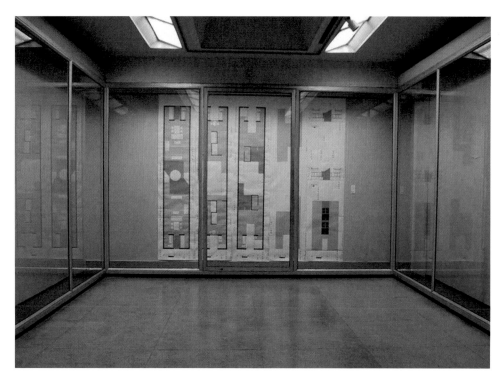

Yung Ho Chang's architectural
drawings of a *xinlinong* house.

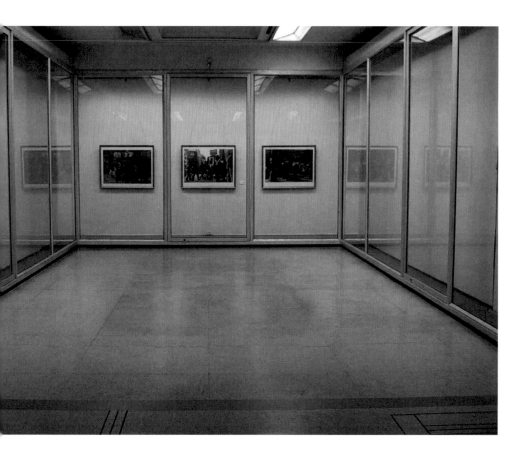

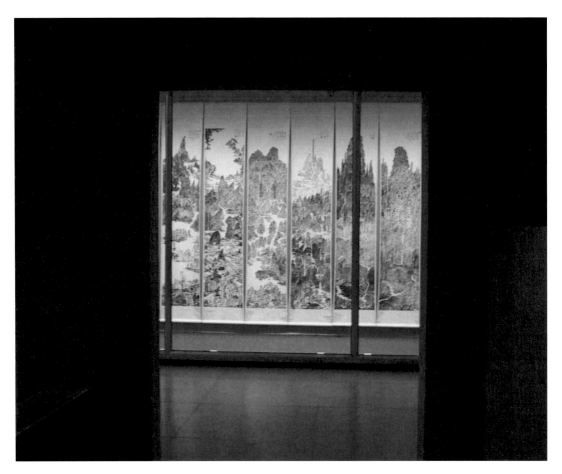

Landscape ink paintings by Yu Peng
于彭 hung at the end of Hall B and were
visible from the final section of 'Urban
Laboratory' in Hall A.

Just outside the 'Urban Laboratory' structure was work by Bodys Isek Kingelez, including *City* (1994–95, left), and by Wang Qiang 王强 (next page).

Wang Qiang's *Floating Forest* 漂浮着的森林 (2000).

At the threshold of Hall
B, coming from Hall A, to
the right of the staircase
were two installations
by Wang Buqing 黄步青.
Seen here, *Picnic, Venice*
野宴 威尼斯 (1999).

180

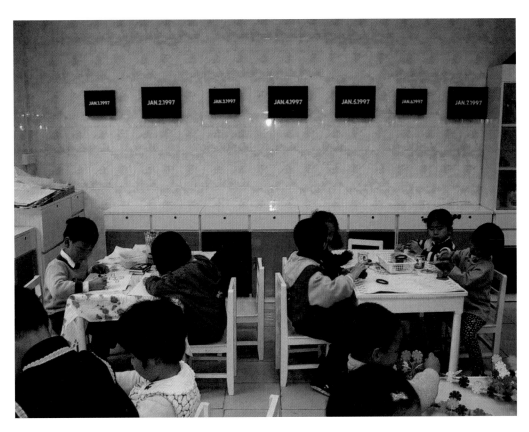

On Kawara's *Pure Consciousness*
(1997) was installed in a kindergarten
in Shanghai, an offsite location that
was not made public to the biennale's
visitors. Teachers and students at the
kindergarten were the work's main
audience.

Fled from Paris, France on 22 October 2000, persued by police for crimes of artistic deseption.

The Copy Statements hereunder are hereby served upon you in connection with the proceedings for the following offences:

The opening events of the biennale also attracted a number of artist interventions that were not part of its official programming. Among these were Chen Qingqing handing out funeral flowers at the opening; Jian Jun Xi and Cai Yuan's performance *Two Artists Arrest Hou Hanru* (above); and Li Wei's *Mirror: November 6 2000* (opposite), which was cut short by museum personnel.

INTERNATIONAL ART CRIMINAL JUSTICE ACT 1987, SECTION 9

'Fuck Off'
不合作方式

不合作方式
FUCK OFF

中国 · 2000 · CHINA

4区

5区　　　　　　6区

1区　　　　　　　2区

3区

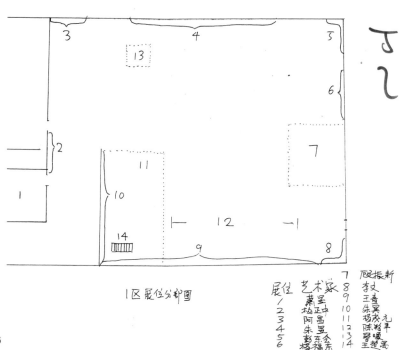

1区展位分部图

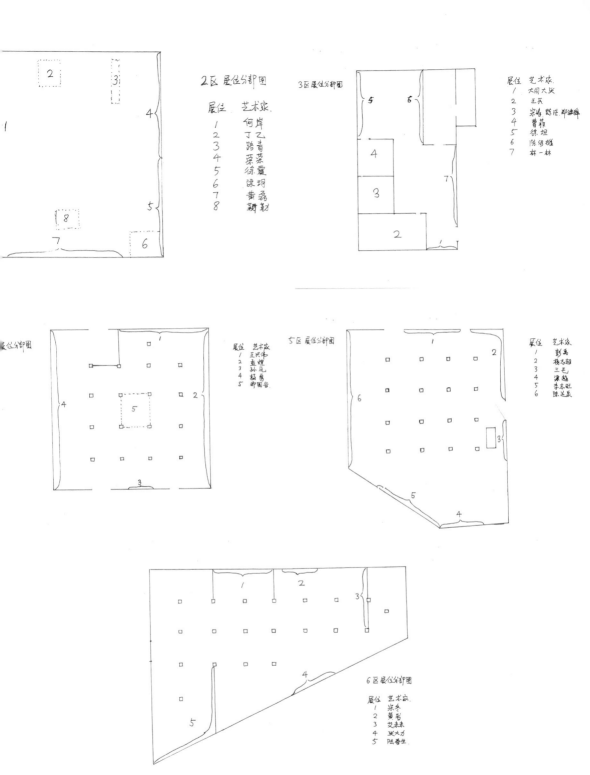

2区 展位分部图

展位	艺术家
1	何岸
2	乙青
3	丁路
4	柔蓉
5	待覆
6	陈玥
7	黄弼
8	鞠勤

3区 展位分部图

展位	艺术家
1	大同大张
2	王天
3	宗鸣 厨房 郑进峰
4	曹恒
5	徐坦
6	陈绍雄
7	林一林

展位分部图

展位	艺术家
1	王兴伟
2	孟煌
3	孙見
4	杨勇
5	郑国谷

5区 展位分部图

展位	艺术家
1	彭禹
2	杨志超
3	三毛 越
4	陈志旺
5	李志宏
6	陈远奥

6区 展位分部图

展位	艺术家
1	宗冬
2	董冉
3	艾未未
4	张大力
5	陆春生

187

'Fuck Off' 不合作方式 took place in a warehouse located on West Suzhou Road, amid old factories and industrial buildings in the suburbs of Shanghai.

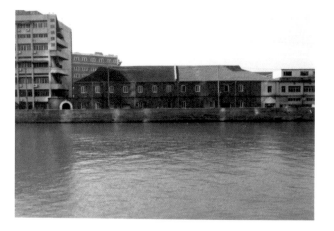

Crowd outside the exhibition venue, by the Suzhou River.

The exhibition space was split over two floors: Eastlink Gallery had recently moved into the warehouse's first-floor space and 'Fuck Off' was the first exhibition it would host; for the purposes of this exhibition the space on the ground floor was also rented out.

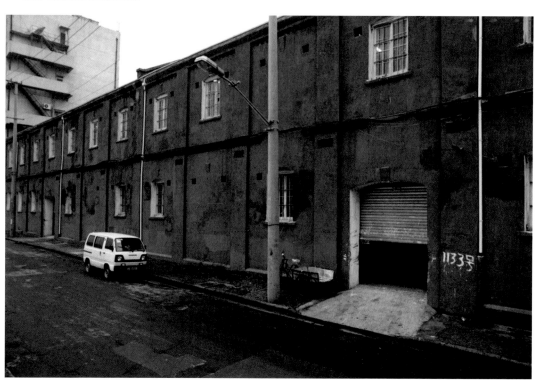

An outdoor performance by Feng Weidong 冯卫东 used wax head sculptures from his installation within the space (see p.197).

Next page:
He Yunchang 何运昌, *Shanghai Water Diary* 上海水记. For this six-hour-long performance, the artist transported ten tonnes of water up the Suzhou River. He collected the water from a location downstream, using a bucket to fill the boat's hold, before travelling upstream and pouring it out again.

Planting Grass 种草, a performance by Yang Zhichao 杨志超, took place on opening night. A doctor implanted grass into the artist's left shoulder without anaesthetic.

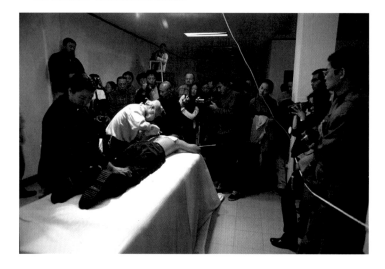

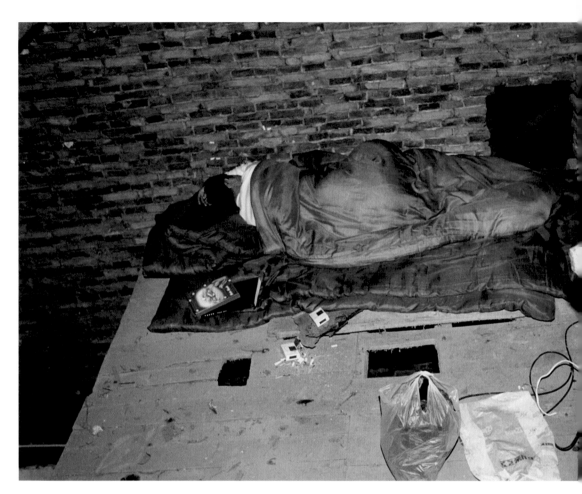

A durational performance by Wang Chuyu 王楚禹 began at 5 p.m. on the opening day and continued until the evening of 8 November. During this period of over a hundred hours, the artist was on hunger strike and slept.

Visitors were greeted by the work of Ai Weiwei 艾未未, Zhang Dali 张大力 and Huang Yan 黄岩 as they entered the warehouse. Visible on the back wall, Ai Weiwei's *Gold Distribution*, a reproduction of a 1949 photograph by Henri Cartier-Bresson, formed part of a larger installation by the artist, titled *F.U.C.K.* (2000). Beside it were pieces by Zhang Dali (on the right wall) and Huang Yan (to the left).

Ai Weiwei's installation *F.U.C.K.* with his
work *Gold Distribution* (right).

Zhang Dali's wall painting and
installation with a video projection
by Wu Ershan 乌尔善.

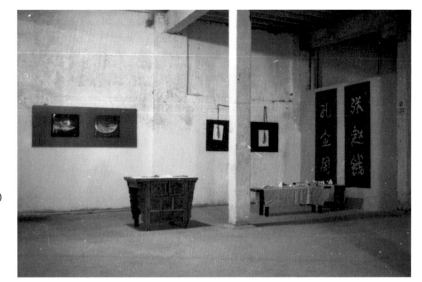

Huang Yan's installation *Flesh Landscape I and II* 肉山水之一和二 (2000) included landscapes painted on bacon and cow bones (see also next spread).

Work by Lu Chunsheng.

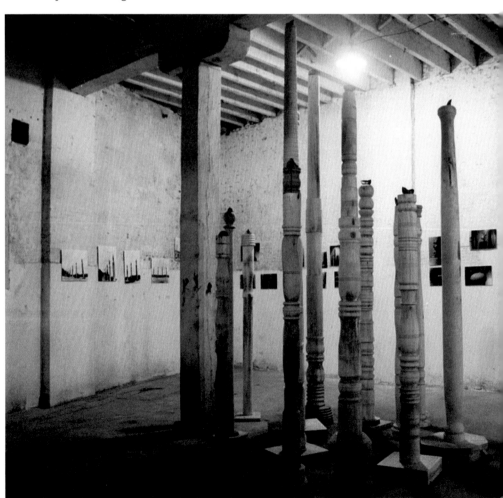

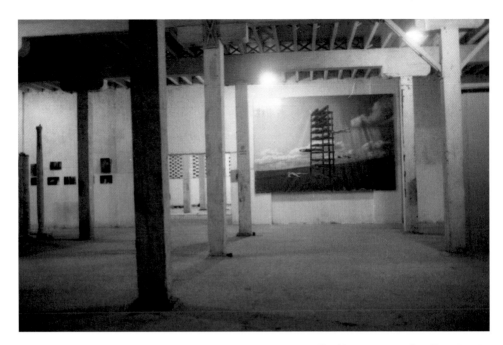

The work of Lin Yilin 林一林 to the right of Lu Chunsheng's.

Feng Weidong, *I Tolerate* 我容 (1999). One of the wax heads from this installation was also used in a performance by the artist (see p.189).

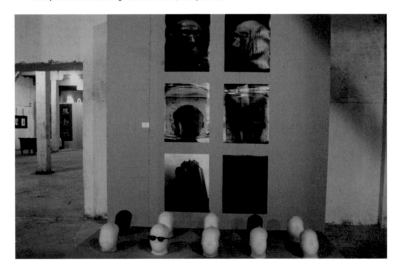

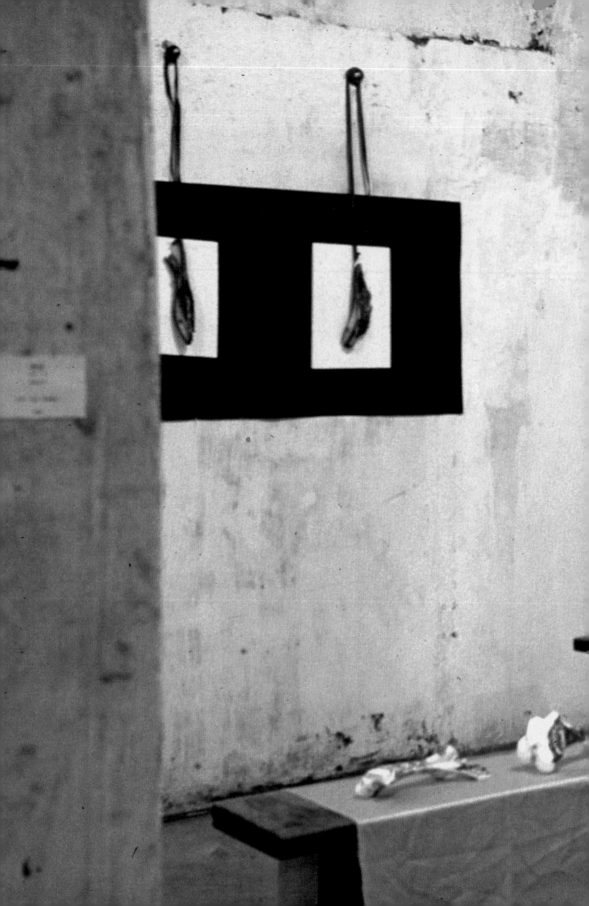

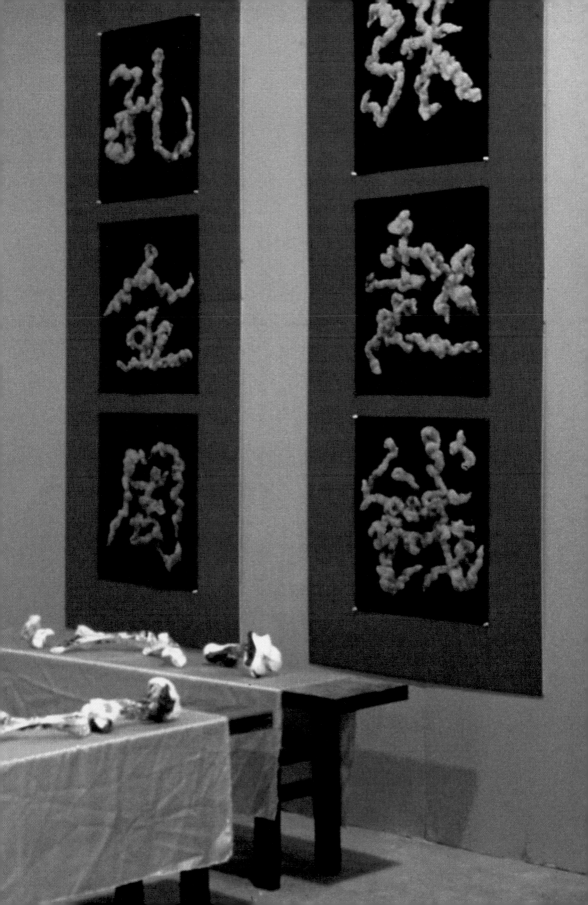

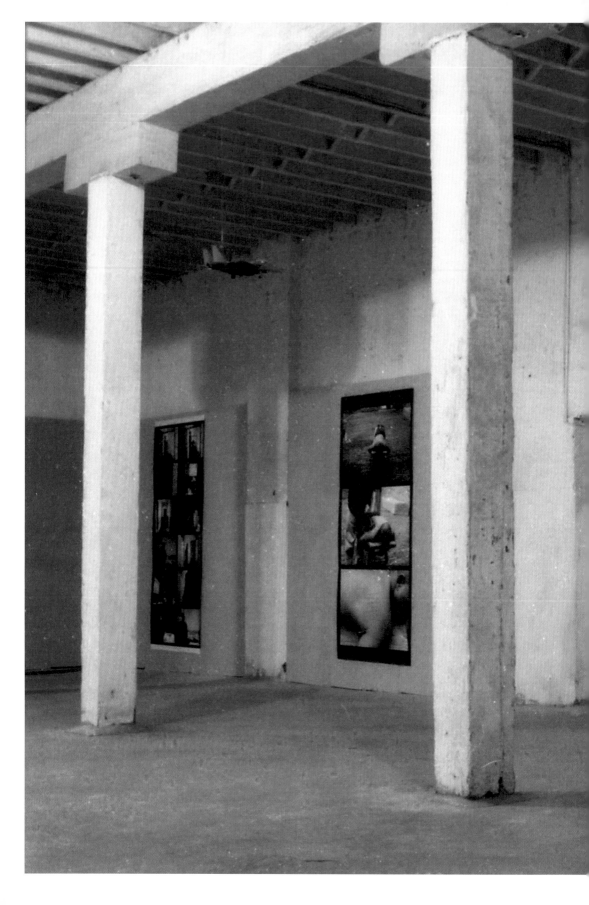

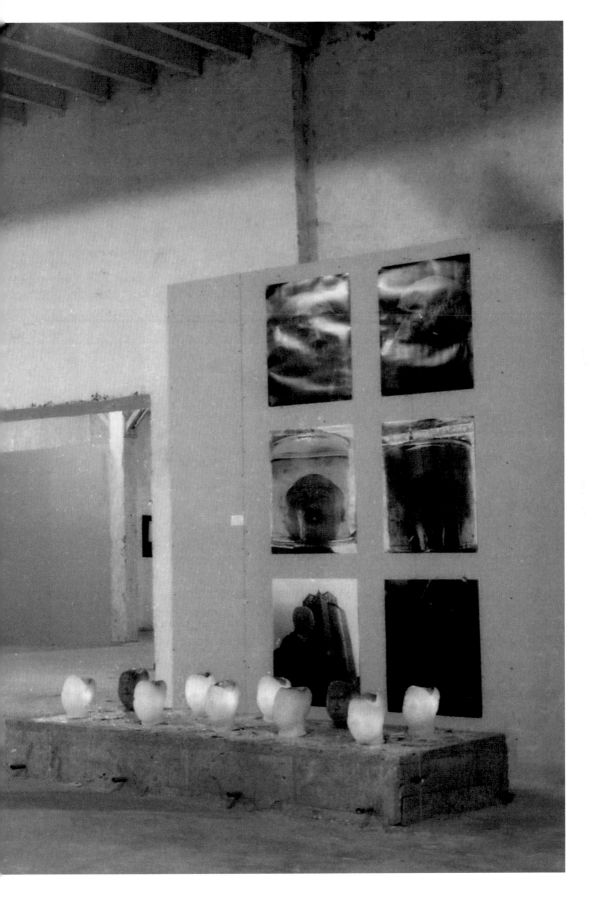

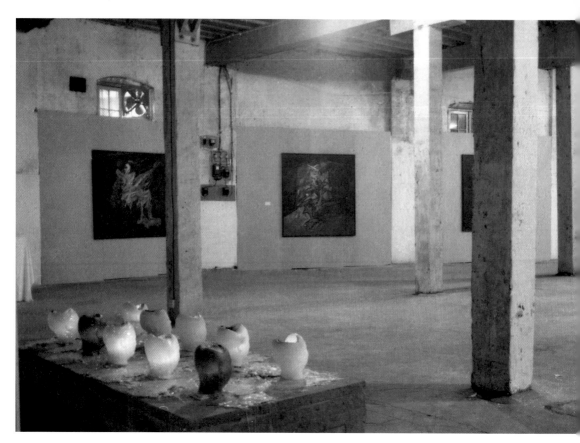

Another large space on the ground floor featured a number of large-scale installations. On the far wall, oil paintings by Li Zhiwang 李志旺.

United Broadcasting 联播 (2000) by Chen Yunquan 陈运泉 filled one wall (see also next spread), with Zheng Guogu's installation *A New Discovery on Geography* 地理学的一大发现 (2000) on the floor in front.

Previous spread:
Photographic documentation of Yang Zhichao's performances hung next to Feng Weidong's installation.

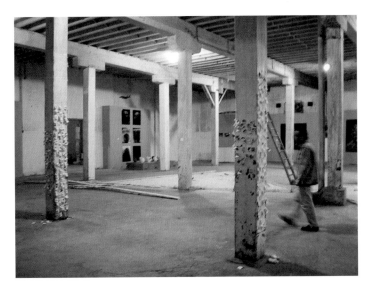

For his work *'Actually, I am also Dim'* 其實我也很模糊 (2000), Xu Zhen 徐震 covered two of the warehouse's columns with approximately one thousand sticky notes printed with fragments of pornographic images found online. A work by Zheng Guogu 郑国谷 lay in the middle of the space, and further on were installations by Feng Weidong 冯卫东 and Lu Chunsheng 卢春生.

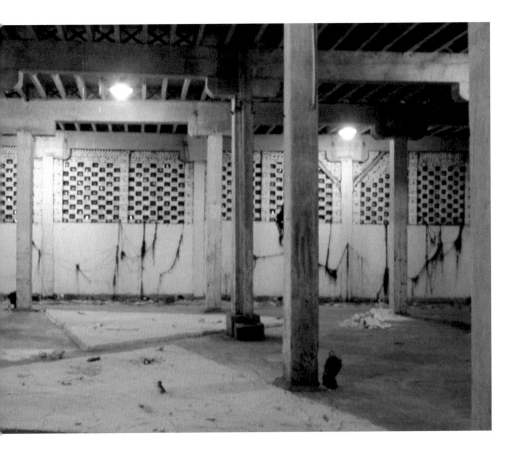

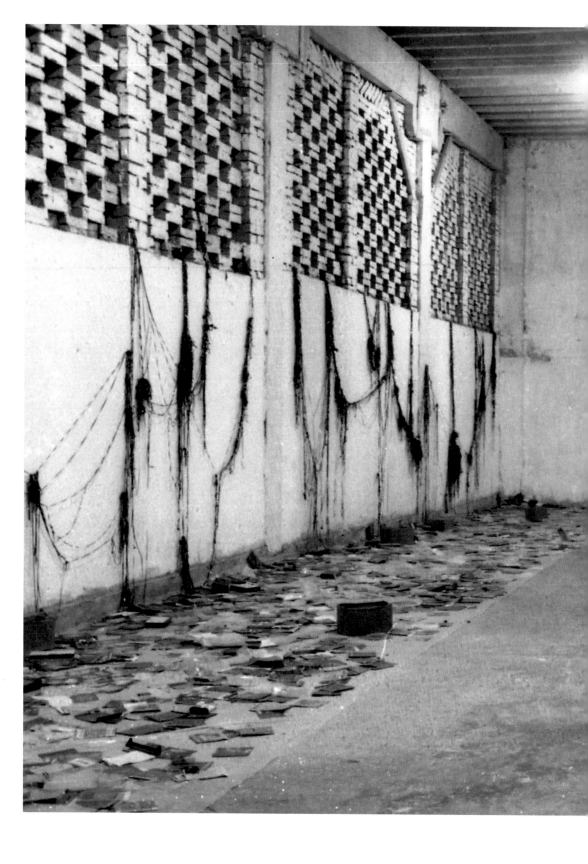

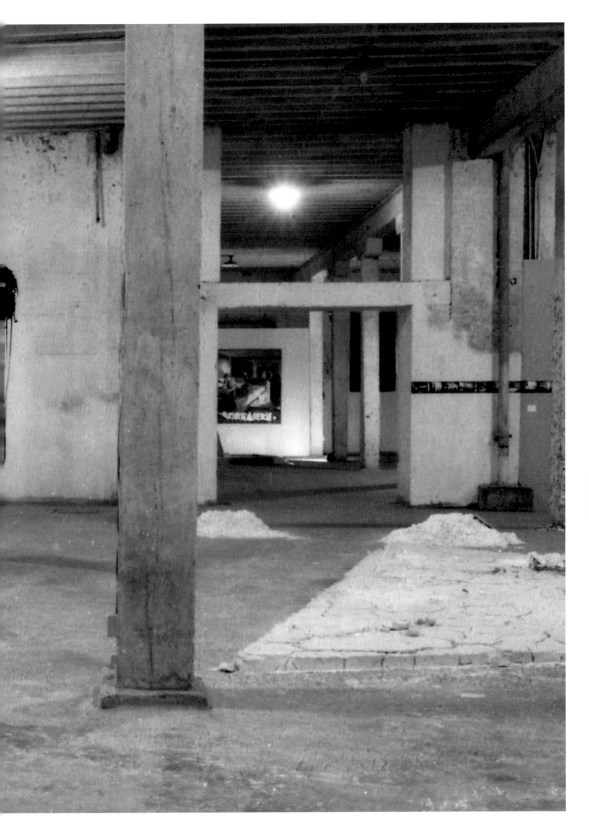

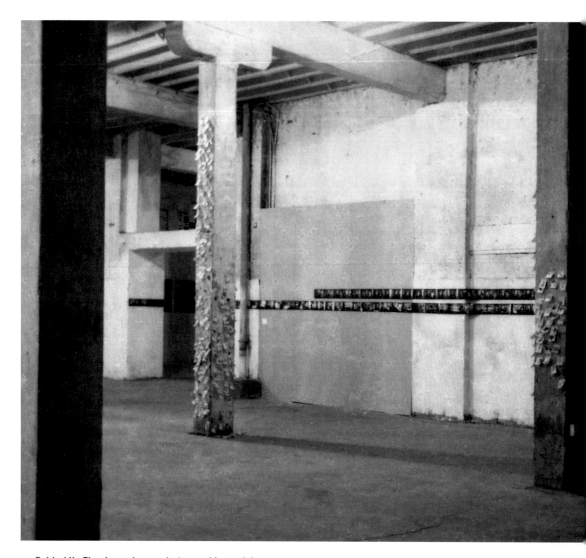

Behind Xu Zhen's work was photographic work by
Li Wen 李文, *Dormitory 2000. 10* 宿舍 *2000. 10* (2000).

A sculpture by Sun Yuan 孙原, *Solitary Animal* 独居动物 (2000), stood in the middle of the next room. The skeleton was coated in barium chloride, a strong poison. Behind it hung photographs by Yang Yong 杨勇, *Diary of Cruel Youth* 青春残酷日记 (1998-2000). On the yellow wall at the right of this image was Wang Xingwei's painting *Life in the void of the decay of capitalism.*

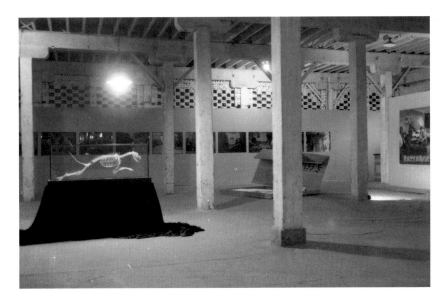

On the opposite wall, a painting
installation with soil by Meng Huang 孟煌:
on the left, *Paradise Lost 38* 失乐园 *38*;
on the right, *Paradise Lost 37* 失乐园 *37*
(both 2000).

Photographic documentation of the work 2000.1.1 去世
(which translates to 'Passed Away') by Zhang Shengquan
张盛泉, known as Datongdazhang 大同大張.

Room with
installation by Ai
Weiwei and Wang
Bing 王冰.

Shenyang Steel Rolling Mill 沈阳软钢厂 (2000), a video installation by Ai Weiwei and Wang Bing.

Installation work by Song Tao 宋涛, Chen Hao 陈浩 and Zheng Jishun 郑继舜.

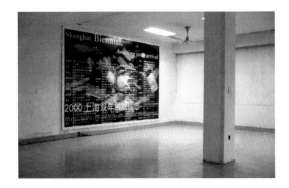

A tongue-in-cheek work by Xu Tan
徐坦, *Web Banner* 网络广告 (2000).

Two works by Chen Shaoxiong 陈绍雄: on
the left, *Streets* 街景 (1999); on the right,
a twelve-minute video work, *Landscape II*
风景2 (1996).

The several rooms of the venue's upper floor, Eastlink Gallery's regular exhibition space, were brighter and more spacious than those below. From left to right: works by Gu Dexin 顾德新, Chen Lingyang 陈羚羊, Wang Yin 王音 and Yang Maoyuan 杨茂源.

Another view of the upper floor, with Chen Lingyang's *Scroll* 卷轴 (1999) in the foreground and Gu Dexin's installation behind it; further along on the right wall was a photograph by Yang Fudong 杨福东; and in the back right corner hung photographs by Peng Donghui 彭东会. On the back wall to the left was a suitcase placed there by Zhu Yu 朱昱, which was rumoured to contain the artist's proposed contribution to the exhibition: a series of subsequently infamous photographs that show the artist eating a human foetus. Ultimately it was decided that this work would not be exhibited in 'Fuck Off' in order to avoid a confrontation with state censors.

Peng Donghui 彭东会, *Are you new, new, new kind of human?* 你是新新新新人类嘛 (1999).

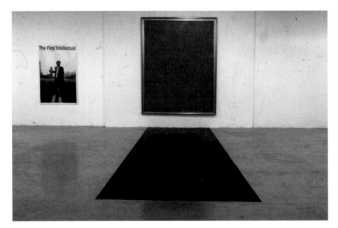

Yang Fudong's *The First Intellectual* 第一个知识分子 (2000, left) and Gu Dexin's installation *November 4, 2000* (2000, right).

Chen Lingyang's *Scroll*, a six-metre-long mixed-media piece centred on a length of tissue paper marked by menstrual blood.

Turning to the other side of the room, behind the scroll by Chen Lingyang was a sculpture by Yang Maoyuan, *Inflated – A Horse* 膨胀－马 (2000), and, on the back wall, documentation of a performance by Zhu Ming 朱冥, *Adding One Meter to An Anonymous Mountain* 为无名山增高一米 (1995). To its right and through the door was an installation by Yang Zhenzhong 杨振中, *What You Can Tolerate Can Not Be Wiped Off By Your Tolerance* 你所忍耐的不能被你的忍耐消除 (1999). Further along, on the right-hand wall, was documentation of performances by He Yunchang 何运昌: *Golden Sunlight* 金色阳光 (1999, left) and *Dialogue with Water* 与水对话 (1999, right).

Yang Maoyuan, *Inflated – A Horse*.

Next spread:
The exhibition continued in a second large room on the upper floor. Seen here on the back walls, photographic works by Huang Yan 黄岩 and Huang Lei 黄磊 (left) and He An 何岸 (right); on the floor, works by Lu Qing 路青 and Jin Le 靳肋.

Work by Qin Ga 琴嘎 hung from
the ceiling.

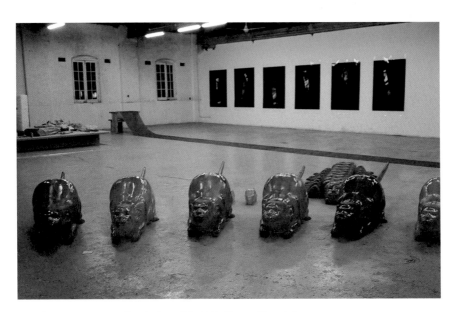

In the same room, a direct view of Jin Le's *Mouse* 鼠 sculptures
(2000). Visible behind them are works by Ding Yi 丁乙 and
Lu Qing; the latter's works extend across the width of the room.
On the back wall appear photographs by Rong Rong 荣荣.

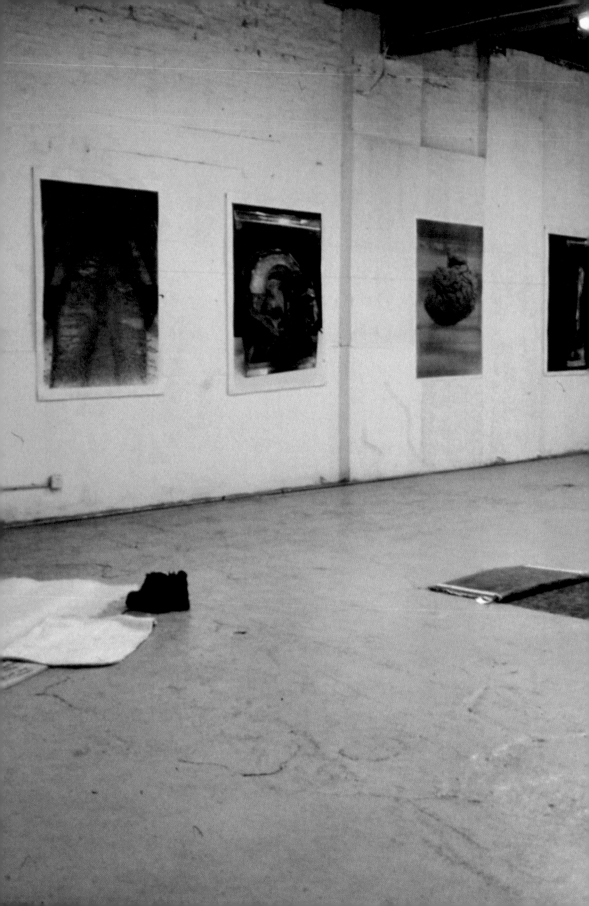

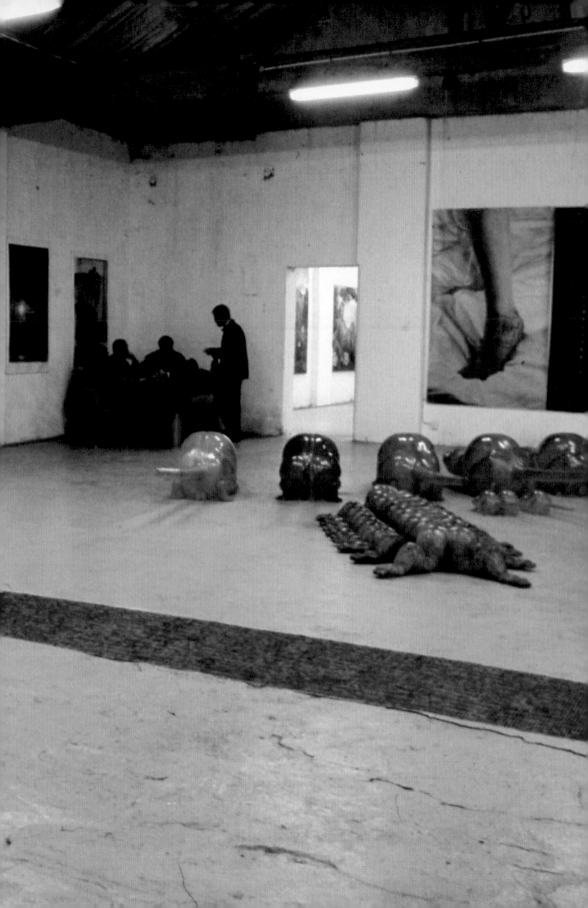

Ding Yi, *A Cube*
一个立方 (2000).

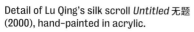

Detail of Lu Qing's silk scroll *Untitled* 无题
(2000), hand-painted in acrylic.

Night-time view of the Suzhou River
from inside the warehouse.

'Useful Life'
有效期

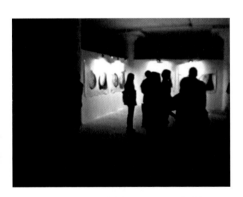

'Useful Life' 有效期 took place in a storage warehouse on Dong Daming Road and featured the work of three artists: Yang Zhenzhong 杨振中, Xu Zhen 徐震 and Yang Fudong 杨福东. Upon entering the space, visitors encountered Yang Zhenzhong's series *On the Pillow* 在枕头上 (2000) on the walls to the left and right.

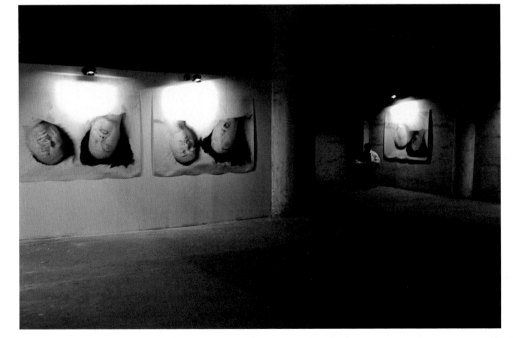

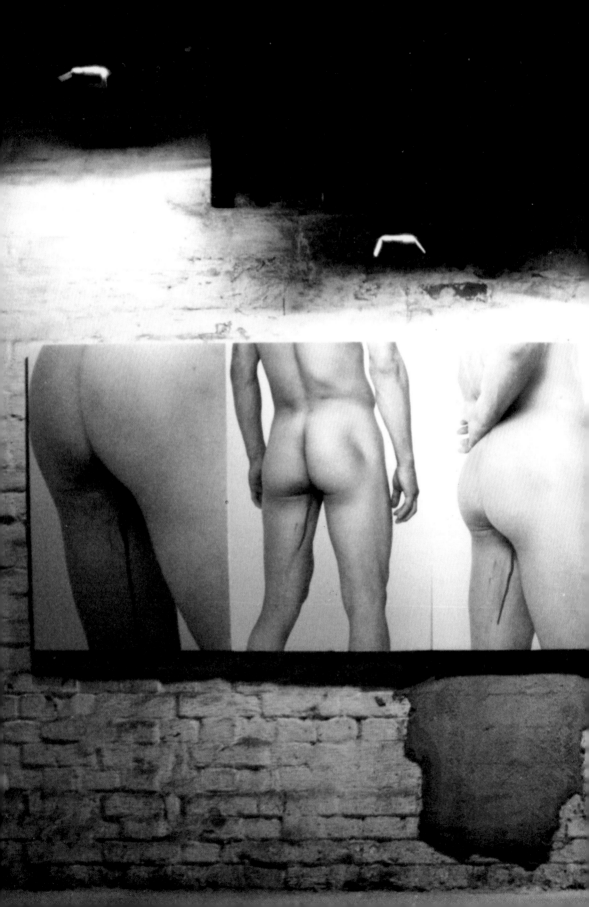

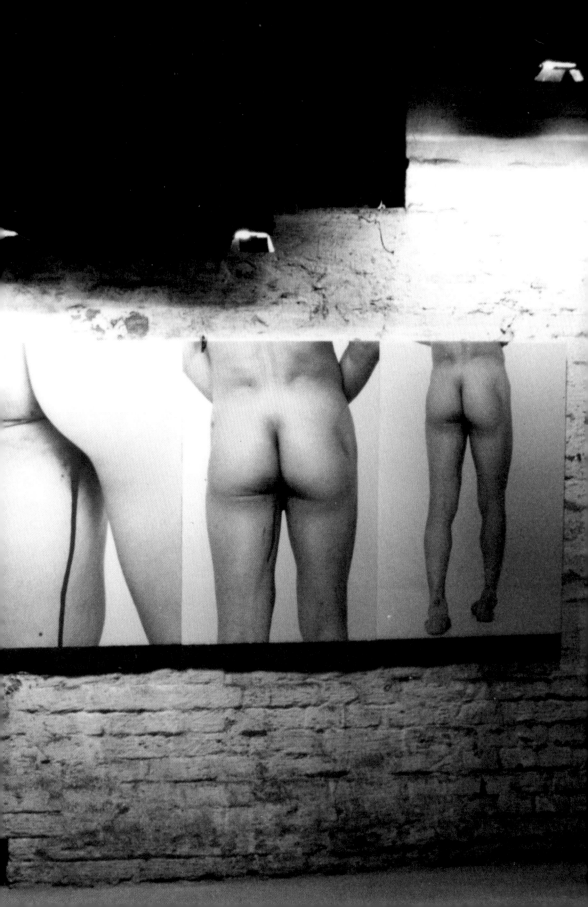

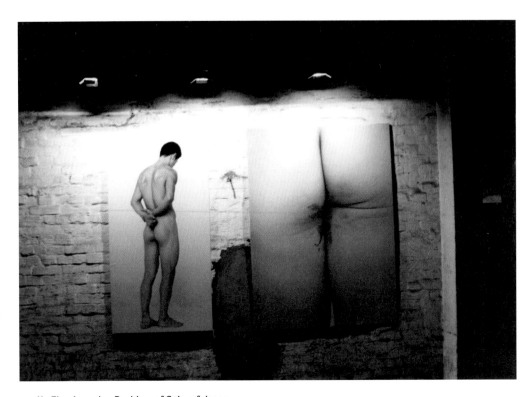

Xu Zhen's series *Problem of Colourfulness*
有颜色的困难 (2000) was displayed along
the length of the wall at the far end of
the room.

On the connecting wall to the right,
leading into a separate space, Yang
Fudong's *Shenjia Alley. Fairy.*
沈家弄 – 小仙人 (2000).

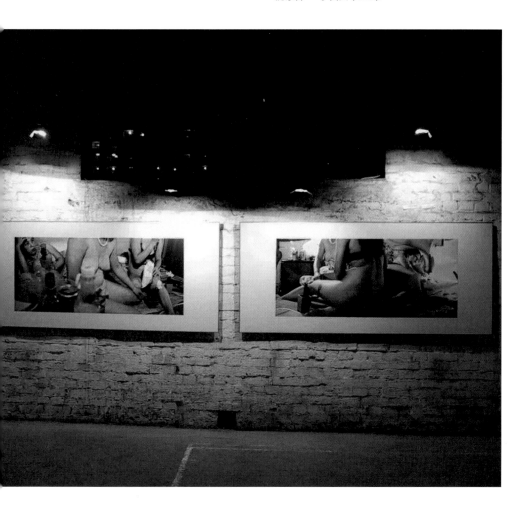

On the same wall as Yang Fudong's *Shenjia Alley* series was another photographic work by the artist, *Forest Diary* 森林日记 (2000).

In an adjacent room, Yang Fudong's video installation *Tonight Moon* 今晚的月亮 (2000).

In the main exhibition space, self-contained rooms were set up to host additional works by Xu Zhen and Yang Zhenzhong.

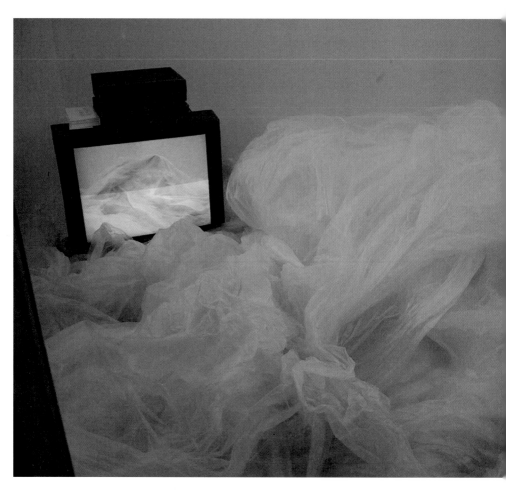

Two rooms hosted a performance-based installation by Xu Zhen, *I'm Changing Here* 我在这里变化, based on the movements of five people under a closed plastic sheet, which were simultaneously recorded by two cameras, one within and one outside of the sheet's enclosure. The performance took place at the opening, when the live audiovisual documentation was projected in a room opposite; the plastic sheet was subsequently left in the space and documentation of the performance shot by the outside camera was shown alongside it, while the other camera's footage, from within the sheet, continued to play in the second room.

Another room showed Yang Zhenzhong's
I Will Die 我会死的 (2000–05), a video work
made up of a succession clips of people
speaking the words 'I will die' directly at
the camera. This was an early version of
the work, which has since been presented
in longer iterations.

USEFUL LIFE
有效期

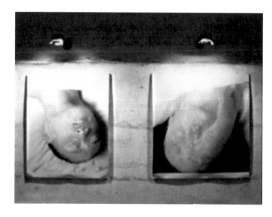

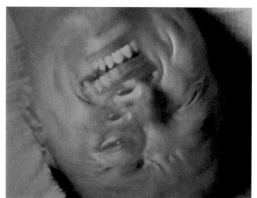

有颜色的困难
摄影
徐震
Xu Zhen
Problem of colorfulness
Photographs

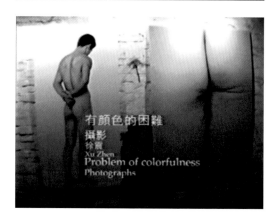

有颜色的困难
摄影
徐震
Xu Zhen
Problem of colorfulness
Photographs

To Select, To Be Selected and Who Selects: The Shanghai Biennale in the Context of Globalisation
— Xu Hong, 2000

pp.134–83

The third Shanghai Biennale (2000) brought forth many issues worthy of our attention. Some of the issues were related to the exhibition, while others had little connection with it but were nonetheless triggered by it. It indeed reflected changes in contemporary Chinese life, and cultural life was an important link in these changes. The issues were at once complex and novel: some were residual problems from history, but of more pressing concern were those having to do with the complicated and subtle relationships between world situations and Chinese questions in the current context.

Emerging from the biennale, the discussion on the relationship between globalisation and Chinese contemporary art appeared genteel but was, in fact, sharply pointed. Apparently centred on culture and art, the discussion reflected, from a certain perspective, the bewilderment and conflictedness of the various interest groups in Chinese society regarding this issue; it therefore deserves our contemplation.

That year's biennale was sponsored by the government and organised by the Shanghai Art Museum. Even though the previous two editions of the biennale had operated exactly the same way, the size of the third biennale and the number of exhibiting artists far exceeded its predecessors. Moreover, beginning that year, the biennale was listed as a regular cultural event in Shanghai, a status not enjoyed by the prior editions.

The first two biennales had confronted issues of domestic Chinese art, such as the historical evolution of types of painting and their cultural transpositions in contemporary contexts; the relationship between contemporary art, social habits of reception and national psychology; the relationship between the dissemination of contemporary art and national ideology; the relationship between the rise of domestic and international art markets, their speculative activities and Chinese contemporary art; and so forth. Out of these concerns, the selection of works to be exhibited at the first two editions of the biennale

236

and the expectations of the associated academic research were predicated on the main themes of the environment and development of Chinese contemporary art, with the hope of deepening relevant discussions. However, these efforts failed to win more approval or generate enough interest. Whether it was the silence or low-key coverage by media outlets, or the polarised attitudes of the more avant-garde or the more traditional within fine arts circles, everything ensued as expected. As publicity organisations, media outlets seemed to be wavering as to how much to cover contemporary art; champions of avant-garde art and guardians of the traditional spirit both held that neither the contents of the selected works nor the modus operandi were adequately 'international' so as to affect the influence that a Chinese biennale was supposed to have; some even went so far as to argue that a Chinese biennale could have Chinese characteristics only if it mirrored the National Fine Arts Exhibition in its grandiosity (the avant-garde's assumption of the biennale's influence was essentially based on how to win the approval of overseas media and curators of major international exhibitions, and they set as their criteria the mode of existing international biennales). For their part, the organisers maintained that as an internationally oriented art project, the biennale was basically in line with the country's economic policy and international publicity strategy, and therefore not in conflict with China's vision to connect with the international community and to participate in the process of globalisation.

However, the state ideology and the national psychology of the public did not agree completely with the set goals of such a major exhibition, for embracing globalisation economically and technologically contradicted the politically and ideologically cautious attitude against it. Taken as common sense, globalisation is an integrated development process, connected to economic modes, political systems and cultural identities, and evolved and completed incrementally. It takes as its fulcrum the technological modernity of the developed countries in Europe and America, and exemplifies a way of viewing and contemplating the whole world. Obviously, China's history and current circumstances are not in accord with such an understanding of globalisation, but China's goals of entering the process and acquiring its own position and interests therefrom are justifiable, for history has proven that contentment with being marginalised and shutting one's doors leads nowhere. Ignoring China's history and present circumstances to fit the needs of globalisation would amount to a denial of Chinese history, not to mention that history has proven that anything inciting confrontational national sentiments would only lead to even more intense resistance and destructiveness. Chinese history of the past hundred years or so could illustrate this point very well. It follows, then, that the most pressing and thorny issue in China now is how to grapple with the dialectic of going global and keeping its distinct national character.

With no ready examples to follow, one could only 'cross the river by feeling the stones': doing things based on vague senses, shifting right when one feels far too left and vice versa. Furthermore, as a government-controlled organisation, the fine arts museum is tasked with researching and exhibiting the artistic imagination and creativity of the Chinese people. It has an indirect relationship to politics and the economy at best; more often it engages in spe-

cific historical research into the discipline of the stylistic evolution of the fine arts. Such research cannot be isolated from the entanglement of the nation's historical changes and current environment, nor be divorced from the conflict between national heritage and foreign culture. These conditions highlight the geographical and national limits of such research projects, which render their relationship with globalisation fickle and complicated, if not full of contradictions. In many cases, extant cultural strategies of globalisation have translated into powerful forces regurgitating or 'rewriting' weaker ones, or into the underprivileged slowing down their own processes or modifying their original goals to resist the powerful. More often we have seen encroachment on the development of culture and art in the Third World. From this perspective, the set goal of the Shanghai Biennale – to connect with the international community – indeed contained an unresolving contradiction, which was the main reason why a subtle and complex situation arose.

On the whole, the third Shanghai Biennale underwent both formal and substantive changes. In order to conform to the common practice of curating international biennales, the erstwhile group-decision-making process was replaced with one where domestic and international curators planned the show and selected the artists and their works. In actuality, project managers at the Shanghai Art Museum collaborated with some painters in Shanghai and Zhejiang to determine who and what works to select, including the selection of curators (no matter the motives or reasons); they also suggested modifications to make the selected works suitable for exhibition in China. What should be affirmed here is that the Shanghai Biennale had a strong and obvious desire to come closer to international criteria. It was manifestly written into the central principle of the first Shanghai Biennale that 'after explorations and accumulation of experience at the first two editions, the Shanghai Biennale is to become a major international exhibition in 2000', so that Shanghai could 'come closer to international common practices and scales', and 'gradually change the situation where Chinese fine arts, despite being from a major fine arts country and having extensive fine arts aficionados and a great number of fine arts geniuses, are in a position of being marginalised and selected at international exhibitions'. Holding China's own major international exhibition to reverse the aforementioned situation serves to prove that the development model of globalisation cannot replace the process of modernisation for Chinese culture and the arts. What was worth noting, however, was that because international curators were invited to events at the third Shanghai Biennale, Chinese avant-garde artists converged on Shanghai in the semi-open exhibition. This was unprecedented in the history of not just the Shanghai Biennale but also of all major exhibitions in China. It appeared that the change in curating policy led the biennale towards 'international common practice'; as international curators became the most notable markers of this edition of the biennale, they selected and introduced artists to the show, which in turn attracted the interest of even more international curators, thereby creating opportunities for more Chinese contemporary artworks to be selected for major international exhibitions. It was these factors that turned out to be the main reason why Chinese avant-garde artists and other people were interested in and paid attention to this edition of the Shanghai Biennale.

Most surprisingly, mainstream media outlets changed their cold and numb attitudes and enthusiastically praised the biennale, a phenomenon rarely seen in the news media, which had taken it upon itself to criticise 'contemporary painting exhibitions organised by the fine arts community' for 'not being accepted by the public'. Up to that point, mainstream media had played the role of 'the representative for the masses', but now it was rooting for such 'inaccessible' art, touting it as 'So vibrant! So amazing ...' In a survey of 176 viewers conducted by the Shanghai Art Museum, 102, or 58 per cent, said that they 'liked this exhibition'; 60, or 34.1 per cent, thought it was 'so-so'; 5, or 2.8 per cent, said it was 'no good'; and 9, or 5.1 per cent, said 'whatever'. Some Shanghai critics made inquiries into young audiences' responses to the exhibited works, and concluded that the exhibition was fresh, 'fun, interesting', and 'easy to make sense of, accessible'. (The survey method was an entirely different topic.) Did all these reactions point to the public's and the media's embrace of a cultural 'coming closer to international standards'? In other words, is Shanghai better than other cities in accepting and digesting everything foreign, in line with how the organisers easily glossed over the thematic phrases of the 'Shanghai Spirit' and 'A Special Modernity'? Or did the media and the public simply equate the biennale to anything with an 'international' label, such as international art festivals, international film festivals, international fashion festivals and international food festivals, and take it to mean that China was in the process of entering the world community and coming closer to international criteria? In fact, if one walked around Shanghai, one could easily find eye-catching advertisements for 'saying goodbye to a merely comfortable life and moving towards a wealthy one'. In a context of media amplification and the city's rapid development, the average Shanghai resident entertained an illusion of 'internationalisation', wherein people thought 'coming closer to international standards' meant 'living life as Westerners do' and 'being wealthy'. 'Coming closer to international standards' was thus made out to be a virtual prospect expected by the public, who had ceased to consider the problems involved.

In contrast to the enthusiastic response from the media and the public, some critics voiced their worries and cautions in a move away from previous avant-garde exhibitions where the public had complained of inaccessibility, the media had lampooned the artists and critics had to help the artists in explaining themselves. This development vividly showed that reality had changed.

Judging from the overall face of the works at the third Shanghai Biennale, the tendency to select from international art by mainstream Western art criteria was unavoidable. It was reflected in the selection criteria by the overseas Chinese and Japanese curators. They not only selected overseas artists whose works had been frequently exhibited at various major international shows, but also complied with a postcolonialist cultural criterion in selecting works by Third World artists, i.e., they assumed that except for ideologies and folk customs, the Third World had no real art to offer (nothing of art historical value). Admittedly, their status as overseas curators determined that they could not break the rules of the game; they could only operate within the boundaries of Western discourse. This attitude and its attendant selection criteria also

influenced the Chinese organisers' thinking. The plans from overseas curators had been mildly resisted and modified by a group of painters assembled by the Shanghai Art Museum, and some works that obviously would not be tolerated in China had been adjusted; but the judgment and selection on the part of Shanghai were only made on the basis of the list of works provided by the curators, rather than on the basis of advance research and understanding by the local Shanghai team. As is well known, even today, no fine arts museum in China has the wherewithal to roam the world and network amongst major shows and galleries as overseas curators can.

The foreign curators made proactive suggestions to the shortlist of domestic Chinese artists, but eventually deferred to the organisers for the final list. It should be noted that the selection of domestic artists had to take into consideration the finalised essential orientation of foreign art both in the substance and style of the works and in the actual effect of the exhibition. Therefore, it could not be guaranteed that 'Chinese art was to be selected by the Chinese'. As a result, the exhibition was quite tendentious, even if some foreign works had to be modified with great difficulty to suit Chinese circumstances. Some artists, after hearing that the theme of the exhibition was 'Shanghai', changed their artistic preferences, or simply chose not to enter their most representative works, citing challenges of transportation or of other sorts. But these artists enjoyed established 'international status', and whatever the case, they represented 'Western discourse'. Accordingly, it was easily imaginable how many of the Chinese works selected for the exhibition were immune to the influence of this 'international discourse'. No matter the works by the various generations of Chinese painters which aimed to highlight national cultural characteristics, or some conceptual and installation works which had obvious traces of imitation, all seemed to issue the call that 'we have what others have; we also have what others haven't'. But in the midst of Western works exuding originality and creativity, these Chinese works became the background, for however one regarded contemporary Chinese artworks, one could always see the powerful shadows of Western art. When it was very clear which way the entire context leaned, it was obvious who had selected whom. Our organisers did not realise that while they were selecting others, they themselves were being selected. It was probably an unintended outcome of the biennale that the exhibition set out to change the fate of being selected for Chinese art, but ended up having to comply with the will of 'the selected'.

The organisers did not seem to want to make a choice between globalisation and national characteristics. Judging from the structure of the exhibition, with equal proportions of international and domestic works, we can sense that the organisers went to extreme lengths to cope with the issue; but in the absence of a clear-cut cultural proposition, they could do no better than alternating between overdoing it or underdoing it, trying to keep a delicate balance. On the one hand, the pledge made at the first Shanghai Biennale had yet to be realised, which demanded sufficient modernity and international attention so that the Shanghai Art Museum, afraid to leave an impression of regression and conservatism, could maintain the 'biennale effect'. On the other, the museum had to rise to the pressure from domestic fine arts circles,

for the original intention of the biennale was to stop Chinese contemporary art from being merely selected and to fight for the rightful artistic place China deserved on the international scene. Otherwise, there would be no need for a Shanghai Biennale when there existed so many biennales already.

As an establishment with a mission to collect and exhibit contemporary artworks, the fine arts museum is supposed to highlight the creativity of Chinese artists, and to have the vision to discover the artists and artworks that can influence and represent the development of Chinese art. If not, how can it be expected to select artists and artworks with international influence? It was the duty of the fine arts museum as well as the justification for the biennale to nurture Chinese contemporary art. To fulfill that duty, the fine arts museum must understand and play along with today's globalisation trends. The problems with the Shanghai Biennale exposed the lack of (adequate) consideration of precisely this challenge on the part of the organisers and curators. I should clarify that it was inevitable that the third Shanghai Biennale was unable to make the selections it should have. The entire cultural domain in China at present has difficulty making selections. Confronted with waves of globalisation, most people in fine arts circles are either shouting slogans or suffering aphasia. The slogan shouters insist on 'national characteristics' and 'locale', unconditionally stressing a strategy of nationalism: one extreme claims that everything Chinese is good, even the country's ugly history, while the other extreme is happy to pay whatever price to be recognised by the 'international community' and to 'come closer to international standards'.

These strategies look like choices and selections, but in essence they are an abandonment thereof. The acts of thinking and choosing in the face of globalisation are forever in flux, with no eternal answers. And despite its origins in Western Europe and North America, globalisation is supposed to be a process involving multiple nations and cultures. Such common development certainly has conditions, one of which is the specific vitality of specific national cultures.

Inability to select invariably leads to being selected, for China can no longer bask in the pleasure of closing its doors and daydreaming about being a superpower, not even in culture and art. China, like other countries, participates in the process of globalisation with its own identity and its own role to play. It should take an active part in the process, to actively protect and develop its own national culture. It is a question and a choice not faced by China alone. True globalisation is not cultural homogeneity. True participation requires that one 'choose to do certain things' and, at the same time, that one 'choose not to do certain things'. We must have the desire and take actions to update and improve the rules of the game of globalisation.

Translated by Zhao Han.

From Niuzhuang Village to BizArt
— Zhou Zixi, 2004

Niuzhuang Village began as a joke.

pp.32–33

It doesn't make much sense to discuss the joke now, for most of the villagers and cadres there have dissipated into the crowds. Only a few people continue to fight, led by the 'director of the women's federation', Xu Zhen 徐震. Writing an article with a given theme of BizArt, I can't help but recall the once prosperous village.

Niuzhuang Village is located in the western suburbs of Shanghai. Perhaps it was always meant to be nothing more than a distribution centre for young artists, all the more so in the beginning. To put it bluntly, comrade Xu Zhen's arrival brought passion and vitality to this village – more precisely, he rekindled the declining passion and vitality there. This was a young man yet to experience the blows of life, a child still unafraid of making a scene. He revitalised the dreams and yearnings of the group. On a fresh and exciting afternoon, Niuzhuang emerged from a joke. It was back in 1997.

In 2003, I worked for the newspaper *Dongfang Zaobao* 东方早报 (Oriental Daily). Jia Bu 贾布, my small but capable female boss, introduced me to someone saying, 'He's an artist, too.' Before I could deny this with embarrassment, that person followed, 'Oh, from the painters' village in Pudong?'

'No', Jia Bu curled her lips. 'Far from it. He belongs in the same gang as Yang Fudong 杨福东 and Xu Zhen. Way accomplished.'

Accomplishment only came later. Back in 1997, celebrity status was not something that people in Niuzhuang were bold enough to dream about – perhaps with the single exception of Xu Zhen, who'd always say, 'We'll make it.' He was full of confidence, which, along with other people's timidity, did nothing to affect the vitality of Niuzhuang. It was still an age of ideals and joy. Besides creating art, they were concerned with how to change the art ecology in Shanghai.

Only after 2000 did avant-garde art become a hot topic. In 1997, it was merely an abandoned child noticed by none and oppressed by all. All that the people of Niuzhuang could hope for was: no complaints, no illusions, no waiting

around. The first thing they thought they could do was to give lectures on avant-garde art on university campuses, where they could cultivate an incipient viewership. Although they carried out the work in 1997–98, they didn't keep it up, because very soon they got busy.

When passion has been incubated, incited, accumulated and mobilised, it awaits a release. Consequently, the idea of an exhibition was brought up again.

In early 1998, Xu Zhen introduced Yang Zhenzhong 杨振中 here, who in turn brought Alexander Brandt 飞苹果, to gradually form a passionate and efficient team. The first exhibition curated by this team perhaps meant more to the individuals. Here, they put to practice the 'norms' they had yearned for and discussed for a long time: unreserved, candid discussions and debates on the direction and details of the exhibition; eligibility reviews of the selected works and not of the artists; an attitude that aimed to separate personal feelings and biases from the eligibility review process; direct criticism and suggestions for works by artists; a habit of sharing the exhibition cost and workload. In addition, what left a deep impression on people – at least on me – was the harsh rigour towards the artworks. Presented to the public, all these factors combined distinguished this exhibition from all previous ones held in Shanghai.

To be sure, the attention that the exhibition drew owed much to the needs of the avant-garde circle in Shanghai, which had been dormant for quite some time. It needed young people, their passion and courage. The exhibition presented a batch of new faces: the main curators Alexander Brandt, Yang Zhenzhong and Xu Zhen; other people in Niuzhuang, including Old Cat 老猫 (Wu Jianxin 吴建新), Gu Lei 顾磊 and Ni Jun 倪俊, who had close connections with Niuzhuang; and even artists who had little to do with Niuzhuang, such as Cai Wenyang 蔡文羊, Jiang Chongwu 蒋崇无 and Hu Jianping 胡建平.

From this list we can identify that Hu Jianping was a veteran artist; so was Yang Zhenzhong, although he could be considered a newcomer to Shanghai; despite their young age, Old Cat, Gu Lei, Jiang Chongwu and Cai Wenyang had been in circulation in Shanghai; the truly green ones were Xu Zhen, Alexander Brandt and Ni Jun. All three had made extremely successful debuts, especially Xu Zhen and Ni Jun. Earlier, Xu Zhen had created works that would later receive extensive attention, such as *Rainbow* 彩虹 and *Shouting* 喊. These works had all been completed with the help of his friends, and it should be noted that the help was not limited to technical assistance, but included beneficial suggestions and debates. Similar things happened with Ni Jun's work *Gift* 礼物, which would go on to win waves of accolades. In fact, such help developed into habit, and has been preserved within the loose yet expanding circle.

The exhibition, which had to rely on itself for its venue and management, ultimately derived its title from the site, a commercial housing complex for sale: '310 Jinyuan Road' 晋元路 310 号.

pp.46−47

It was a happy beginning, as more enthusiam mobilised. And the few of them started to discuss a bigger and more ambitious project, which would be the subsequent 'Art for Sale' 超市.

'310 Jinyuan Road' impacted more than those involved. In Niuzhuang, more passion was waiting to burn. In Shanghai, a new enthusiasm was awakening. The city undergoing rapid economic development was ready for her artistic rise.

The rise undoubtedly began with the exhibition 'Art for Sale', in March 1999. Deemed the most important exhibition of the decade in Shanghai, it brought even more emerging artists into the spotlight, including Shanghai's Yang Fudong and Liang Yue 梁玥; Hangzhou's Chen Xiaoyun 陈晓云 and Xiang Liqing 向利庆; and Beijing's Liu Wei 刘炜, Zhu Yu 朱昱 and Kan Xuan 阚萱.

Yang Fudong had lived briefly in Niuzhuang, in the second half of 1997, and had left some very happy memories with the people there. Around the time of '310 Jinyuan Road', in 1998, he came to work in Shanghai. Later the same year, he married a Shanghai woman and settled down in the city.

'Art for Sale' has been reviewed too many times for me to say anything refreshing about it. Today nobody questions the significance of the exhibition, but at the time, Shanghai's *Xinmin Wanbao* 新民晚报 (Xinmin Evening News) criticised it fiercely. Such a story is certainly not surprising in art history.

1999 was an important year for Shanghai, for it was the point when contemporary art turned from dormancy to 'prosperity'. Surely this wasn't embodied in 'Art for Sale' alone. The official Young Artists Fine Arts Exhibition 青年美展 that year also demonstrated an expectation for contemporary art to make an entry, although it never really materialised. Even so, as an official, large-scale event, the Young Artists Fine Arts Exhibition and its related events contributed, along with some underground shows, to the sudden eruption of avant-garde art in Shanghai that year.

The success of 'Art for Sale' naturally triggered greater enthusiasm. In August of that year, Xu Zhen, Yang Zhenzhong, Alexander Brandt and Yang Fudong curated a photography show titled 'The Same Yet Changed' 物是人非. In this exhibition, which was shuttered by the authorities before it even opened, Yang Fudong demonstrated his unique artistic vision and mature narrative style, establishing his position in contemporary art and guaranteeing his fame in the following years even though there were absolutely no signs of such fame at the time. Of course, we now know that Yang's film *An Estranged Paradise* 陌生天堂, which was officially selected for Documenta in Kassel, had been completed by the first half of 1997. (By the way, Gu Lei and Zhou Zixi 周子曦, both residents of Niuzhuang at the time, travelled to Hangzhou for the film, in which they appear as extras.)

In 'The Same Yet Changed', works by Jiang Zhi 蒋志 and Chen Xiaoyun were widely praised. They had been introduced here as friends of Yang Fudong's,

and now, through their own talent and hard work, they won the friendship and respect of the team. Besides, Beijing's Liu Wei and Zhu Yu also built a close relationship with the team.

As with 'Art for Sale', the photography exhibition included some veteran artists from Shanghai, which showed that there was no intended goal based on age or generation. From the outset, they showed a contempt for and discontent with the modus operandi that had the pretentious labels of such-and-such an age.

An intriguing but rarely noticed phenomenon at the show was that Old Cat's work began to move away from contemporary art. His work, closer to photojournalism than the conceptual photography on display, seemed rather out of place. Perhaps since then, or maybe even before then, Old Cat started to shift away from the conceptually ambiguous but directionally clear circle of contemporary art.

In Niuzhuang, besides video, installation and conceptual photography, painting still preoccupied the minds of some people. Although they didn't participate in the three exhibitions mentioned above, they gave their friends the utmost encouragement and support, and were genuinely happy about the success of the shows. It was now their friends' turn to encourage and support them.

In early 2000, 'Beyond Desire: Paintings by Six Artists' 欲望之外—六人绘画展 opened. This exhibition was nominally curated by Zhou Zixi, but in fact was the result of a group effort. Yang Fudong, Shi Dehong 史德宏 and Gao Ming 高鸣 all contributed a great deal during the curating and preparatory stages of the show.

In retrospect, the exhibition was obviously not much of a success. Besides Zhou Zixi, Yang Fudong, Shi Dehong and Gao Ming, Lu Chunsheng 陆春生 and Chen Zhongzhu 陈钟柱 also participated in the show. Lu and Chen appeared on the radar during an extensive search; Lu was introduced by Chen Xiaoyun. Lu had spent a few years in Shanghai as a lonely and unknown artist, creating a large number of paintings during that time.

Painting has always been a weak spot for Shanghai; the situation hasn't changed much today, and we still cannot identify an emerging painter worthy of our expectations. The exhibition that year likewise didn't bring much hope to painting in Shanghai, but it presented two interesting newcomers: Lu Chunsheng and Gao Ming.

Lu didn't receive the attention he deserved at the exhibition, but later, as he turned to photography and video, he achieved persuasive progress and became an important and even indispensable young artist after Yang Fudong, Xu Zhen and Yang Zhenzhong. In the text he wrote for the exhibition, Chen Xiaoyun attributed Lu's unique attractiveness to his 'internal imaginations' and 'mystic aura'.

Gao Ming, dubbed 'bohemian' by Chen Xiaoyun, proved the most dazzling artist at the exhibition, and for a while he was about to become a legend of painting in Shanghai. Graffiti-like, his works exude a natural simplicity which, despite his own initial disavowal, had won him some acclaim at the Young Artists Fine Arts Exhibition a year earlier, in 1999. Before then, Gao Ming was just a graduate of Fudan University with a degree in computer science, and little known to Shanghai's art circles.

For different reasons, Shi Dehong and Chen Zhongzhu inched away from activities in contemporary art after the exhibition.

For his part, Yang Fudong completely abandoned his illusions (or hankering) for painting after the exhibition, and devoted himself to video art, which promised better prospects.

Perhaps Zhou Zixi found himself in more complicated circumstances. An early member of the Niuzhuang community, he had wielded considerable influence among Shanghai's young artists, and accordingly won enough expectations. His subsequent career path belied those expectations. He extended the process of his artistic maturation far too long – if we continue to entertain any hope for him. It is obvious that after the exhibition, he entered a down period. For all the new experiments he made later, he saw no clear results and thus lost confidence. It has been quite some time since we last saw his new work.

In the second half of 1999, another contemporary art exhibition was held in Shanghai. Titled 'Ideas and Concepts' 观念与概念, it was curated by artists in Nanjing, but the venue was found by a Shanghai artist by the name of Zhou Hongxiang 周弘湘.

In early 2000, Zhou went to Yang Fudong with the idea of an exhibition of works on paper, and it was realised in 'Inertia and Mask' 惰性与伪装, in August of that year. The curating team later expanded dramatically to include Zhou Hongxiang, Yang Fudong, Xu Zhen, Yang Zhenzhong, Lu Chunsheng and Zhou Zixi.

Beginning with this exhibition, a large number of Hangzhou-based artists, exemplified by Chen Xiaoyun, joined the group. Later, they either participated in exhibitions in Shanghai or invited Shanghai artists to take part in shows they organised in Hangzhou. A new tale of two cities emerged.

Another striking young artist at this exhibition was undoubtedly Xiang Liqing. He and his densely cramped apartment buildings with Chinese characteristics began to draw more and more attention.

From today's vantage point, perhaps we can say that 'Inertia and Mask' was the last collective showing of the friendly and spirited group that had formed in Niuzhuang and gradually expanded. It was also the most focussed show of the group, even though the exhibition itself wasn't particularly bad-arse.

With the exception of Shi Dehong, all the early members of Niuzhuang (Old Cat, Xu Zhen, Gu Lei, Gao Ming, Zhou Zixi, Ni Jun and Liang Yue), those who joined later (Yang Fudong, Yang Zhenzhong, Alexander Brandt and Lu Chunsheng), artists hailing from Hangzhou (Chen Xiaoyun, Tong Biao 佟飙, Zhang Xin 张新 and Zhao Yang 赵洋) and Beijing's Kan Xuan all exhibited their work. As more new friends joined, the lively community continued to grow. What started as a dream by a few young artists sheltered in a shabby village room in Shanghai's western suburbs was now receiving more and more attention.

Yet it was after this exhibition that the original Niuzhuang community began to disintegrate, as its main members dissipated. Shi Dehong, who didn't participate in the show, was perhaps the first to leave. Then it was Old Cat: in 2001 he had a solo exhibition at BizArt, but the photojournalistic works on show had almost nothing to do with avant-garde art. Besides that, he attended an event as a 'devoted amateur' in a 2002 exhibition titled '24:30'. Gu Lei, another important leader in the early stages of Niuzhuang, had been widely recognised since the mid-1990s as a talented and noted young artist, but he gradually lost his voice after this exhibition.

Another exhibition in 2000 that merits mentioning is 'Home' 家, curated by Wu Meichun 吴美纯. The exhibition was arguably too big for its own good, but it once again reminded us that as China's economic centre, Shanghai held a potentially significant position in China's contemporary art scene.

pp.134–83

The Shanghai Biennale 上海双年展 of November 2000 was, perhaps, a watershed. At that biennale, contemporary art entered the official exhibition halls of China for the first time. Heavyweights of contemporary art such as Matthew Barney, Anselm Kiefer and Cai Guo-Qiang 蔡国强 converged on Shanghai. It meant that contemporary art had won official approval in China, or at least its acquiescence (or maybe enlistment?). Contemporary art could now rise from underground and enjoy the light of day. Around the same time, all kinds of fashion magazines took off and set trends. Admittedly, it would be some time before the budding magazines caught up with contemporary art. Nevertheless, avant-garde art in China could hope for the day when it would walk tall.

The contemporary art effect in Shanghai achieved through such exhibitions as 'Art for Sale' and 'Home' was further confirmed in the parallel exhibitions at the Shanghai Biennale. Of the numerous collateral shows, 'Fuck Off' 不合作方式 and 'Useful Life' 有效期 were particularly striking.

pp.184–221

Curated by Ai Weiwei 艾未未, 'Fuck Off' provided an opportunity for various generations of artists to show their work together. The young artists from Shanghai, Beijing and Hangzhou – including Yang Fudong, Yang Zhenzhong, Lu Chunsheng, Liu Wei, Qin Ga 琴嘎, Sun Yuan 孙原, Zhu Yu, Wu Ershan 乌尔善 and Song Tao 宋涛 – garnered more attention. The age of searching for and focussing on young artists had arrived: afterwards, there arose any number of exhibitions billed 'the 1970s' and 'post-1970s', although

they trailed slightly behind literary circles, which had already begun a search for 'the 1980s'.

pp.222–35

'Useful Life' was the first, and perhaps only, joint exhibition of the works of Yang Fudong, Xu Zhen and Yang Zhenzhong, the three leading young artists in Shanghai. This time, thanks to funding support from ShanghART Gallery 香格納画廊, they could put their ideas on display as much as they wanted. With their outstanding and compelling works, they once again confirmed their indisputable position and prowess as Shanghai's leading young artists. Several years of hard work had displaced the days of self-made stages and self-gratifying endeavours, and now bigger and more important stages were already beckoning, or would soon beckon.

Another little-noticed development in 2000 was the departure of Alexander Brandt early that year. The young German-French artist, with his stubborn earnestness and enthusiastic industriousness, left on his Chinese friends and colleagues a deep impression and influence.

So far, the so-called 'opportunities' for Chinese contemporary art have all indisputably arisen overseas – many people have made efforts to redress it, but to no avail. And the opportunities stemming from the West would hardly grace a strange Western artist in China. Brandt had to leave China and return to the West.

pp.32–33

As we wrap up our story of 2000, we finally arrive at BizArt.

A brief timeline is in order: before 2000, BizArt played no role in almost any of the important contemporary art events in Shanghai. Largely sponta-neous amongst young artists, these events started as regular gatherings for pp.35 & 37 the big-name and up-and-coming artists represented by ShanghART Gallery, and later evolved to include curated shows from outside Shanghai. The de-termining factors might have been the city's economic power and the official tolerance demonstrated in the Shanghai Biennale. As for the young artists, they happened to be in the right place at the right time – though I don't mean to deny their hard work and talent, which surely are the prerequisites for any artist's success.

In 1998, BizArt was founded.

In the second half of 2000, Xu Zhen joined BizArt. Around the same time, BizArt began to have some influence in Shanghai. I don't know if the two developments were related – or how they were related – perhaps the question could be answered by people who know BizArt better.

In the second half of 2000, BizArt invited Xie Deqing 谢德庆 and Fei Dawei 费大为 to give talks in Shanghai.

2001 was a lively year. New nests for contemporary art such as Eastlink Gallery and East Daming Road blossomed, as people shuffled through gal-

leries and underground exhibition halls, greeting one another and looking forward to the future.

BizArt played an extremely important role that year – I say so perhaps only because the people I followed tended to rally around BizArt. I now turn to their individual activities.

In June 2001, Xu Zhen was invited to participate in the Venice Biennale. Earlier that year, he and his friends had learnt the news, which undoubtedly gave them great encouragement. Old Cat, who was now working as an entertainment reporter for *Shanghai Yizhou* 上海一周 (Shanghai Weekly), dedicated a whole page to an introduction of the young artist. This was perhaps the beginning of the fashion media's attention on contemporary art, which would later become a hot topic in fashion circles and among the urban middle class. The lonely days were finally over.

In March, a digital image and video art exhibition titled 'Mantic Exstasy' p.33 附体, curated by Chen Xiaoyun and Tong Biao, opened by the beautiful West Lake in Hangzhou. Young artists from Hangzhou, Shanghai and Beijing gathered together again, along with Jiang Zhi, from Shenzhen, whose work *Mumu in Luobupo* 罗布泊的木木 won high praise.

This exhibition travelled to Shanghai in April, and settled at BizArt, which, without question, was the first venue that came to mind at the time.

BizArt had a busy schedule of exhibitions, with 'Developing Time' 进行时 in February and 'Inertia' 惯性 in March.

'Inertia' was a joint exhibition of works by Ni Jun and Gao Ming. This was the last relatively important show for Gao Ming. Afterwards, he sunk into ceaseless discussions and reveries, and was ultimately unable to turn painting around for Shanghai.

Ni Jun was still at the peak of her career around this time. Beginning with her installation/performance art piece *Gift* at '310 Jinyuan Road', her work garnered accolades, on the one hand, but failed to draw enough sustained attention, on the other. Perhaps this was because her work was classified as women's art from the outset – even though she herself never approved such a label – and by then women's art was no longer popular stuff. In fact, Ni Jun's work differed remarkably from what was usually considered women's art, as was readily apparent in her nonchalance towards gender identity and gender difference. However, the issues she was concerned with, such as love, marriage and reproduction, as well as the subtle, sensitive and melancholy ways in which she contemplated these issues, revealed quite obvious womanly traces. In this sense, perhaps her works could be called women's art. But without question, her approach was not 'spontaneously' or 'effectively' women-centred. In other words, it was an approach that didn't expect to win the approval of the dominant men's art. Thus, the lack of sustained attention on her was a matter of course, although it undoubtedly bothered her.

As in previous exhibitions, 'Inertia' received the help of many friends, this time including a young man by the name of Song Tao 宋涛. He looked like Xu Zhen, so much so that according to legend, as he entered the exhibition hall with Xu Zhen in tandem at the 2000 Shanghai Biennale, Jiang Mei 江梅 greeted him warmly, and Song Tao retorted, 'The one you're looking for is behind me.' It appeared that he was often mistaken for the other – he was too young then to be known in Shanghai.

Song Tao had recently graduated from the College of Arts and Crafts. He was initially affiliated with Eastlink Gallery, and came to BizArt in early 2001. Compared with Xu Zhen at a similar age, the warm and cheerful twenty-year-old was reminiscent more of a bandit than a ruffian.

At a large-scale exhibition in August titled 'Homeport' 分别的, 不同的, 各自的, he was officially presented to the public. It was an international exhibition co-sponsored by BizArt – co-sponsoring international shows had been a major commitment for BizArt.

The most interesting aspect of the exhibition was that it took an entirely open space, Fuxing Park, as its exhibition hall, and thereby turned a contemporary art show into a large-scale park tour. The four Chinese artists in the exhibition were all active in Shanghai: Yang Fudong, Yang Zhenzhong, Liang Yue and Song Tao. Yang Fudong and Yang Zhenzhong already counted as veteran artists by then; Liang Yue had been in multiple exhibitions ('Art for Sale', 'Inertia and Mask', 'Mantic Exstasy' …), but she still had a long way to go in her maturation.

As I have already mentioned, these young artists used to rely on themselves for venues and funding. With BizArt, they now finally had a relatively fixed place for their activities.

Since all kinds of joint and group exhibitions had been done, they wanted to try something different this time. A simple idea emerged – a series of successive solo exhibitions called 'One by One' 一个接一个.

The first was Jin Feng 金峰. It must be noted that this was not the 'old Cossack' of Nanjing – of course, he was no longer very young if we don't apply the standards of our country's cadres.

Prior to this, Jin Feng had stay away from this circle, though he had exhibited his work at 'Inertia and Mask' a year earlier, when he was still doing works on paper that resembled experimental ink washes. Beginning with this solo exhibition, titled 'Top-Down' 自上而下, his interests shifted gradually towards more mainstream art forms such as conceptual photography and video. Meanwhile, he built a closer relationship with the growing circle.

The group of artists who had gotten their start in Niuzhuang had a brief hiatus in the second half of the year. Some of them appeared frequently in various exhibitions at home and abroad, as more and more opportunities cropped up.

After Xu Zhen in Venice, Yang Fudong was invited to exhibit at Documenta in Kassel in 2002. Yang Zhenzhong had shot to fame with his 'Lucky Family' at the 1999 'Jiangnan' 江南 exhibition in Vancouver; in 2003, he and Yang Fudong were invited to the Venice Biennale. Now no one questioned their importance to contemporary art in Shanghai.

Behind them, a large number of artists including Lu Chunsheng, Zhou Hongxiang and Ni Jun were biding their time before imminent success. In the second half of 2001, they got their works ready, made preparations for solo exhibitions and waited for opportunities.

From December 2001 to April 2002, Kan Xuan, Song Tao, Xu Zhen, Yang Zhenzhong, Liang Yue and Ni Jun all had solo exhibitions, held without exception at BizArt. BizArt provided not merely a venue, support and assistance; perhaps more importantly, it offered a forum for enthusiastic discussions and candid opinions. The honest friendship was preserved here.

Kan Xuan's solo exhibition was notable in that she would afterward no longer be regarded as a newcomer. It was around this time that she left for France, but she would often come back to visit. She wasn't ready to leave the circle.

Song Tao exhibited an old piece. While he didn't turn out to be another Xu Zhen, as expected, he didn't disappoint either.

Liang Yue was young as ever, although she had better opportunities than her contemporaries. She moved to Beijing afterwards, and disappeared from sight.

Compared with 'Inertia' a year before, Ni Jun matured noticeably. Her sadly beautiful imagery seemed to presage her soon-to-end marriage. Maybe a new destiny awaited her.

At 24:30 hours on 31 March 2002, a large-scale exhibition opened at BizArt.

Aptly titled '24:30', the exhibition was large and chaotic, with nothing more to the curatorial principle than that 'no one had opened an exhibition in the middle of the night'. The idea was more simplistic than simple. Perhaps the young artists just wanted to have some fun. But the swarming media, expectant fans and packed exhibition hall all seemed to proclaim the advent of a contemporary art carnival.

On that joyful day, other people left quietly. Some of the earliest characters began to vanish.

Old Cat exhibited a video at '24:30'. Just when everyone thought he was turning to video art, he exited the lively scene.

Gu Lei had tried painting, installation, performance art and video. At '24:30', he made a return to painting, but left the scene afterwards. He is said to work in the music industry now.

I can't remember if Gao Ming showed his work at '24:30'. Whatever the case, since then he has been dormant for far too long.

And Shi Dehong, who hadn't been seen for a while, decided to apply to post-graduate programmes in aesthetics. He hasn't been successful in that pursuit.

In May 2002, Zhou Zixi held a solo exhibition in a warehouse on North Suzhou River Road, titled 'Sorry, I Don't Know' 对不起，我不知道. The exhibition had been planned for BizArt, but had to be moved to the curious venue due to all sorts of concerns, and thus was excluded from the series 'One by One'.

Soon afterwards, the once passionate child left Shanghai dejected for various reasons. When he returned here a year later, everything was different.

28 May 2004

Translated by Zhao Han.

这届双年展是中国官方机构举办的首个国际当代艺术展览，它的出现以及持续性是中国当代艺术史的一个转折点。在过去的二十多年中，中国的前卫艺术家徘徊幸存于合法与地下之间、容忍与审查之间、个人自由与全球市场的压力之间……在我看来，这也是一个重新发掘知识自由、独立思考、表达、质量、时间、空间、多元化、深度、複杂性和矛盾性等思维意识的契机。这些概念在公共话语和意识中不断受到压迫、抹杀，且被一种"结构性媚俗"的舆论所替代。策划本届双年展的责任和意义也超越了仅仅做一个好展览的目的。它应该是一种对策略、协商和决心的长期实践，以达到彻底改变机构结构和思维模式为目标。

侯瀚如
第三届上海双年展策展人
引自〈上海，一个赤裸的城市 —— 2000年上海双年展策划笔记〉，2001年

The 2000 Shanghai Biennale is the first major international contemporary art event in China to be organised by a state-run institution. For the first time, one can aspire to a more legitimised and regular space for contemporary art in China, after two decades of struggles by avant-garde artists who have been navigating and surviving between legality and the underground, between tolerance and censorship, and between individual freedom and global market pressures. The biennale is also an occasion, at least in my own understanding, for bringing back a consciousness of intellectual freedom, independent thinking, expression, diversity, complexity and contradiction – all of which have been oppressed and erased from public discourse and consciousness and replaced by a consensus based on structural kitsch. Curating such a biennale is much more than creating a good exhibition; it is a long-term exercise of strategy, negotiation and determination to achieve fundamental changes in institutional structures and the ideology behind such structures.

~Hou Hanru, co-curator of the 2000 Shanghai Biennale. From 'A Naked City: Curatorial Notes Around the 2000 Shanghai Biennale'

这个展览 [《不合作方式》] 无足轻重。它不会对中国的所谓的艺术发展 [有所推进]，或者是说有一个怎样承上启下的作用。因为中国的艺术家和所谓的艺术思潮根本没有形成，直到今天也没有形成。中国是没有世界观的一个国度，它是无序的。在某种程度上，是非常自由的，但是同时又很难量化和定位的这么一个社会。中国的重要性是在于它的无序性，它像一个单独的世界，突然地出现。那么，这个展览的发生又非常确定，确实是有40多个艺术家在关键的时刻 [做了这麼一件事]。那是中国的一个转型期的关键时刻，它从对西方文化的全面抵制，转变到利用西方文化来作为城市名片，来宣传中国，期望成为被理解的 [国际社会] 成员。

[这一个转型] 的巅峰时期是到2008年的奥运会，还有2010年的世博会，在此之后，中国又再次宣布了不承认普世价值。所以我们要现在看这样的展览，它是应运而生的，抓住了机会，该喊出一声的时候喊出了一声，很快，当然会被中国的泡沫所淹没。对我来说，它是我个人理想的一部分，因为作为艺术家，如果说也算是知识分子，还是要重申一些基本原则，这原则可能很幼稚，很不值得推敲，但是毕竟是原则，它是一个时期的一个最大的可能性。它和我今天所做的从事的很多工作，仍然是具有一致性的，那就是去寻找个人的感受方式和表达方式。

艾未未
《不合作方式》策展人
卢迎华、刘鼎访谈，2020年1月

['Fuck Off'] was insignificant. It wasn't going to [promote] China's so-called artistic development, or serve as something of a link between the past and the future. Chinese artists and the so-called artistic ethos had not taken shape, and has not even today. China is a country without a world view or any order.

To a certain extent, it is very free, but at the same time it's rather difficult to quantify or place such a society. China's significance consists in its disorder: like an isolated world, it has appeared suddenly. On the other hand, the occurrence of the exhibition was a certainty; indeed, some forty artists [did it] at a critical moment. It was a critical moment during China's transitional period, when the country went from completely resisting Western culture to using it for city branding in a publicity campaign for China, expecting to be understood and accepted as a member of the 'international community'.

[This transition] peaked around the time of the 2008 Olympics and Expo 2010. Since then, China has once again renounced universal values. So from today's perspective, the exhibition was born at the right time, seized the right opportunity, and shouted out when it was supposed to. Pretty soon, of course, the shout would be drowned out by China's bubbles. To me, it was part of my personal ideals, for if an artist is to be considered an intellectual, he ought to reiterate certain fundamental principles, which, though perhaps naïve and unsound, are principles nevertheless. It was the biggest possibility in a certain period. It is still consistent with much of the work I do today, in that they are united in the search for personal ways of feeling and expression.

~Ai Weiwei, artist, co-curator of 'Fuck Off'. Interviewed by Liu Ding and Carol Yinghua Lu, January 2020

对我来说，自由是一种追求，或者是一种提醒，而不是一个标准。你也不是24小时需要它。或者，自由更多是一种动态的生长。相对而言，我们这一代的艺术家（1968-1977年出生的一代人）对"具体政治"的自由，并没那么强烈的要求。成长于改革开放后，因为新事物出现的频率，分散了我们对"自由"的注意力：城市快速建设，早期受自由主义影响，艺术市场的崛起，互联网时代来临，身上同时有资本主义逻辑和社会主义习惯的痕迹，从赤贫到中产，从封闭到全球化，从学院主义教育到国际化竞争……等等，我们可能是经历了最多矛盾性的一代人。这一代艺术家在创作上体现出的特点是：多题材，多媒介，早熟，创作生命周期偏长，没有前辈沉重，比后一代更理想主义。

徐震
藝術家，參加《有效期》及《不合作方式》
翁子健访谈，2019年9月

To me, freedom is a pursuit or a reminder rather than a standard. You don't need it round the clock. Or freedom is more like a dynamic growth. Comparatively speaking, artists of my generation (born between 1968 and 1977) don't really have strong demands for 'specifically political' freedom. Having grown up after the country began reforms and an opening-up programme, we were often distracted by new things and situations, which emerged with high frequency: the rapid development of cities, the early influence of liberalism, the rise of art markets, the arrival of the internet age. We bear at once the logic of capitalism and vestiges of socialist habits. From bone-stricken poverty to middle-class comfort, from a closed environment to globalisation, from an academy-dominated education to internationalised competition... we may very well be the generation that has experienced the most contradiction. Artists of this generation demonstrate the following characteristics in their work: a myriad of themes, a multiplicity of mediums, precocity, relatively longer creative life cycles, fewer burdens than our predecessors and more idealism than the next generation.

~Xu Zhen, artist, participant in 'Useful Life' and 'Fuck Off'. Interviewed by Anthony Yung, September 2019

Acknowledgements

We would like to thank the authors, artists and photographers for their contributions to this book.

Uncooperative Contemporaries has benefitted greatly from the research collections held at Asia Art Archive and the dedicated support of the AAA team. Collections relating to the majority of the exhibitions and projects explored in this publication are held at AAA and many of these resources can be accessed online. Visit *https://aaa.org.hk/en* for more details.

For support in the research process that led to this publication we are additionally grateful to: Ai Weiwei; Robert Bernell; Biljana Ciric; Wing Chan; Chen Lingyang; Chen Yanyin; Garfield Chow; Contemporary Art China; Ding Yi; Noopur Desai; Feng Boyi; Lorenz Helbling; Hou Hanru; Claire Hsu; Jin Le; Hazel Kwok; Nicole Lai; Li Liang; Li Xiangyang; Li Xu; Liang Shaoji; Warren Leung Chi Wo; Lesley Ma; Davide Quadrio; Qing Ga; Sha Yue; Sneha Ragavan; Song Tao; Gilane Tawadros; Chuong-Dai Vo; Michelle Wong; JJ Xi; Congyang Xie; Xu Zhen; Yang Zhenzhong; Yang Zhichao; Pauline Yao; Yung Ho Chang; Zhang Qing; Zhao Danhong; Zheng Shengtian; and Zhu Yu.

The *Exhibition Histories* series is generously supported by: Asia Art Archive; Central Saint Martins, University of the Arts London; the Center for Curatorial Studies, Bard College; and public funding through Arts Council England. The series was initially developed with Teresa Gleadowe as Research Consultant and as a Series Editor with Stephan Schmidt-Wulffen and Sabeth Buchmann. It was launched in 2010 with the support of the following institutions: Academy of Fine Arts Vienna, Van Abbemuseum and Musée d'Art Moderne Grand-Duc Jean.

Picture and text credits

Contributors

Jane DeBevoise is co-chair of the board of directors of Asia Art Archive in Hong Kong and chair of the Asia Art Archive in America in New York. Prior to moving to Hong Kong in 2002, DeBevoise was deputy director of the Guggenheim Museum, responsible for museum operations and exhibitions globally. She joined the museum in 1996 as project director of 'China: 5000 Years', a large-scale exhibition of traditional and modern Chinese art that was presented in 1998 at the Guggenheim museums in New York and Bilbao. DeBevoise has an MA from the University of California, Berkeley, and a PhD from the University of Hong Kong, both in art history. Her book *Between State and Market: Chinese Contemporary Art in the Post-Mao Era* was published in 2014 by Brill.

Lee Weng Choy is an independent art critic and consultant based in Kuala Lumpur, and is president of the Singapore section of the International Association of Art Critics. Previously, Lee was artistic co-director of The Substation in Singapore. He has taught at the School of the Art Institute of Chicago, the Chinese University of Hong Kong and the Sotheby's Institute of Art – Singapore. Lee writes on contemporary art and culture in Southeast Asia, and his essays have appeared in journals including *Afterall* and the anthologies *Modern and Contemporary Southeast Asian Art* (2012), *Over Here: International Perspectives on Art and Culture* (2005) and *Theory in Contemporary Art Since 1985* (2005), amongst others. He is currently working on a collection of essays on artists, to be titled *The Address of Art and the Scale of Other Places*.

Liu Ding is a Beijing-based artist and curator. His artistic and curatorial practices focus on connecting the historical and the contemporary from a perspective embedded in the history of thoughts and through descriptions and gazes of multiple layers. He has participated in international exhibitions including: the Istanbul Biennial and the Asia Pacific Triennial, in 2015; the Shanghai Biennale and Prospect.3 New Orleans, in 2014; the 2012 Taipei Biennial; the Chinese Pavilion of the 2009 Venice Biennale; Media City Seoul, in 2008; and the 2005 Guangzhou Triennial, and his work has been presented in art institutions and museums around the world.

Carol Yinghua Lu is an art critic and a curator. She is a PhD scholar in art history at the University of Melbourne and director of Beijing Inside-Out Art Museum. She is a contributing editor at *frieze* magazine and on the advisory board of the journal *The Exhibitionist*. Lu was on the jury for the Golden Lion Award at the 2011 Venice Biennale. She was the artistic co-director of the 2012 Gwangju Biennale and co-curator of the 7th Shenzhen Sculpture Biennale in 2012. She is on the jury for the Tokyo Contemporary Art Award, Hugo Boss Asia and Rolex Mentor and Protégé Arts Initiative.

John Tain is head of research at Asia Art Archive, where he leads a team based in Hong Kong, New Delhi and Shanghai, with projects spanning across Asia. In addition to co-curating an exhibition at the Serendipity Arts Festival in Goa (2018), he is co-convener of MAHASSA (Modern Art Histories in and across Africa, and South and Southeast Asia, 2019–20), a collaboration between Dhaka Art Summit, Cornell University's Institute for Comparative Modernities and AAA. His writings on Rirkrit Tiravanija, Wu Tsang, Charles Gaines and Kara Walker, among others, have appeared in *Artforum, Flash Art, ArtReview Asia, The Brooklyn Rail* and in various exhibition catalogues; and he is a series editor for Afterall's *Exhibition Histories* series. He was previously a curator for modern and contemporary collections at the Getty Research Institute in Los Angeles.

Xu Hong 徐虹 is a scholar, critic and museum curator who specialises in contemporary art and women artists. She was a member of the academic department of Shanghai Art Museum from 1985 to 2000, and participated in organising the first and second editions of the Shanghai Biennale, in 1996 and 1998. Between 2000 and 2013, she was a member of the academic department at the National Art Museum of China, Beijing.

Mia Yu is an art historian, critic and curator based in Beijing. Her research is focussed on transnational modernism, global exhibition histories and geo-aesthetics in contemporary art. She has collaborated on various exhibitions, publications and research projects with Times Art Center Berlin; Guangdong Times Museum; Villa Vassilieff, Paris; the Asia Society Hong Kong; New Century Art Foundation, Beijing; and Beijing Inside-Out Museum. Mia Yu is the recipient of a Yishu Award for Critical Writing on Contemporary Art, in 2018; a Tate Asia Research Travel Fellowship, in 2017; and a CCAA Art Critic Award, in 2015. Since 2019, she has been on the jury of the Hyundai Blue Prize for emerging curators.

Anthony Yung 翁子健 is senior researcher at Asia Art Archive, specialising in the history of contemporary art in the Chinese regions. He received a Yishu Award for Critical Writing on Contemporary Chinese Art in 2014, and co-curated 'A Hundred Years of Shame – Songs of Resistance and Scenarios for Chinese Nations' in 2015, at Para Site Art Space, Hong Kong. He is also co-founder of Observation Society, an independent art space in Guangzhou.

Zhou Zixi 周子曦 is an active member of the experimental art circle in Shanghai, where he has lived and worked since 1992. His major solo exhibitions in the city include 'Sorry, I Don't Know' 对不起, 我不知道 (2002) and 'Happy Life' (2008), both at BizArt; 'China 1946–1949' (2008), at ShanghART H-Space; and 'Spring Outing in Xiaogang' (2015).

Index

Notes

Notes

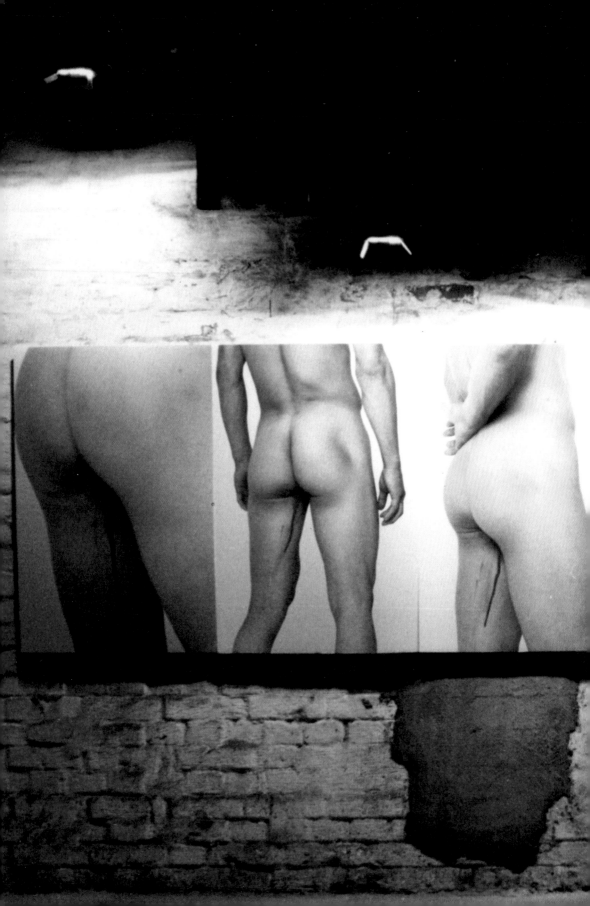